500 POSES *for*
Photographing Infants and Toddlers

A VISUAL
SOURCEBOOK FOR
DIGITAL PORTRAIT
PHOTOGRAPHERS

D1293736

Michelle Perkins

AMHERST MEDIA, INC. ■ BUFFALO, NY

The Stella B. Foundation
www.stellabfoundation.org

A portion of the proceeds from this book will be donated to The Stella B. Foundation. The foundation believes that no family should have to decide how to divide their time between work and a child with a long-term or life-threatening illness. By assisting with rent, utility bills, and travel arrangements for imperative medical appointments, they help ensure that finances do not impede the family's ability to be by their child's side. The Stella B. Foundation is committed to helping make the parents' decision to hold their child's hand an easy one.

Copyright © 2013 by Michelle Perkins.
All rights reserved.

Front cover photographs by Brett Florens.
Back cover photograph by Christie Mumm.

Published by:
Amherst Media, Inc.
P.O. Box 586
Buffalo, N.Y. 14226
Fax: 716-874-4508
www.AmherstMedia.com

Publisher: Craig Alesse
Senior Editor/Production Manager: Michelle Perkins
Editor: Barbara A. Lynch-Johnt
Editorial Assistance from: Carey Anne Miller, Sally Jarzab, John S. Loder
Business Manager: Adam Richards
Marketing, Sales, and Promotion Manager: Kate Neaverth
Warehouse and Fulfillment Manager: Roger Singo

ISBN-13: 978-1-60895-602-9
Library of Congress Control Number: 2012920993
Printed in Korea.
10 9 8 7 6 5 4 3 2 1

Check out Amherst Media's blogs at: http://portrait-photographer.blogspot.com/
http://weddingphotographer-amherstmedia.blogspot.com/

About This Book

As any experienced portrait photographer will tell you, working with children can be both challenging and rewarding. When things aren't going well, the shoot can come to a crashing halt—but when they come together well, the results can be amazing depictions that families will cherish for generations to come.

In this book, we'll look at poses for the very youngest (and most frequently photographed) of child portrait subjects: newborns and toddlers. Obviously, poses that work with a sleepy newborn are quite different from those that suit an adventurous toddler, so why group these kids into one book? There are some good reasons.

It can be difficult to remain creative day after day, year after year, but sometimes all you need to break through the slump is a little spark.

First, much of early childhood photography involves documenting developmental milestones—the newborn holding her head up, the child's ability to sit up unassisted, the toddler taking his first steps, etc. These are best understood when viewed in the context of what came before (what the younger child couldn't yet do) and what will come later (what only an older child can do).

A second common thread in these portraits is an emphasis on relationships. More than with any other age group, very young children are commonly depicted with their parents or siblings. These portraits offer special posing challenges and opportunities, so a section of the book is devoted to images with more than one subject. The child's relationship with their environment is a related theme, so children are often shown interacting with props. Props can assist with posing, but they also need to be managed carefully and never allowed to overwhelm the small subject.

A final—and critical—common thread is the need for speed and efficiency. Portrait sessions with infants and toddlers are generally not long, drawn-out affairs. While flexibility is important, walking into the session with a few great ideas ready to go can help make the session a success.

Filled with images by accomplished portrait, fashion, and editorial photographers, this book provides a resource for photographers seeking inspiration. Stuck on what to do with a particular child? Flip through the sample portraits, pick something you like, then adapt it as needed to suit your tastes. Looking to spice up your work with some new poses? Find a sample that appeals to you and look for ways to implement it (or some element of it) with your subject. For ease of use, the portraits are grouped according to the age of the subject, and further delineated by the type of pose (seated, standing, with a parent, etc.).

It can be difficult to remain creative day after year, but sometimes all you need to break through a slump is a little spark. In this book, you'll find a plethora of images designed to provide just that.

Contents

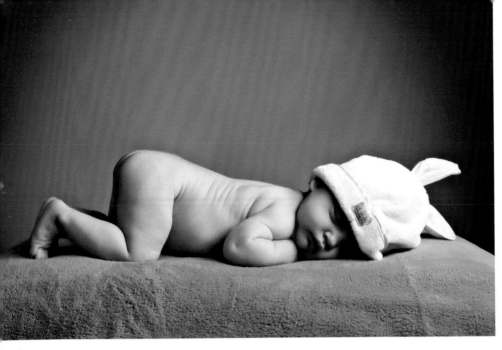

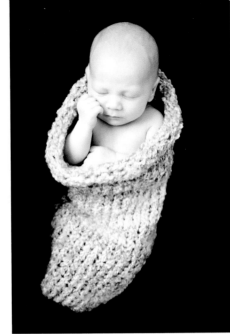

PLATE 1. Photograph by Christie Mumm.

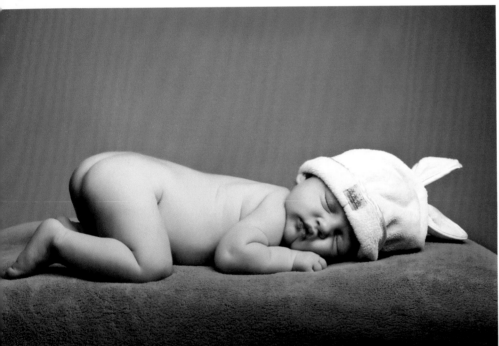

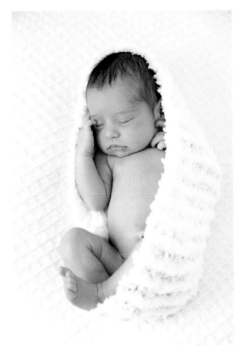

PLATE 2. Photograph by Christie Mumm.

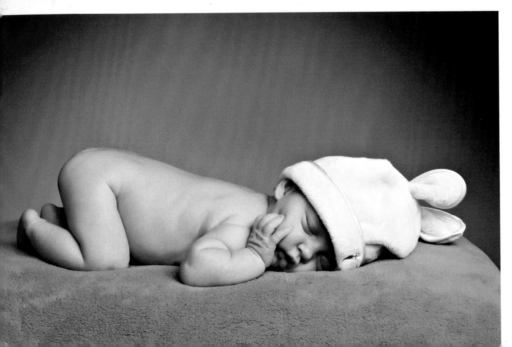

PLATE 3 (TOP LEFT).
Photograph by Marc Weisberg.

PLATE 4 (CENTER LEFT).
Photograph by Marc Weisberg.

PLATE 5 (BOTTOM LEFT).
Photograph by Marc Weisberg.

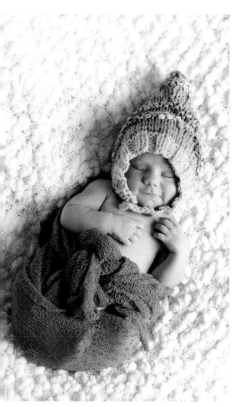

PLATE 6. Photograph by Jenean Mohr.

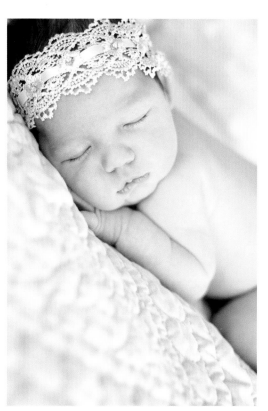

PLATE 7. Photograph by Jenean Mohr.

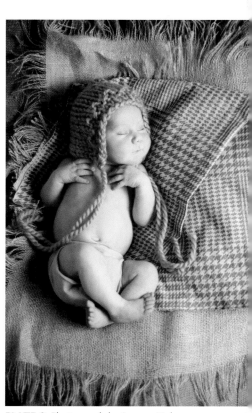

PLATE 8. Photograph by Jenean Mohr.

PLATE 9. Photograph by Jenean Mohr.

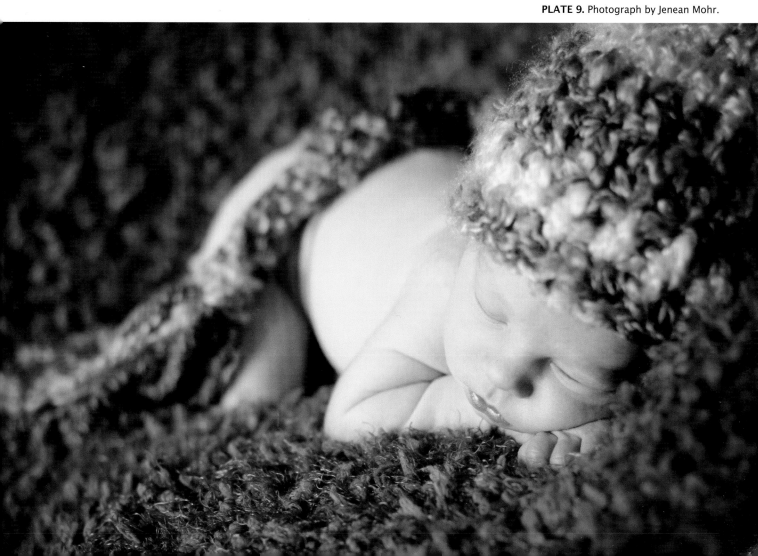

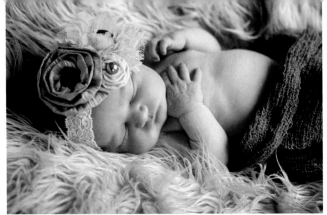

PLATE 10. Photograph by Jenean Mohr.

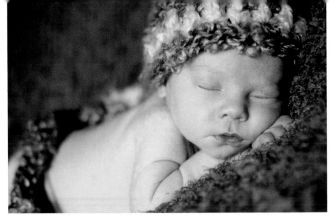

PLATE 11. Photograph by Jenean Mohr.

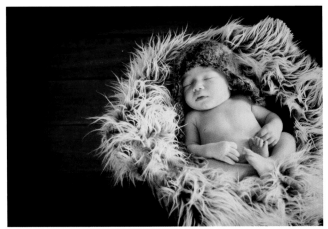

PLATE 12. Photograph by Heather Magliarditi.

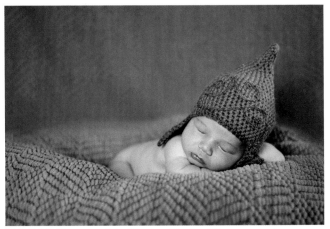

PLATE 13. Photograph by Heather Magliarditi.

PLATE 14. Photograph by Krista Smith.

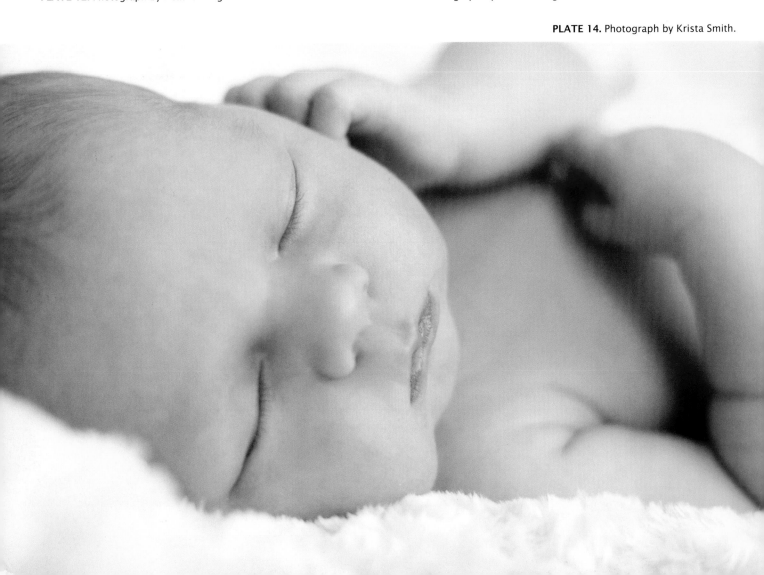

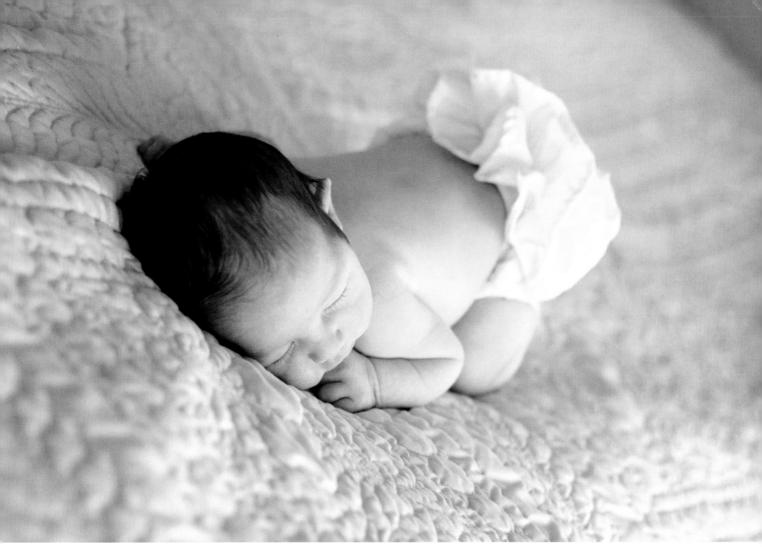

PLATE 15. Photograph by Jenean Mohr.

PLATE 16. Photograph by Heather Magliarditi.

PLATE 17. Photograph by Jenean Mohr.

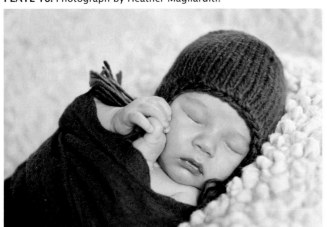

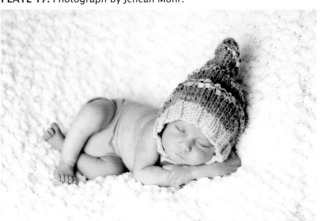

PLATE 18. Photograph by Jenean Mohr.

PLATE 19. Photograph by Jenean Mohr.

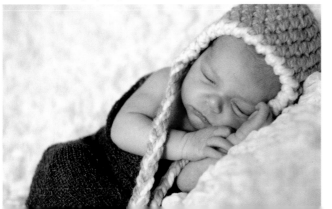

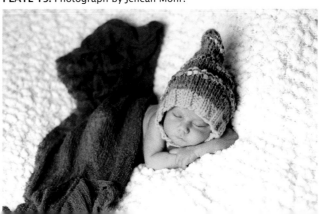

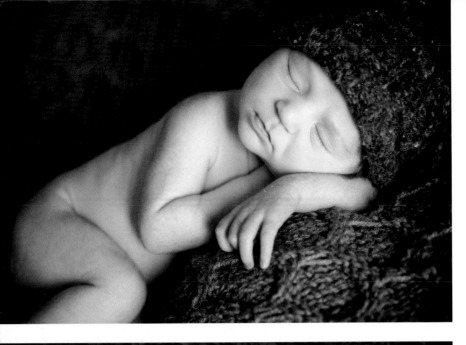

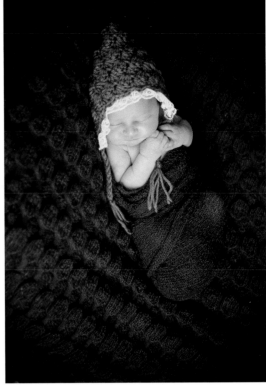

PLATE 20. Photograph by Jenean Mohr.

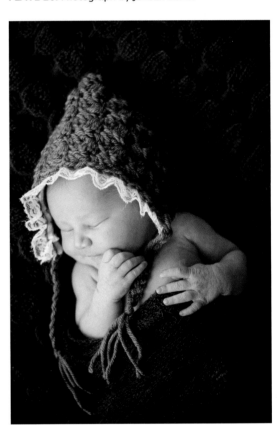

PLATE 21. Photograph by Jenean Mohr.

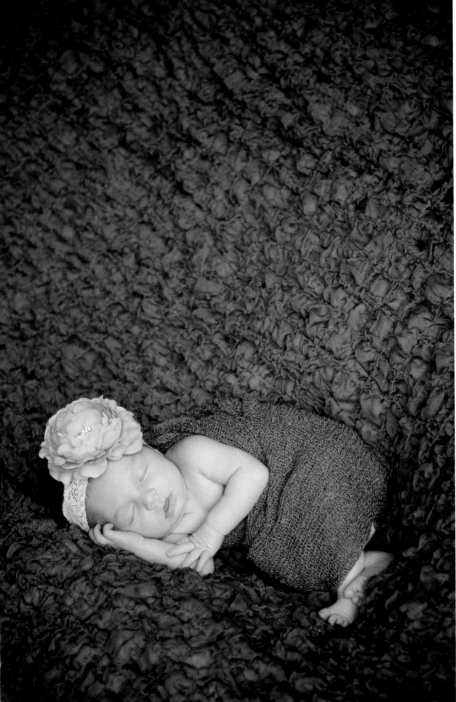

PLATE 22 (TOP LEFT).
Photograph by Jenean Mohr.

PLATE 23 (BOTTOM LEFT).
Photograph by Jenean Mohr.

PLATE 24. Photograph by Jenean Mohr.

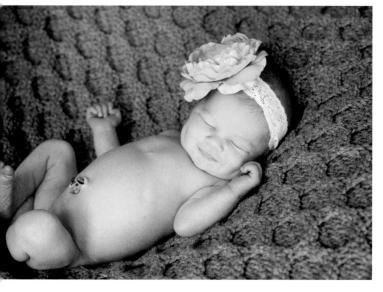

PLATE 25. Photograph by Jenean Mohr.

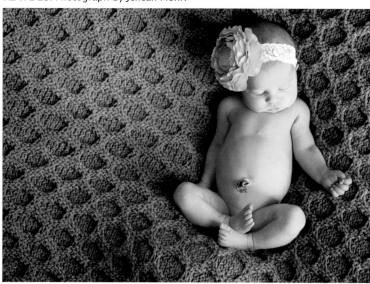

PLATE 26. Photograph by Jenean Mohr.

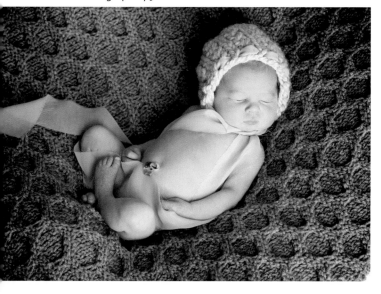

PLATE 27. Photograph by Jenean Mohr.

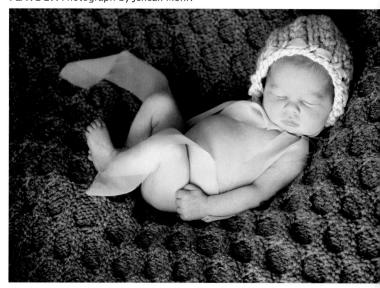

PLATE 28. Photograph by Jenean Mohr.

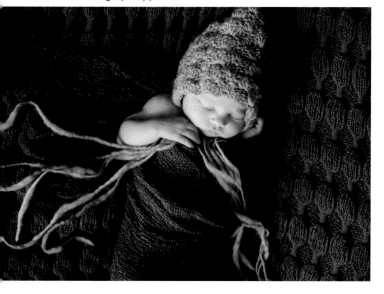

PLATE 29. Photograph by Jenean Mohr.

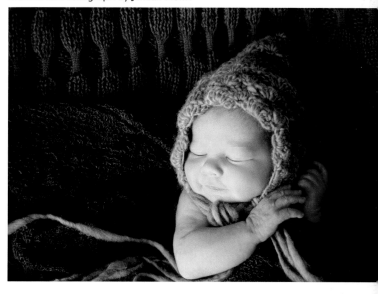

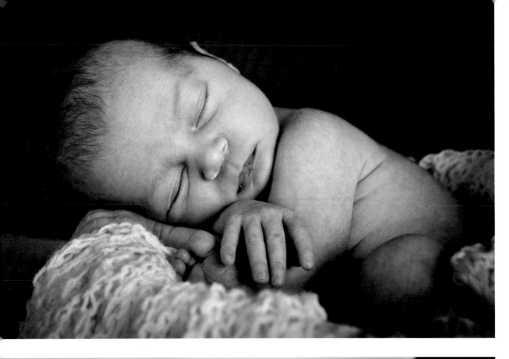

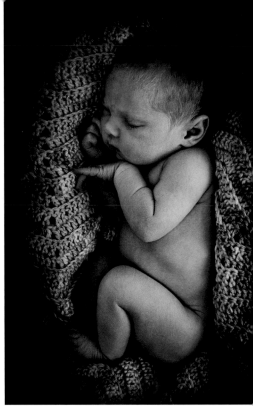

PLATE 30. Photograph by Marc Weisberg.

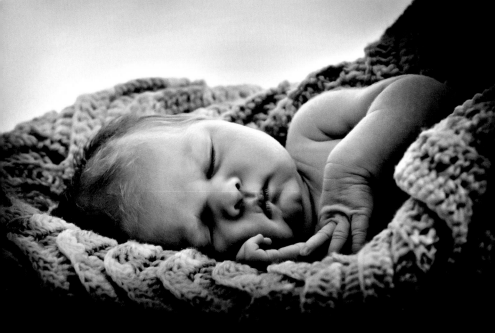

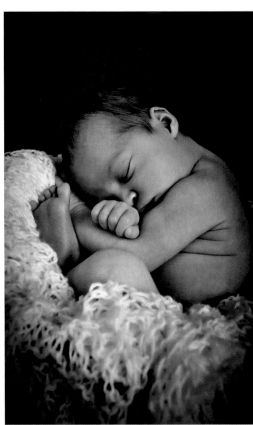

PLATE 31. Photograph by Marc Weisberg.

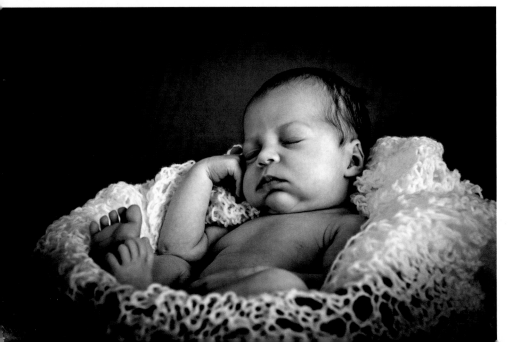

PLATE 32 (TOP LEFT).
Photograph by Marc Weisberg.

PLATE 33 (CENTER LEFT).
Photograph by Marc Weisberg.

PLATE 34 (BOTTOM LEFT).
Photograph by Marc Weisberg.

PLATE 35 (TOP RIGHT).
Photograph by Marc Weisberg.

PLATE 36 (BOTTOM RIGHT).
Photograph by Beth Forester.

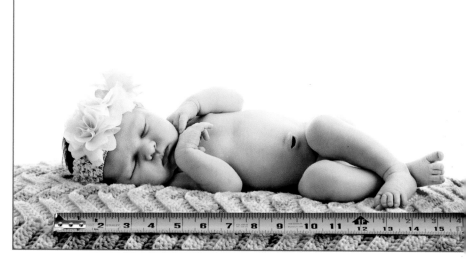

PLATE 37. Photograph by Jenean Mohr.

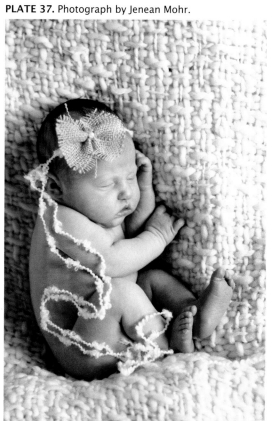

PLATE 38. Photograph by Christie Mumm.

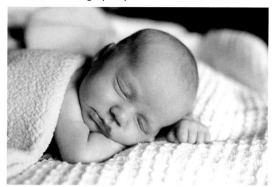

PLATE 39. Photograph by Marc Weisberg.

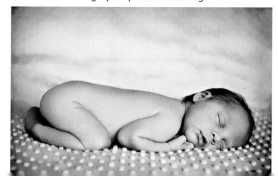

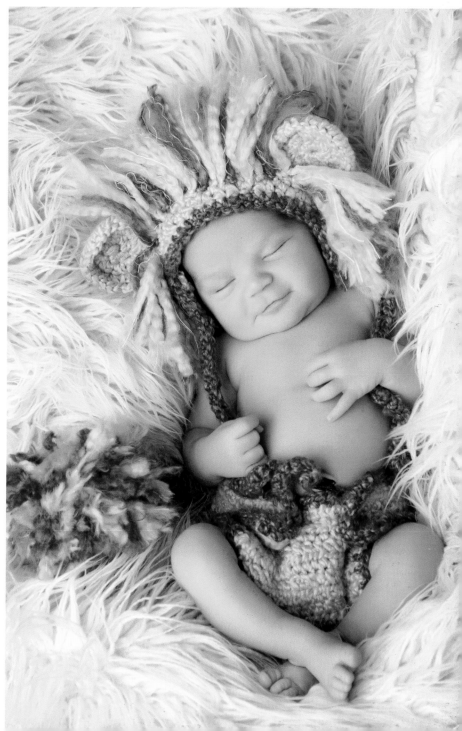

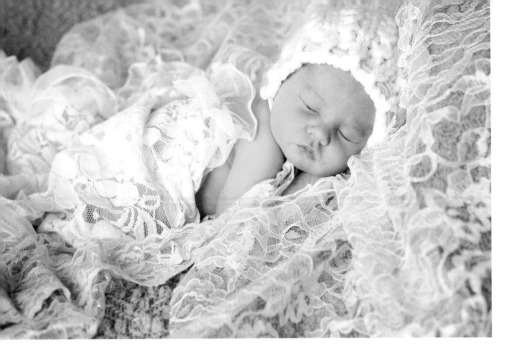

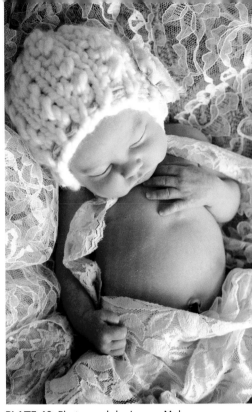

PLATE 40. Photograph by Jenean Mohr.

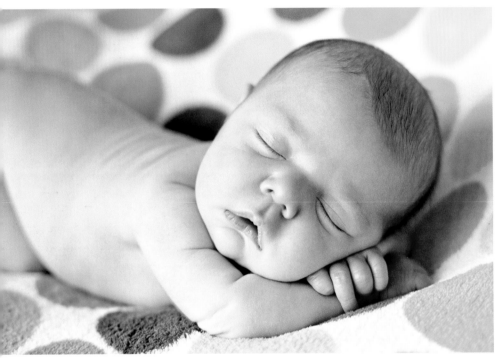

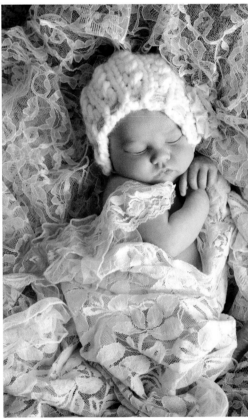

PLATE 41. Photograph by Jenean Mohr.

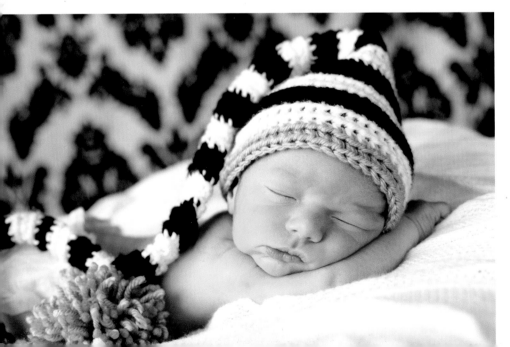

PLATE 42 (TOP LEFT).
Photograph by Jenean Mohr.

PLATE 43 (CENTER LEFT).
Photograph by Christie Mumm.

PLATE 44 (BOTTOM LEFT).
Photograph by Christie Mumm.

PLATE 45. Photograph by Christie Mumm.

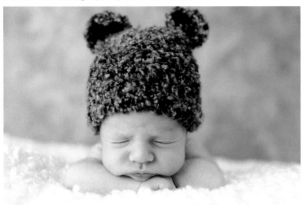

PLATE 46. Photograph by Christie Mumm.

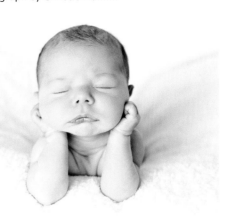

PLATE 47. Photograph by Christie Mumm.

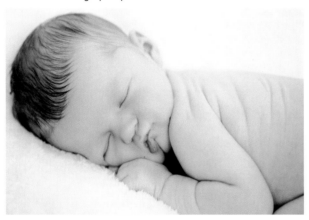

PLATE 48. Photograph by Christie Mumm.

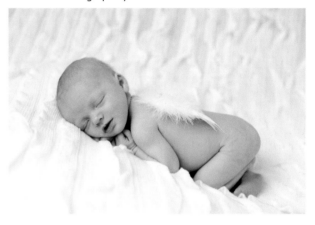

PLATE 49. Photograph by Christie Mumm.

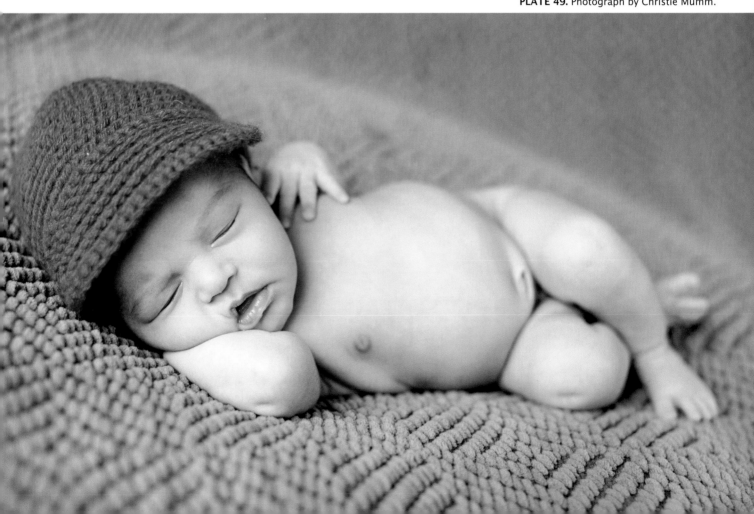

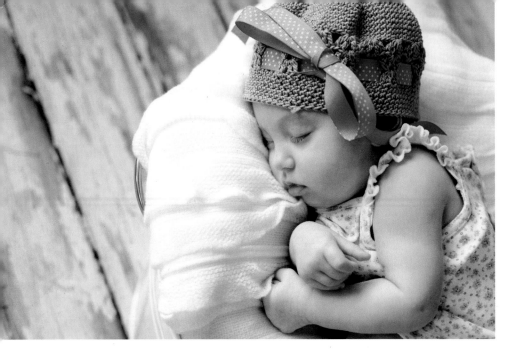

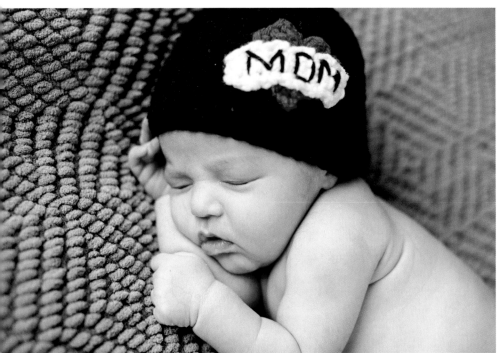

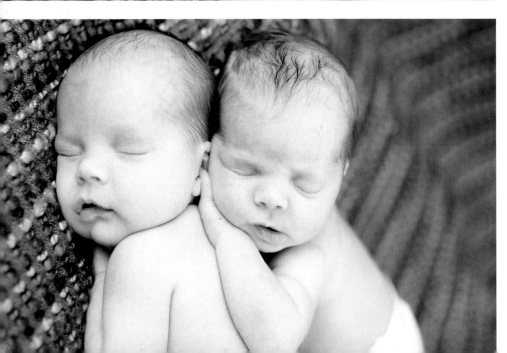

PLATE 50 (TOP LEFT).
Photograph by Christie Mumm.

PLATE 51 (CENTER LEFT).
Photograph by Christie Mumm.

PLATE 52 (BOTTOM LEFT).
Photograph by Christie Mumm.

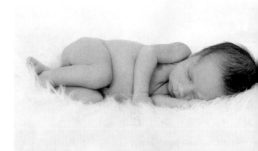

PLATE 53. Photograph by Krista Smith.

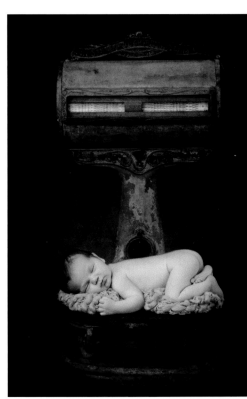

PLATE 54. Photograph by Beth Forester.

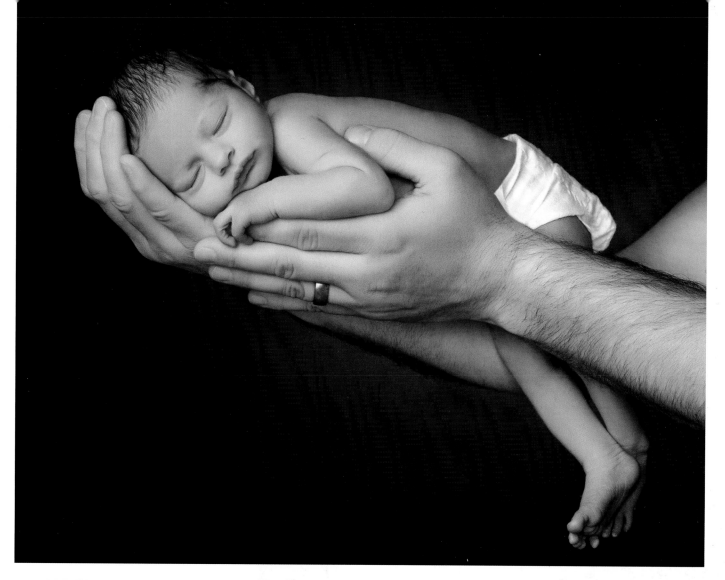

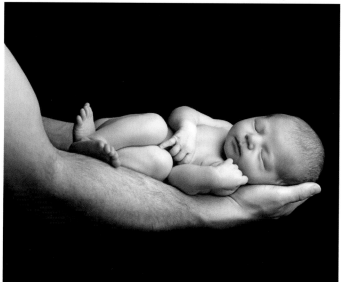

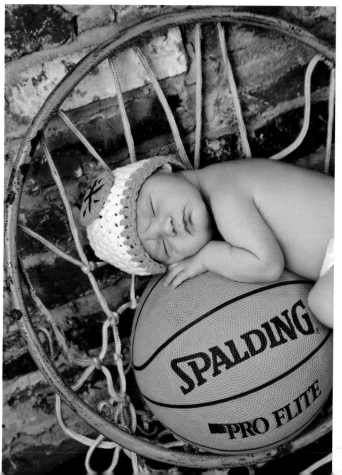

PLATE 55 (TOP).
Photograph by Beth Forester.

PLATE 56 (ABOVE LEFT).
Photograph by Beth Forester.

PLATE 57 (RIGHT).
Photograph by Beth Forester.

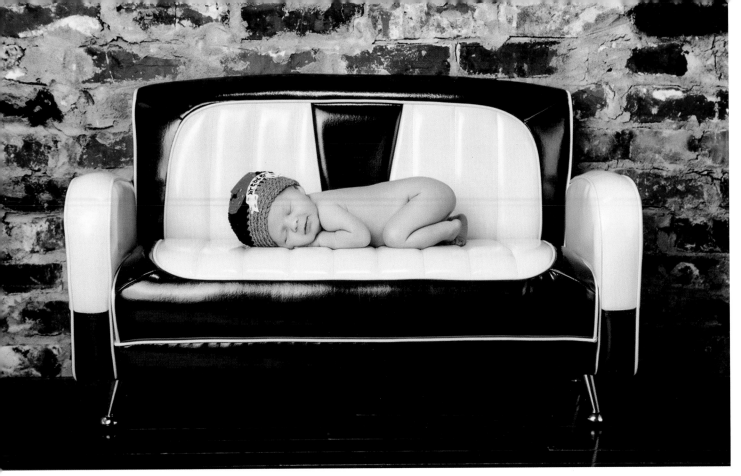

PLATE 58. Photograph by Beth Forester.

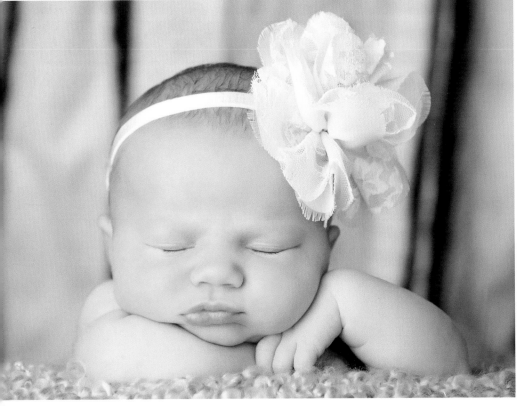

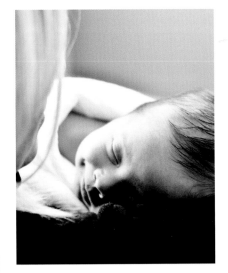

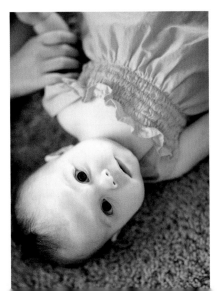

PLATE 59 (ABOVE). Photograph by Beth Forester.

PLATE 60 (TOP RIGHT). Photograph by Krista Smith.

PLATE 61 (RIGHT). Photograph by Christie Mumm.

PLATE 62. Photograph by Beth Forester.

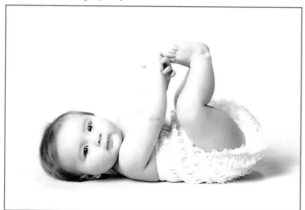

PLATE 63. Photograph by Tracy Dorr.

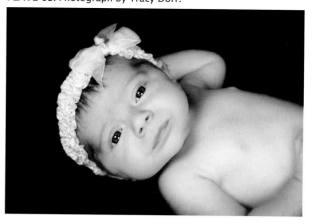

PLATE 64. Photograph by Heather Magliarditi.

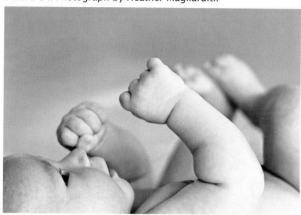

PLATE 65. Photograph by Krista Smith.

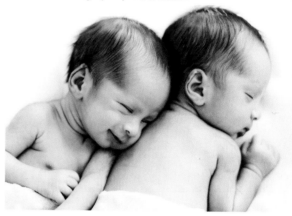

PLATE 66. Photograph by Jenean Mohr.

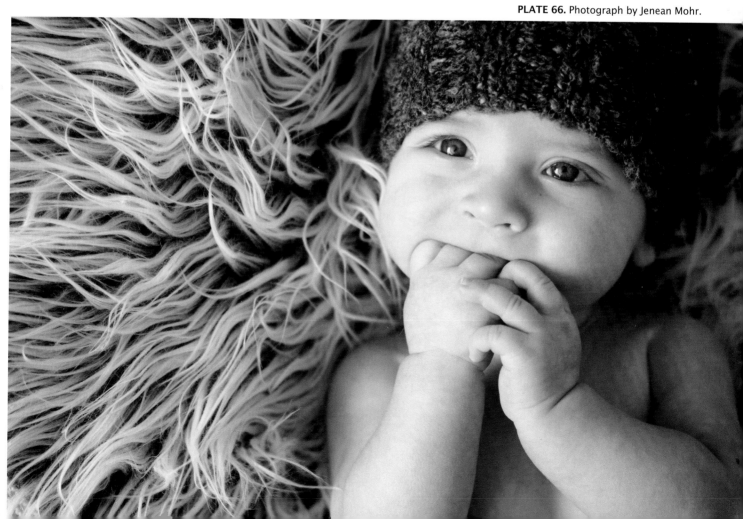

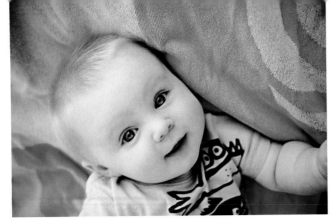

PLATE 67. Photograph by Christie Mumm.

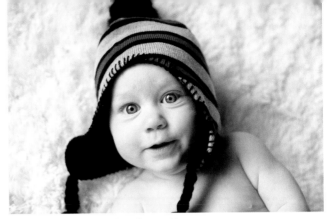

PLATE 68. Photograph by Christie Mumm.

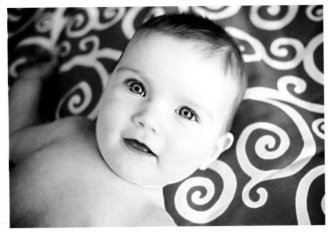

PLATE 69. Photograph by Christie Mumm.

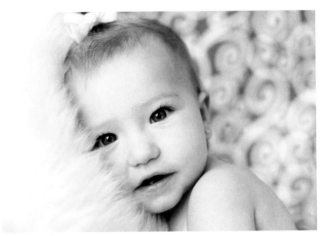

PLATE 70. Photograph by Christie Mumm.

PLATE 71. Photograph by Christie Mumm.

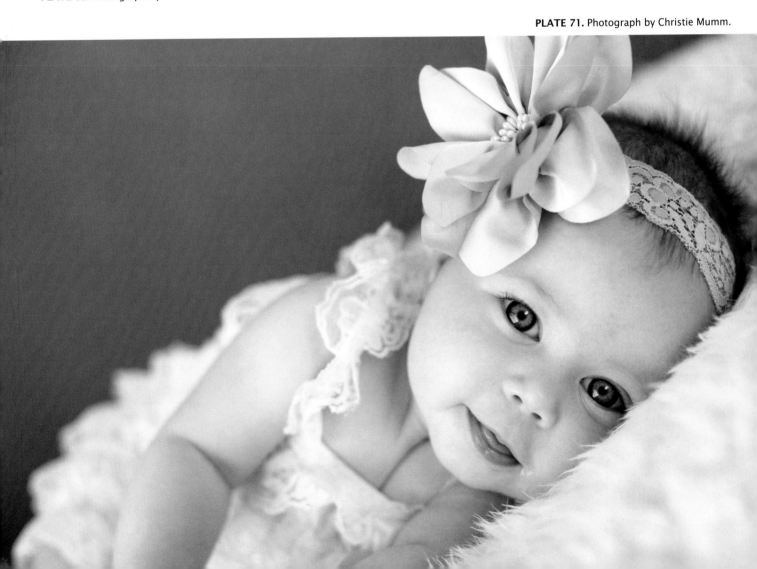

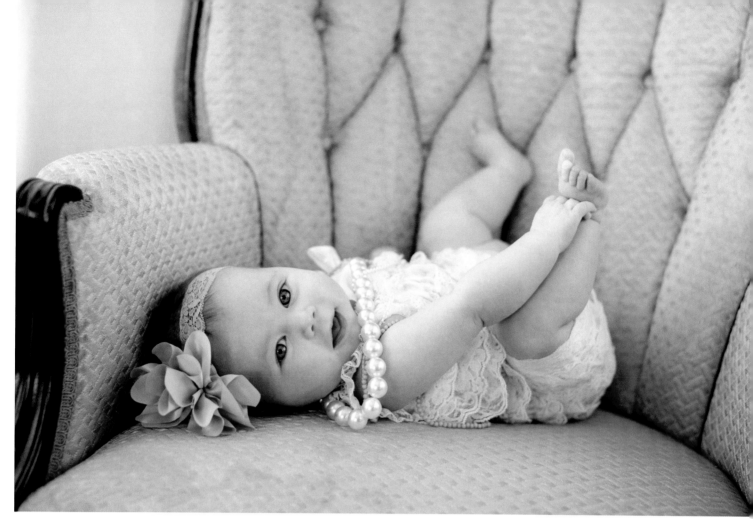

PLATE 72. Photograph by Christie Mumm.

PLATE 73. Photograph by Christie Mumm.

PLATE 74. Photograph by Christie Mumm.

PLATE 75. Photograph by Mimika Cooney.

PLATE 76. Photograph by Mimika Cooney.

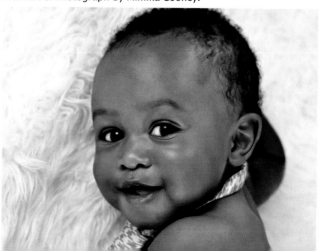

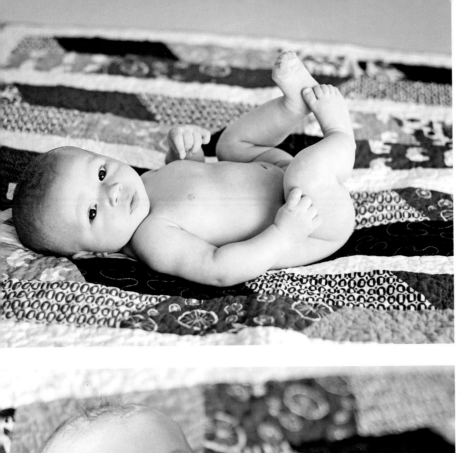

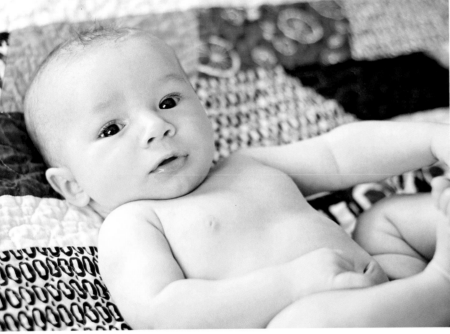

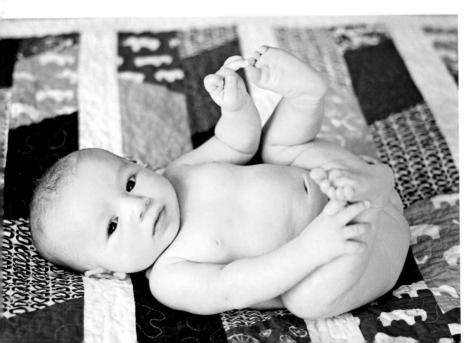

PLATE 77 (TOP LEFT).
Photograph by Heather Magliarditi.

PLATE 78 (CENTER LEFT).
Photograph by Heather Magliarditi.

PLATE 79 (BOTTOM LEFT).
Photograph by Heather Magliarditi.

PLATE 80. Photograph by Christie Mumm.

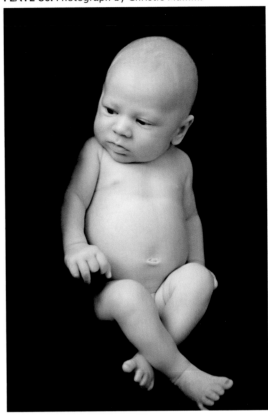

PLATE 81. Photograph by Krista Smith.

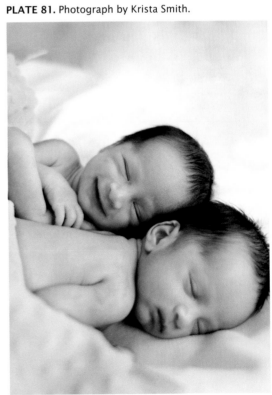

PLATE 82 (LEFT).
Photograph by
Mimika Cooney.

PLATE 83 (RIGHT).
Photograph by
Mimika Cooney.

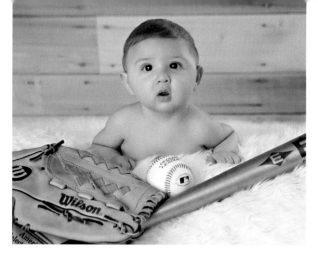

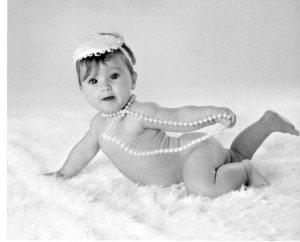

PLATE 84 (LEFT).
Photograph by
Heather Magliarditi.

PLATE 85 (RIGHT).
Photograph by
Mimika Cooney.

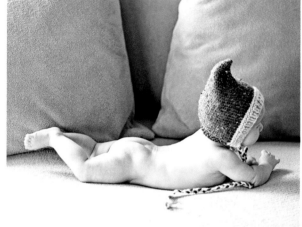

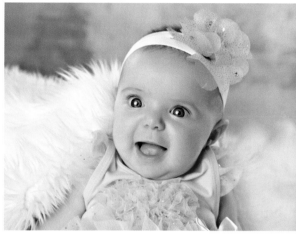

PLATE 86. Photograph by Christie Mumm.

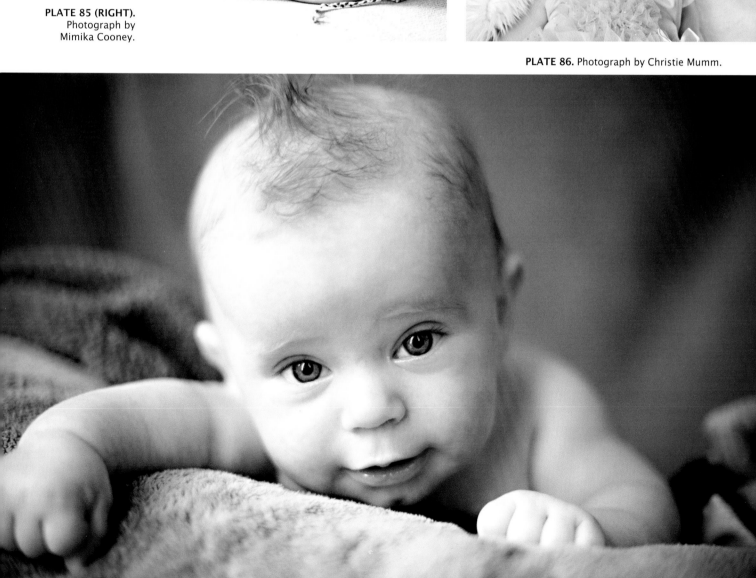

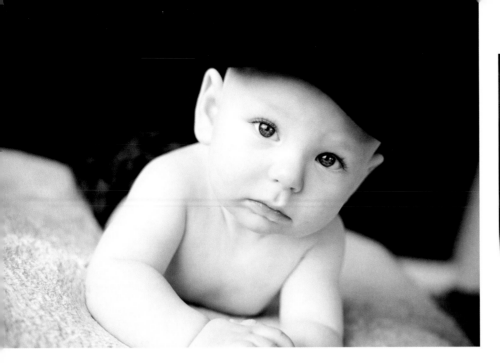

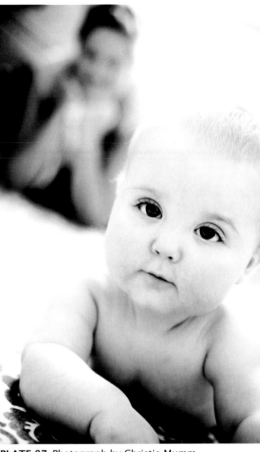

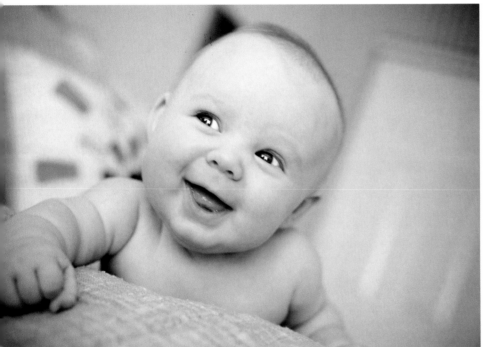

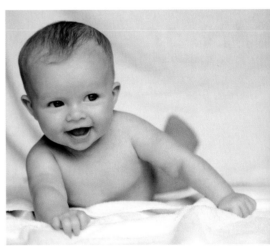

PLATE 87. Photograph by Christie Mumm.

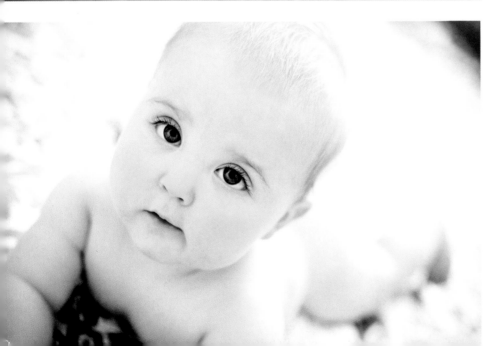

PLATE 88. Photograph by Brett Florens.

PLATE 89 (TOP LEFT).
Photograph by Christie Mumm.

PLATE 90 (CENTER LEFT).
Photograph by Christie Mumm.

PLATE 91 (BOTTOM LEFT).
Photograph by Christie Mumm.

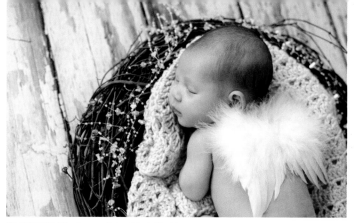

PLATE 92. Photograph by Christie Mumm.

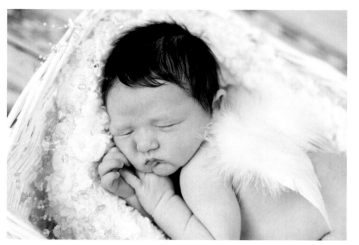

PLATE 93. Photograph by Christie Mumm.

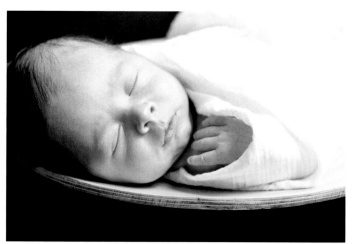

PLATE 94. Photograph by Krista Smith.

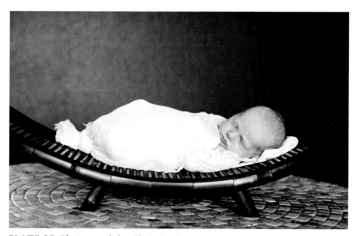

PLATE 95. Photograph by Christie Mumm.

PLATE 96. Photograph by Christie Mumm.

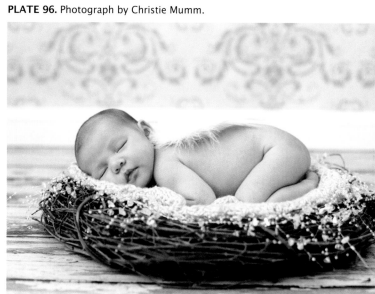

PLATE 97. Photograph by Krista Smith.

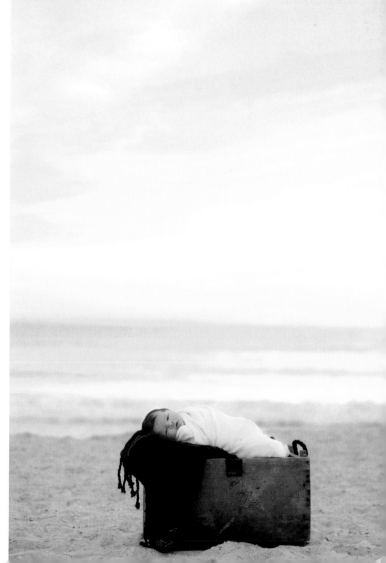

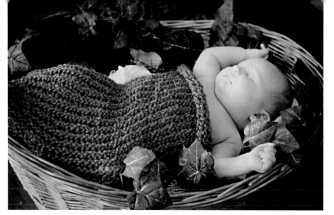

PLATE 98. Photograph by Christie Mumm.

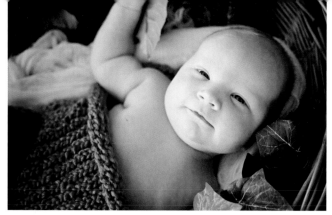

PLATE 99. Photograph by Christie Mumm.

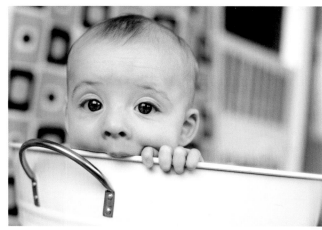

PLATE 100. Photograph by Christie Mumm.

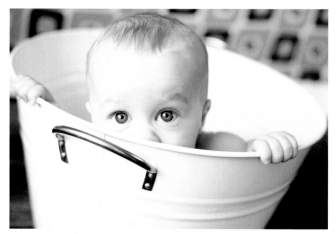

PLATE 101. Photograph by Christie Mumm.

PLATE 102. Photograph by Christie Mumm.

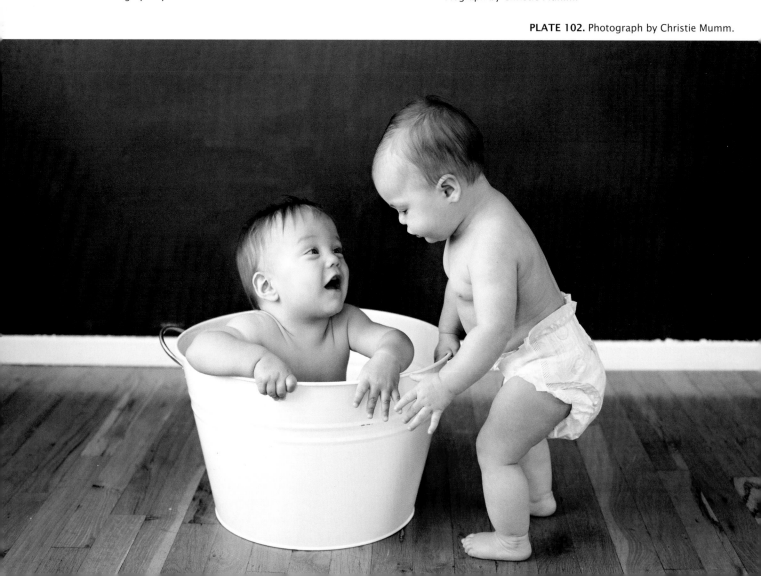

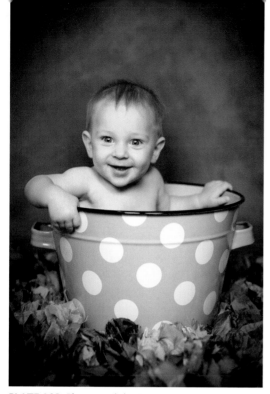

PLATE 103. Photograph by Tracy Dorr.

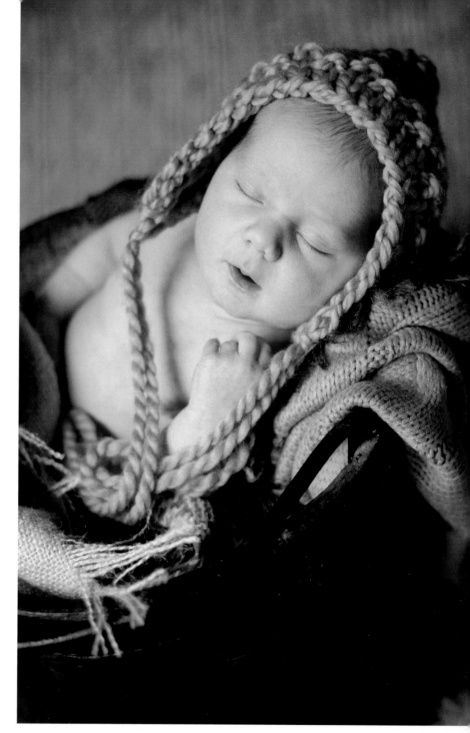

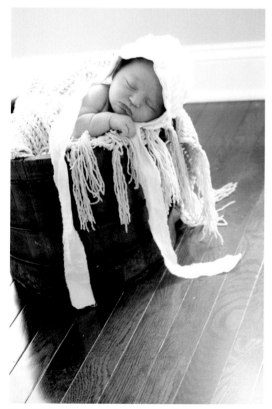

PLATE 104. Photograph by Jenean Mohr.

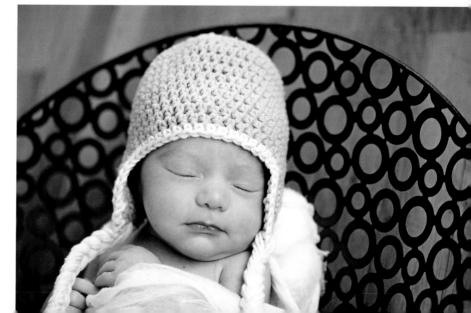

PLATE 105 (TOP RIGHT).
Photograph by Jenean Mohr.

PLATE 106 (BOTTOM RIGHT).
Photograph by Christie Mumm.

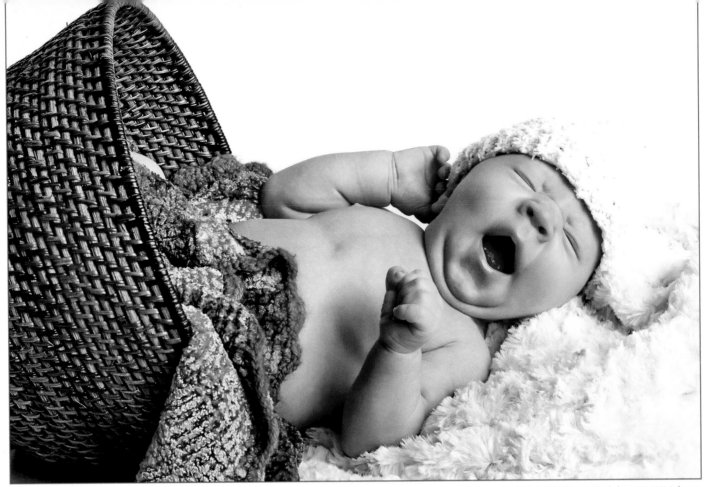

PLATE 107. Photograph by Marc Weisberg.

PLATE 108. Photograph by Christie Mumm.

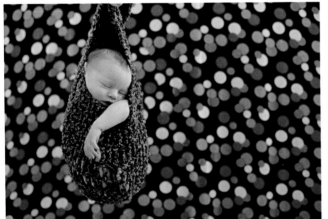

PLATE 109. Photograph by Christie Mumm.

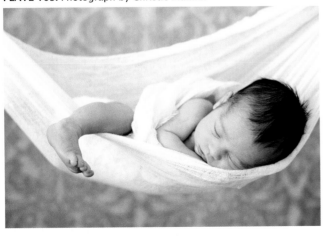

PLATE 110. Photograph by Beth Forester.

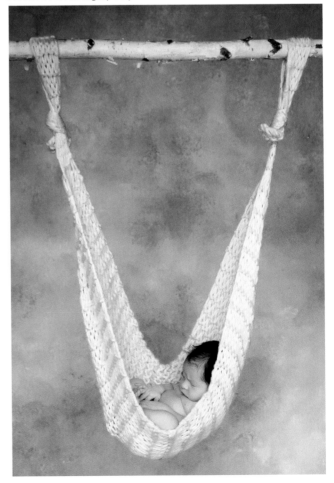

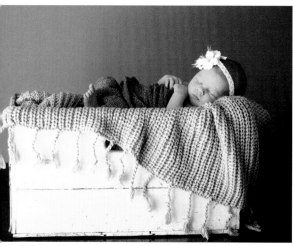

PLATE 111. Photograph by Jenean Mohr.

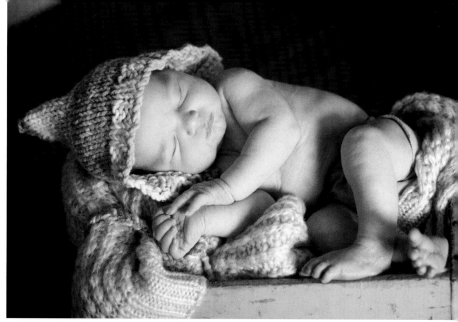

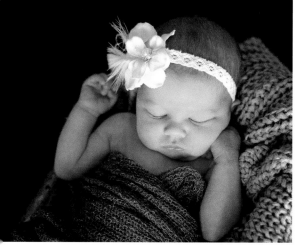

PLATE 112. Photograph by Jenean Mohr.

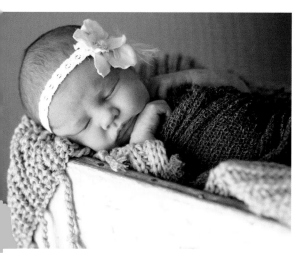

PLATE 113. Photograph by Jenean Mohr.

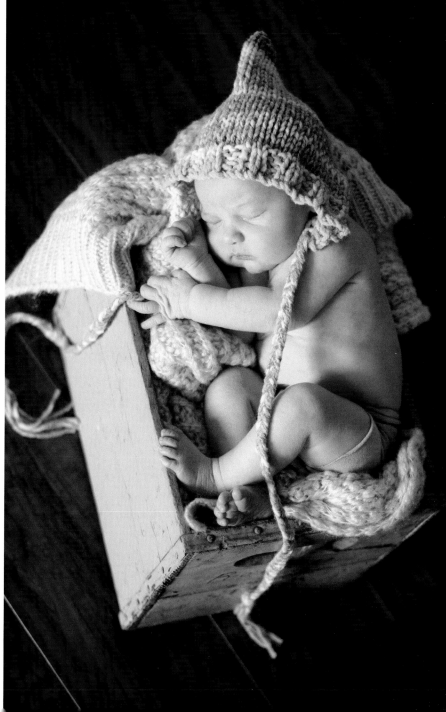

PLATE 114 (TOP RIGHT).
Photograph by Jenean Mohr.

PLATE 115 (BOTTOM RIGHT).
Photograph by Jenean Mohr.

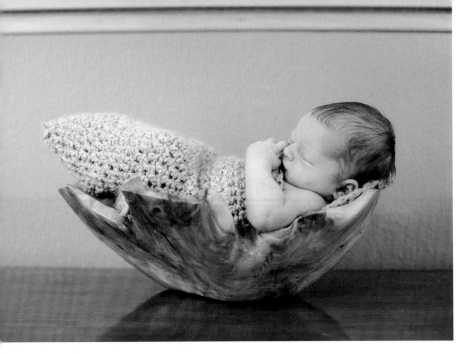

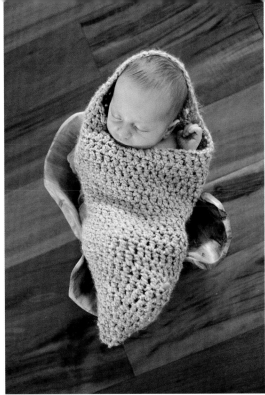

PLATE 116. Photograph by Christie Mumm.

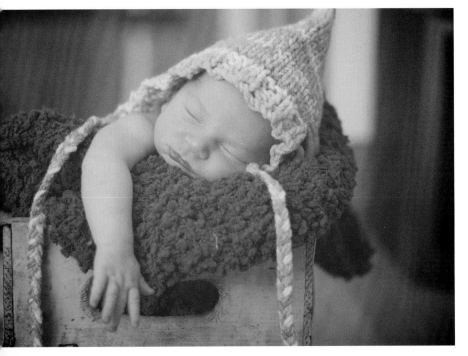

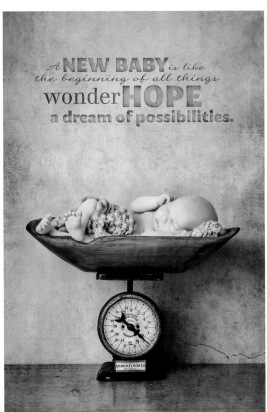

A NEW BABY is like the beginning of all things wonder HOPE a dream of possibilities.

PLATE 117. Photograph by Beth Forester.

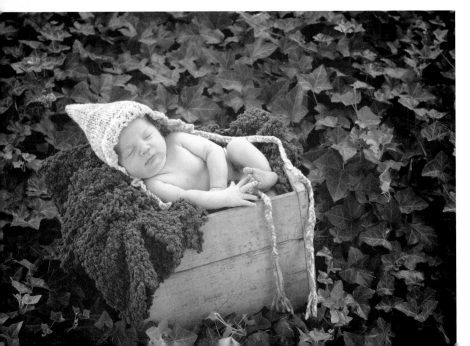

PLATE 118 (TOP LEFT).
Photograph by Christie Mumm.

PLATE 119 (CENTER LEFT).
Photograph by Jenean Mohr.

PLATE 120 (BOTTOM LEFT).
Photograph by Jenean Mohr.

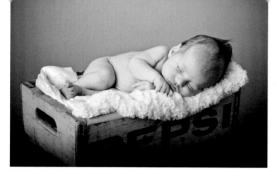

PLATE 121. Photograph by Marc Weisberg.

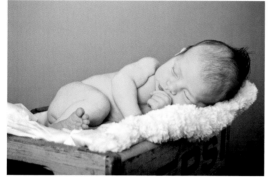

PLATE 122. Photograph by Marc Weisberg.

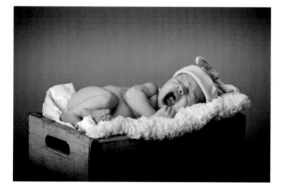

PLATE 123. Photograph by Marc Weisberg.

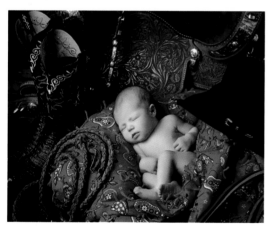

PLATE 124. Photograph by Beth Forester.

PLATE 125 (TOP RIGHT).
Photograph by Christie Mumm.

PLATE 126 (BOTTOM RIGHT).
Photograph by Jenean Mohr.

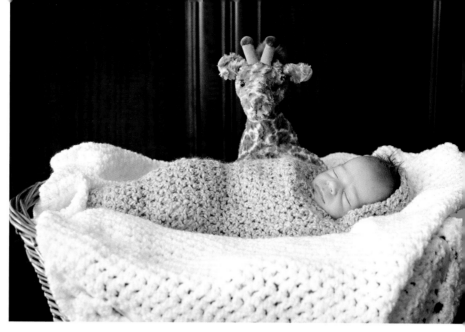

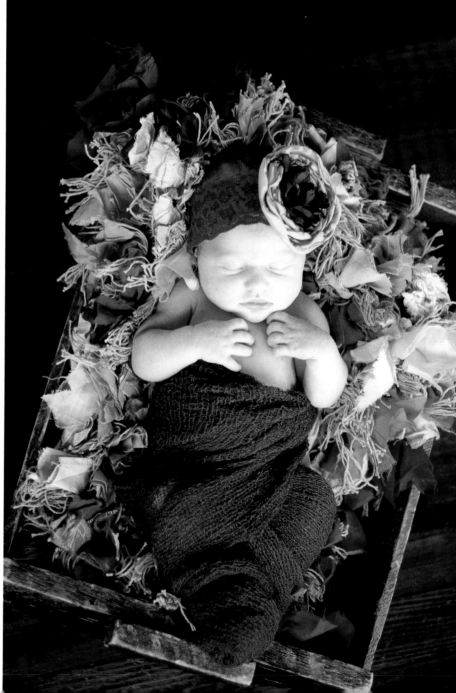

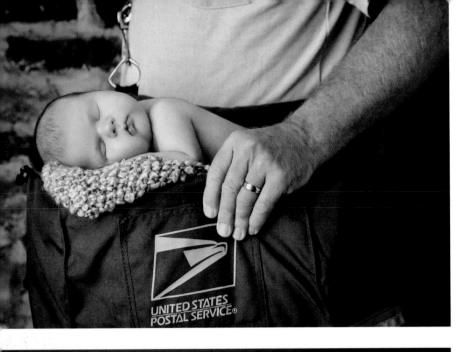

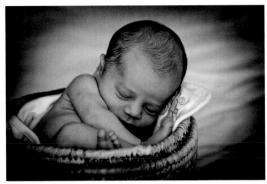

PLATE 127. Photograph by Marc Weisberg.

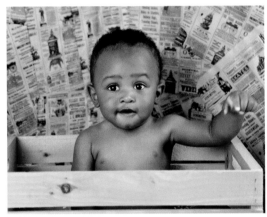

PLATE 128. Photograph by Mimika Cooney.

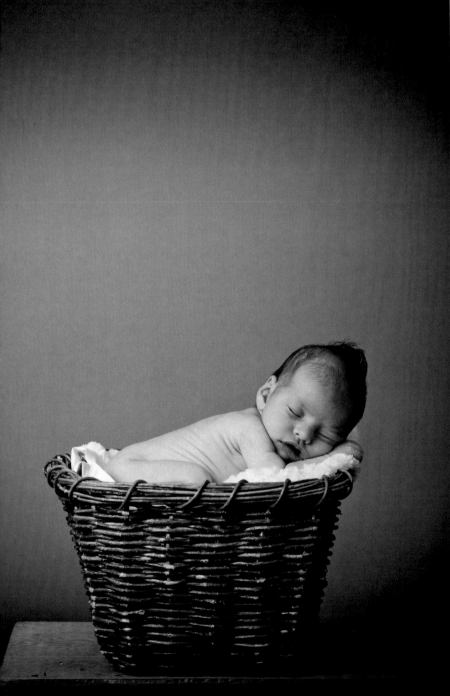

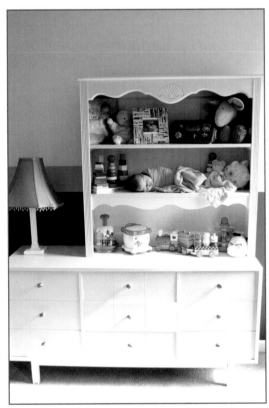

PLATE 129. Photograph by Jenean Mohr.

PLATE 130 (TOP LEFT).
Photograph by Beth Forester.

PLATE 131 (BOTTOM LEFT).
Photograph by Marc Weisberg.

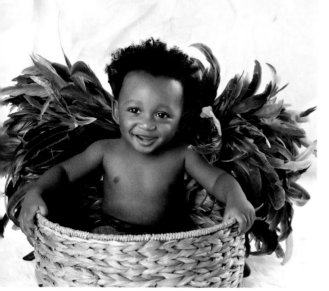

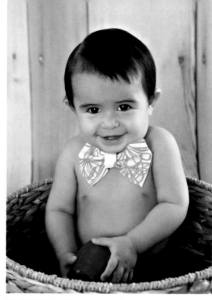

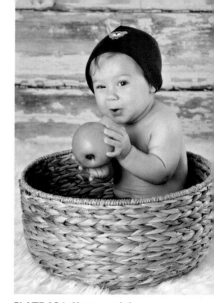

PLATE 132. Photograph by Mimika Cooney.

PLATE 133. Photograph by Mimika Cooney.

PLATE 134. Photograph by Mimika Cooney.

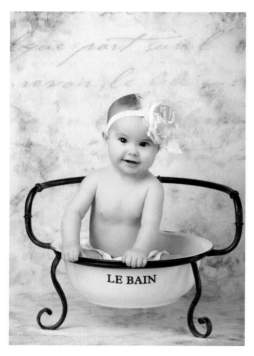

LE BAIN

PLATE 135 (ABOVE). Photograph by Beth Forester.

PLATE 136 (RIGHT). Photograph by Beth Forester.

PLATE 137 (BELOW). Photograph by Vicki Taufer.

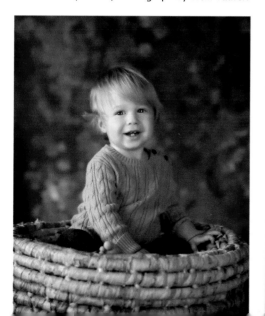

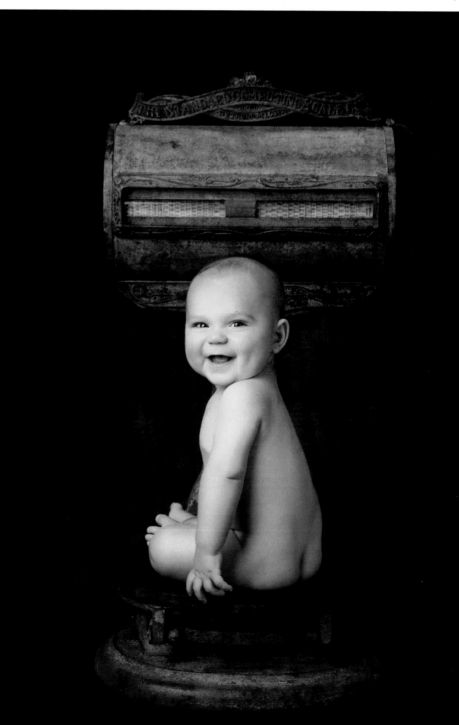

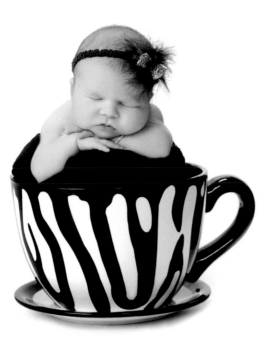

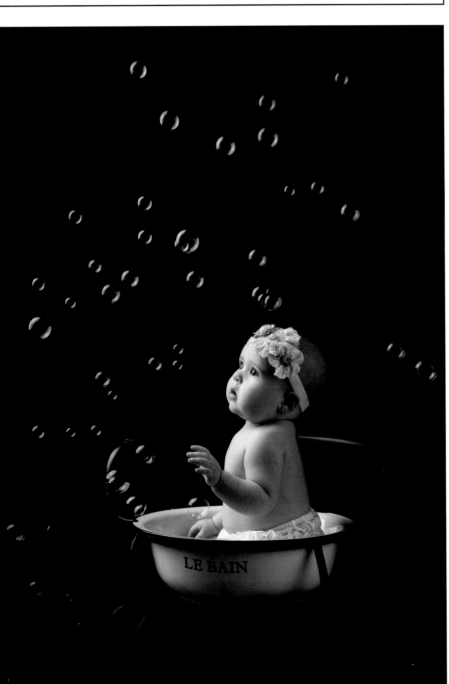

PLATE 138 (TOP LEFT).
Photograph by Beth Forester.

PLATE 139 (BOTTOM LEFT).
Photograph by Beth Forester.

PLATE 140. Photograph by Tracy Dorr.

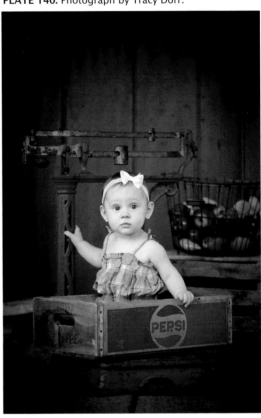

PLATE 141. Photograph by Tracy Dorr.

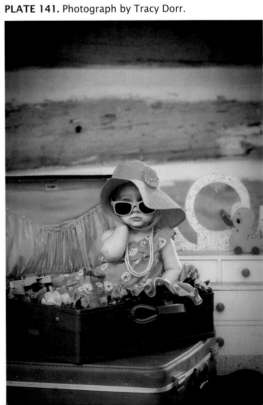

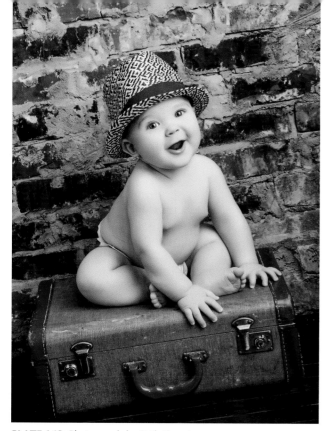

PLATE 142. Photograph by Beth Forester.

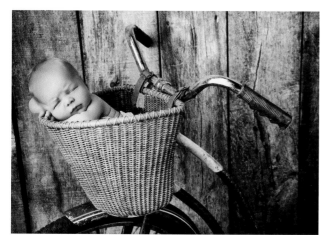

PLATE 143. Photograph by Beth Forester.

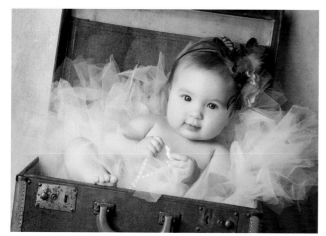

PLATE 144. Photograph by Beth Forester.

PLATE 145 (TOP RIGHT). Photograph by Beth Forester.

PLATE 146 (BOTTOM RIGHT). Photograph by Beth Forester.

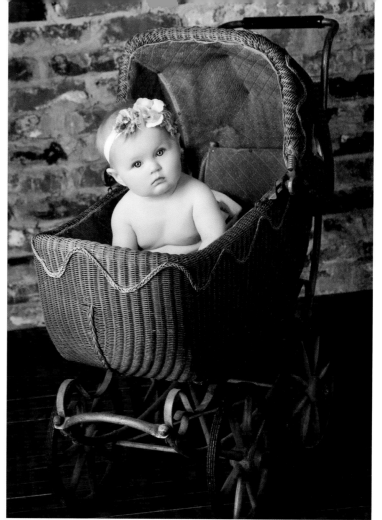

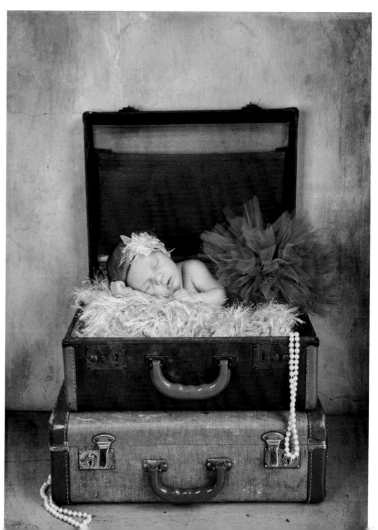

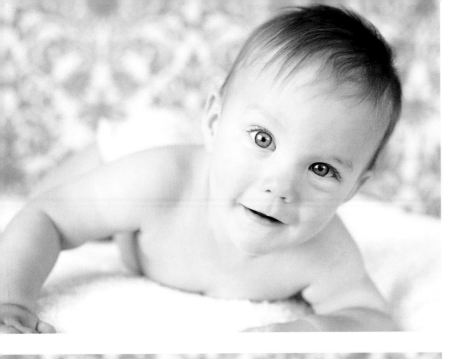

PLATE 147 (TOP LEFT).
Photograph by Christie Mumm.

PLATE 148 (CENTER LEFT).
Photograph by Christie Mumm.

PLATE 149 (BOTTOM LEFT).
Photograph by Vicki Taufer.

PLATE 150. Photograph by Heather Magliarditi.

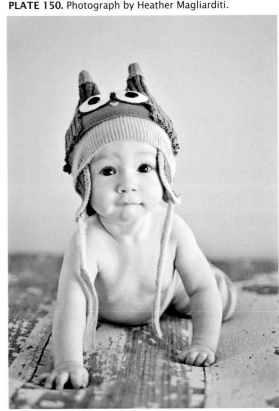

PLATE 151. Photograph by Heather Magliarditi.

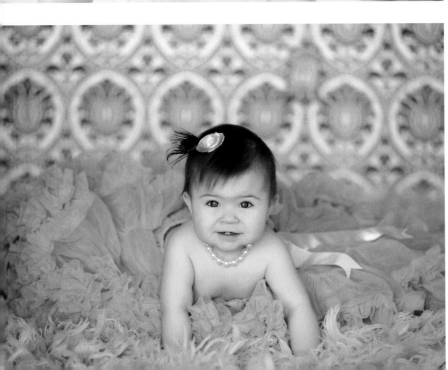

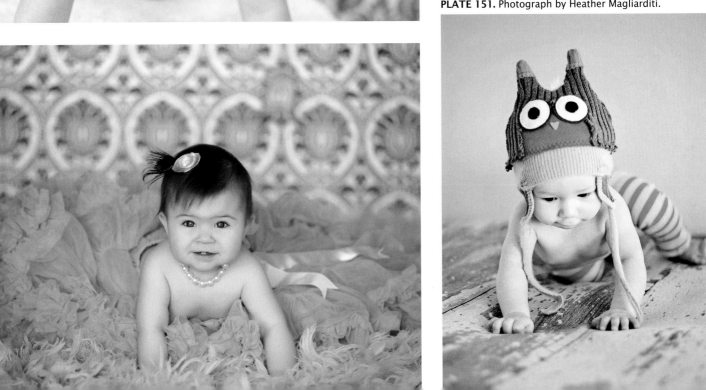

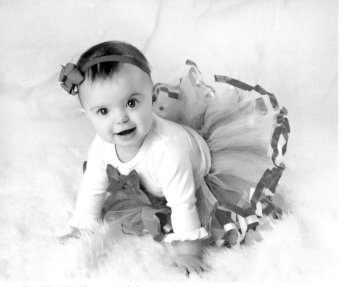

PLATE 152. Photograph by Mimika Cooney.

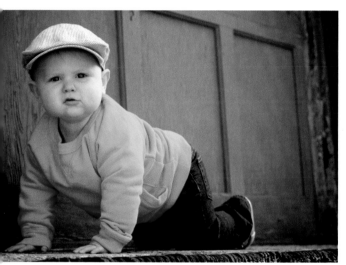

PLATE 153. Photograph by Jenean Mohr.

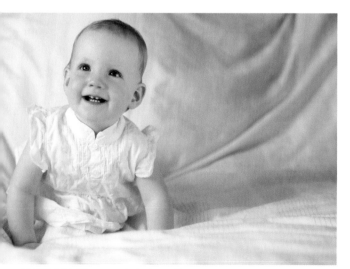

PLATE 154. Photograph by Brett Florens.

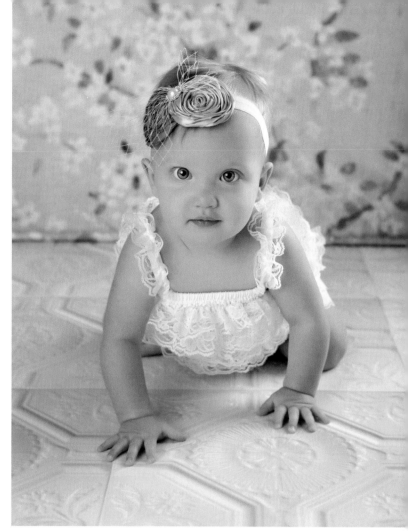

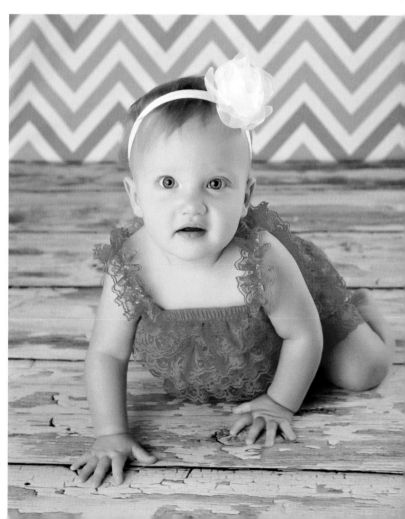

PLATE 155 (TOP RIGHT). Photograph by Mimika Cooney.

PLATE 156 (BOTTOM RIGHT). Photograph by Mimika Cooney.

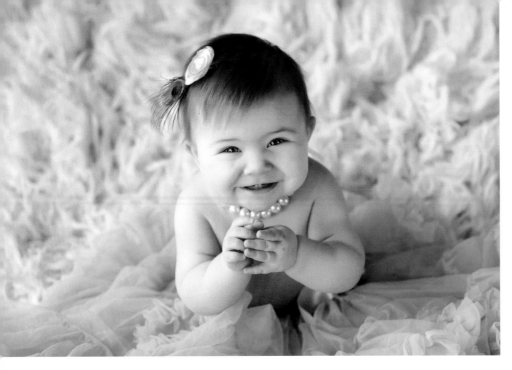

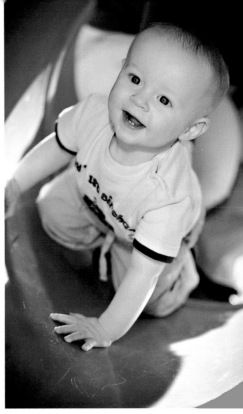

PLATE 157. Photograph by Christie Mumm.

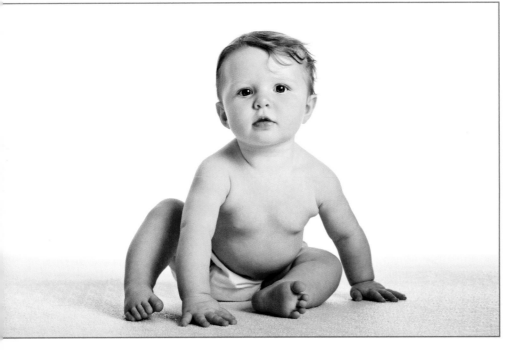

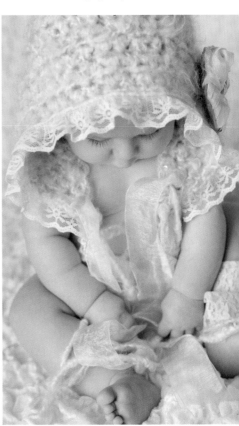

PLATE 158. Photograph by Jenean Mohr.

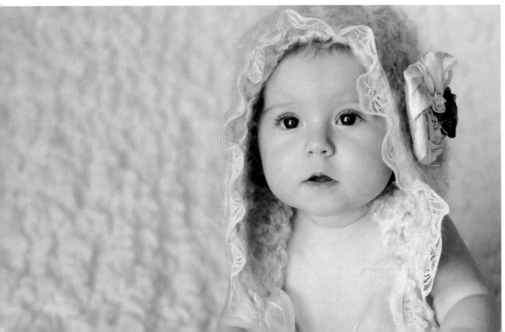

PLATE 159 (TOP LEFT).
Photograph by Vicki Taufer.

PLATE 160 (CENTER LEFT).
Photograph by Marc Weisberg.

PLATE 161 (BOTTOM LEFT).
Photograph by Jenean Mohr.

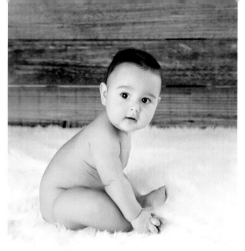

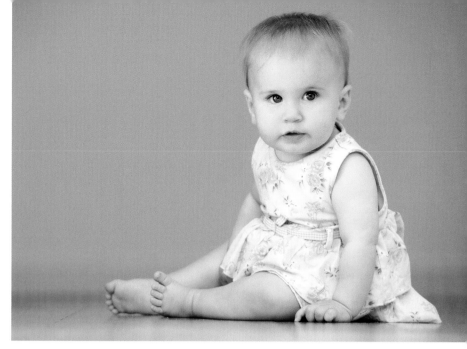

PLATE 162 (ABOVE). Photograph by Mimika Cooney.

PLATES 163 (TOP RIGHT) AND 164 (BOTTOM RIGHT). Photographs by Brett Florens.

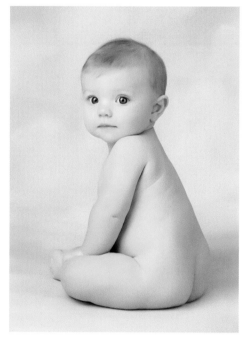

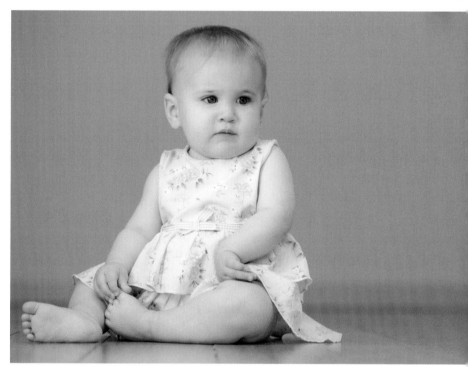

PLATE 165 (ABOVE). Photograph by Beth Forester.

PLATE 166 (BELOW). Photograph by Beth Forester.

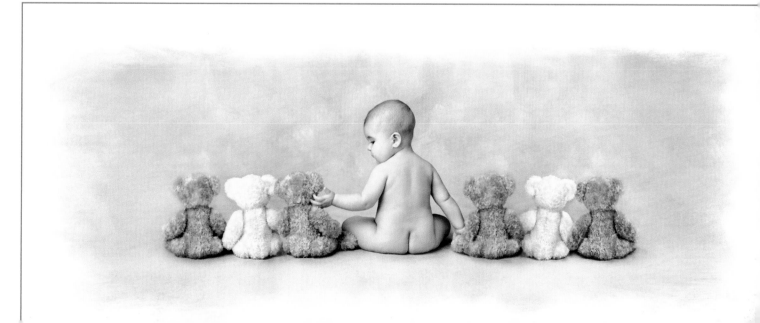

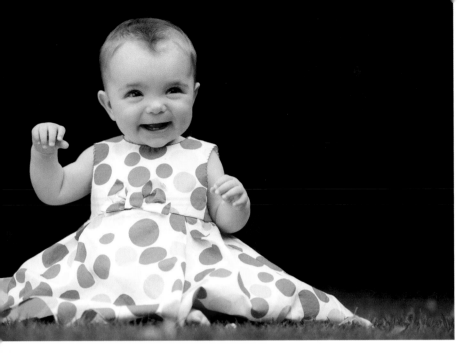

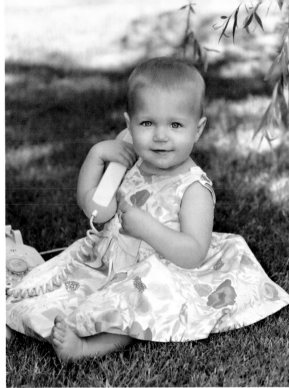

PLATE 167. Photograph by Mimika Cooney.

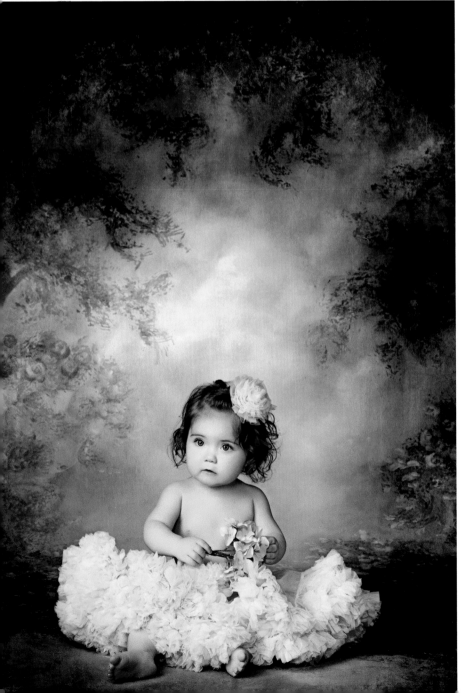

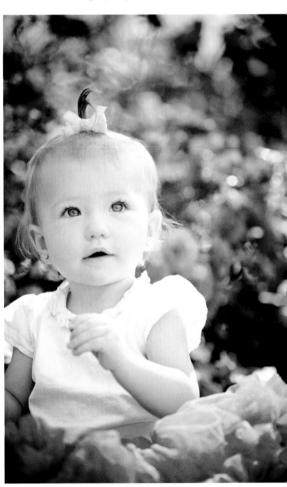

PLATE 168. Photograph by Christie Mumm.

PLATE 169 (TOP LEFT).
Photograph by Brett Florens.

PLATE 170 (BOTTOM LEFT).
Photograph by Beth Forester.

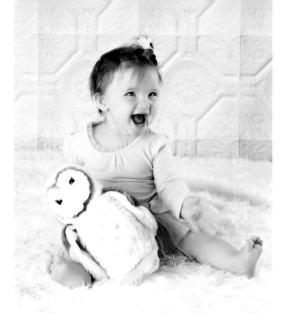

PLATE 171. Photograph by Mimika Cooney.

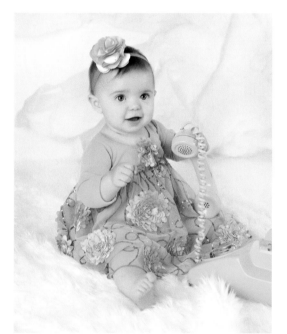

PLATE 172. Photograph by Mimika Cooney.

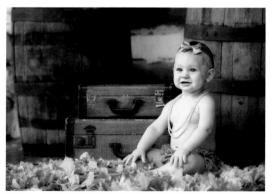

PLATE 173. Photograph by Tracy Dorr.

PLATE 174 (TOP RIGHT).
Photograph by Beth Forester.

PLATE 175 (BOTTOM RIGHT).
Photograph by Beth Forester.

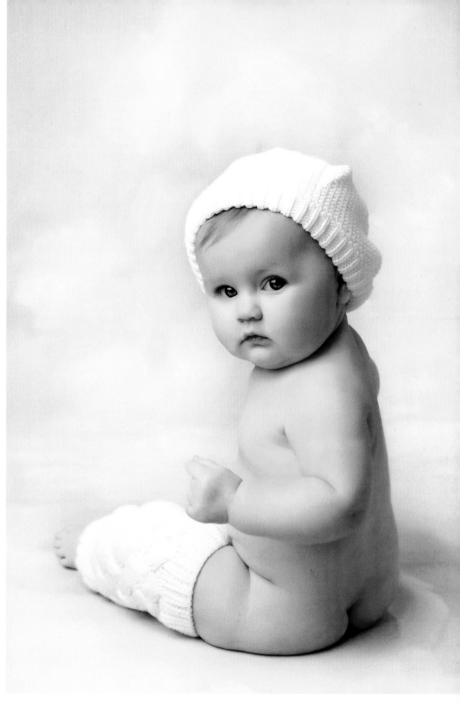

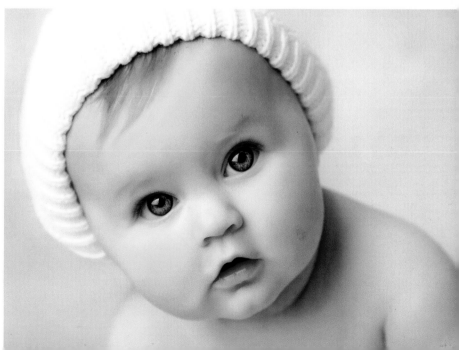

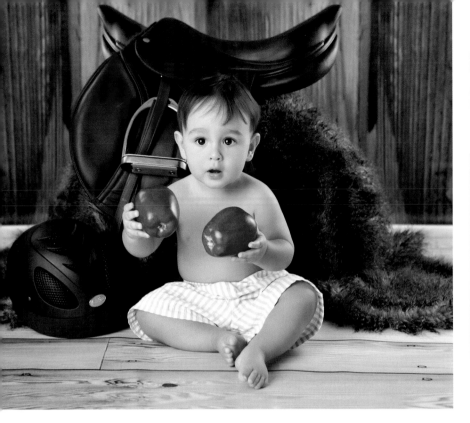

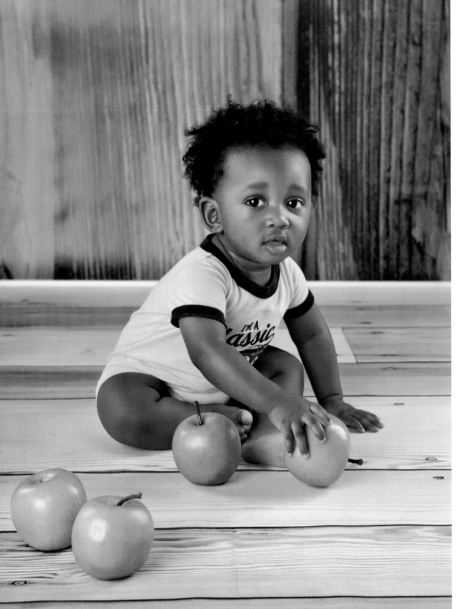

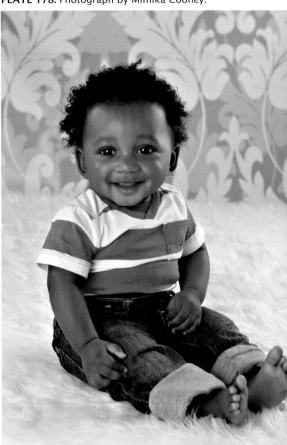

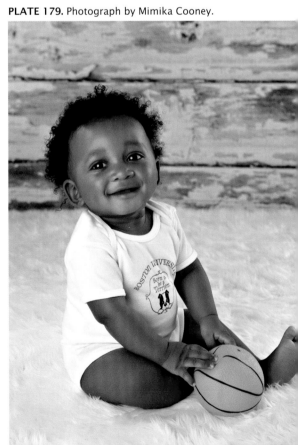

PLATE 176 (TOP LEFT).
Photograph by Mimika Cooney.

PLATE 177 (BOTTOM LEFT).
Photograph by Mimika Cooney.

PLATE 178. Photograph by Mimika Cooney.

PLATE 179. Photograph by Mimika Cooney.

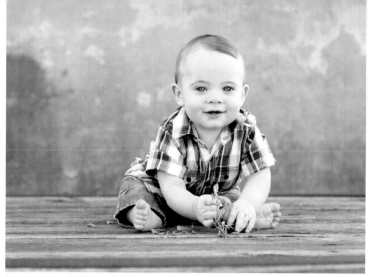

PLATE 180. Photograph by Jenean Mohr.

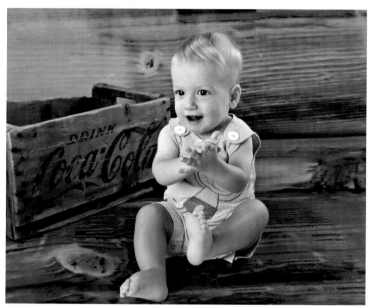

PLATE 181. Photograph by Mimika Cooney.

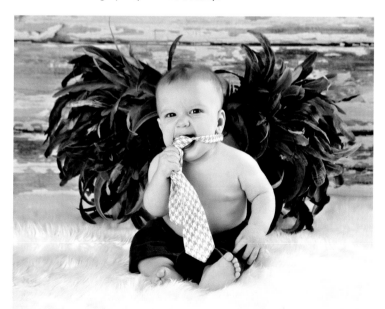

PLATE 182. Photograph by Mimika Cooney.

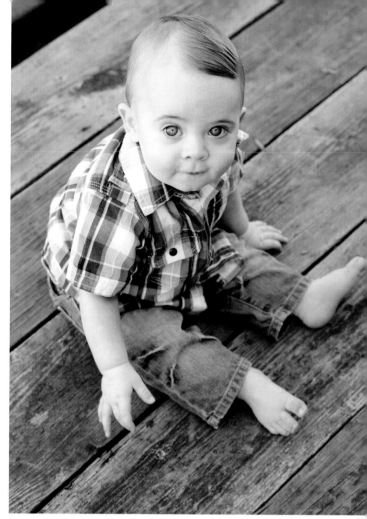

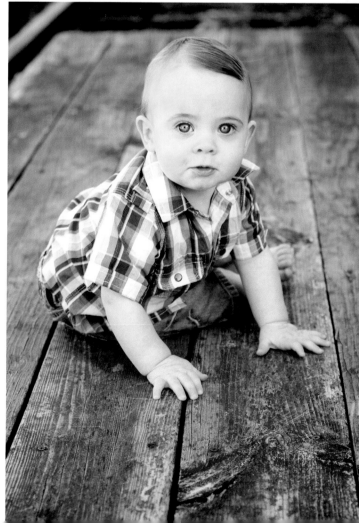

PLATE 183 (TOP RIGHT). Photograph by Jenean Mohr.

PLATE 184 (BOTTOM RIGHT). Photograph by Jenean Mohr.

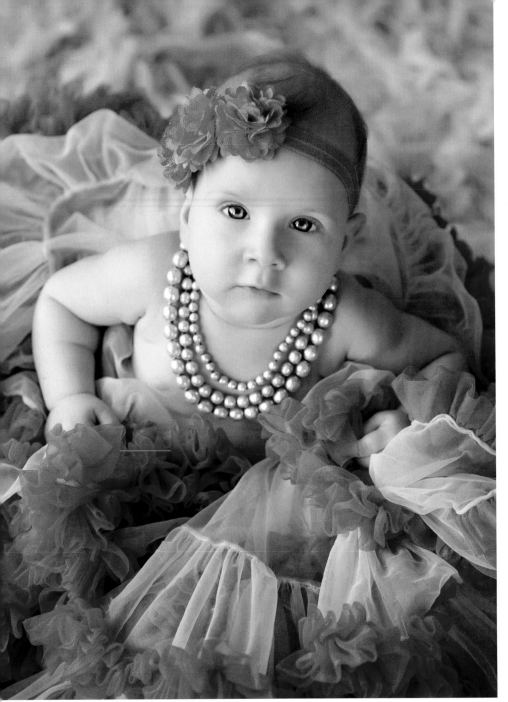

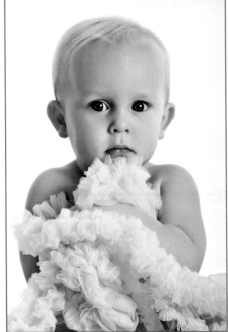

PLATE 185. Photograph by Marc Weisberg.

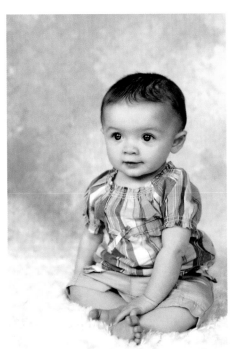

PLATE 186. Photograph by Tracy Dorr.

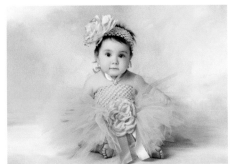

PLATE 187 (ABOVE).
Photograph by Beth Forester.

PLATE 188 (TOP LEFT).
Photograph by Vicki Taufer.

PLATE 189 (BOTTOM LEFT).
Photograph by Marc Weisberg.

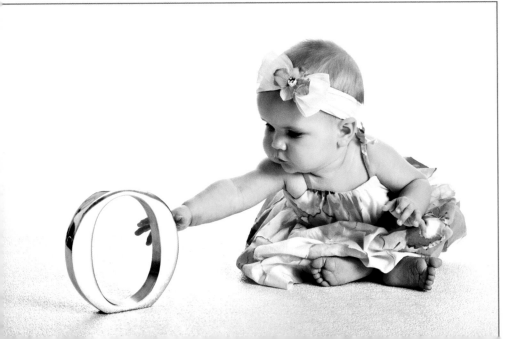

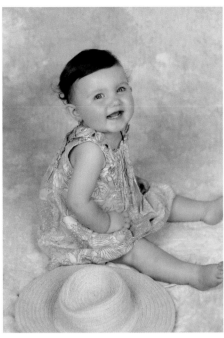

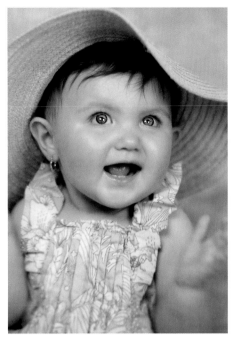

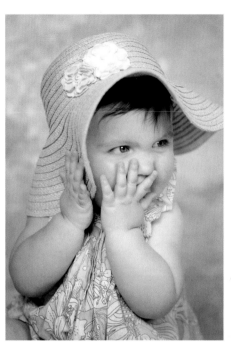

PLATE 190. Photograph by Tracy Dorr.

PLATE 191. Photograph by Tracy Dorr.

PLATE 192. Photograph by Tracy Dorr.

PLATE 193. Photograph by Tracy Dorr.

PLATE 194. Photograph by Tracy Dorr.

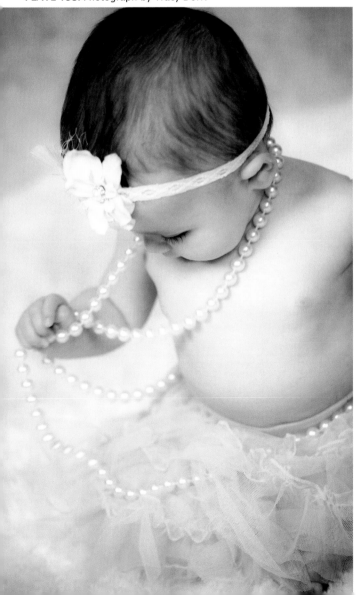

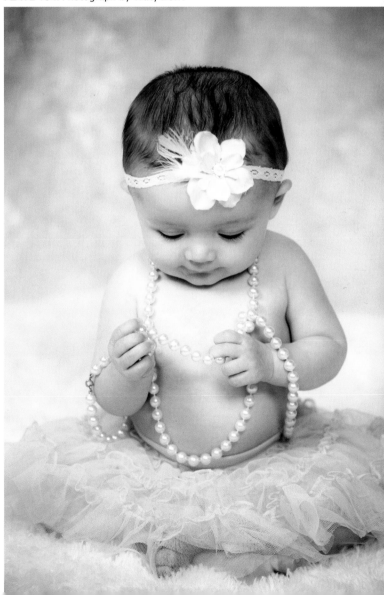

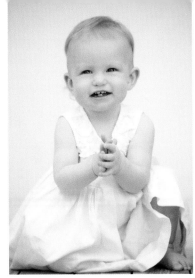

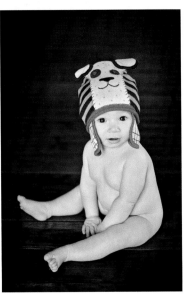
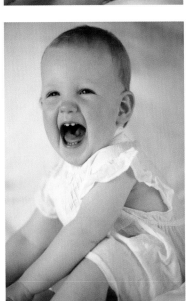
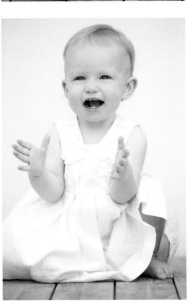

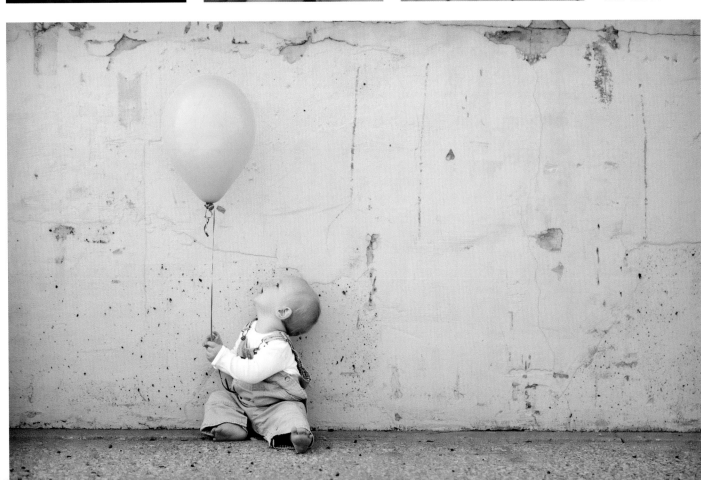

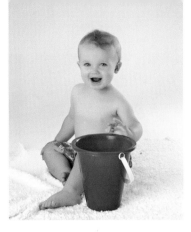

PLATE 202 (RIGHT).
Photograph by Mimika Cooney.

PLATE 203 (FAR RIGHT).
Photograph by Marc Weisberg.

PLATE 204 (BELOW).
Photograph by Mimika Cooney.

PLATE 205 (BOTTOM).
Photograph by Marc Weisberg.

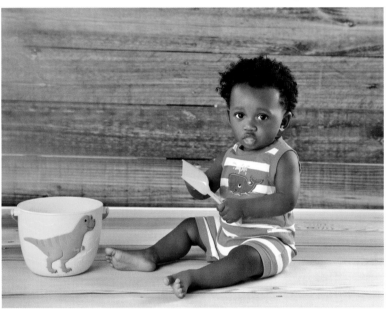

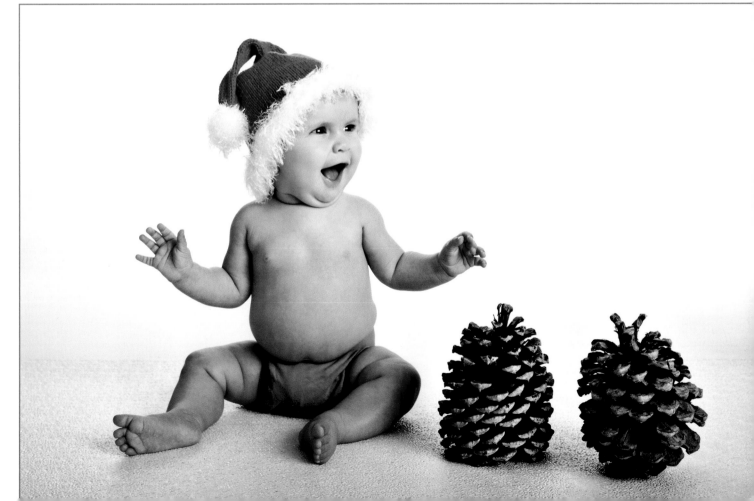

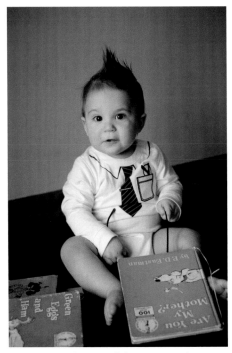

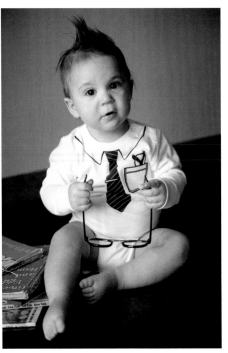

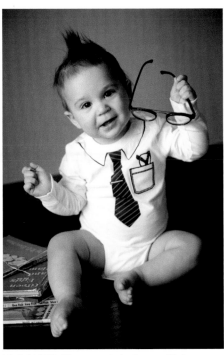

PLATE 206. Photograph by Jenean Mohr.

PLATE 207. Photograph by Jenean Mohr.

PLATE 208. Photograph by Jenean Mohr.

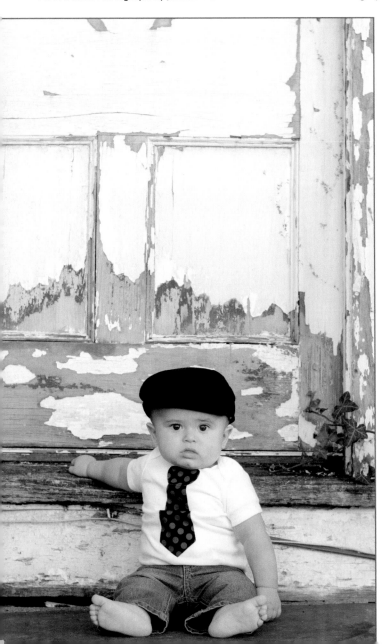

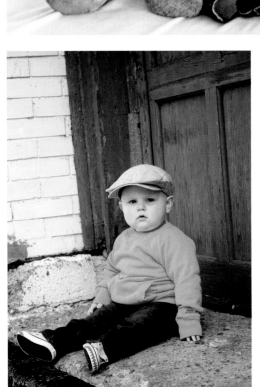

PLATE 209 (ABOVE). Photograph by Heather Magliarditi.

PLATE 210 (FAR LEFT). Photograph by Jenean Mohr.

PLATE 211 (LEFT). Photograph by Jenean Mohr.

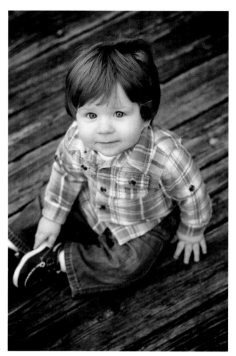

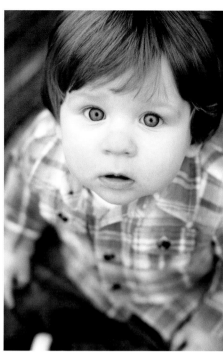

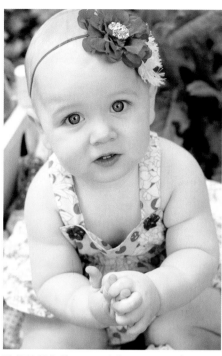

PLATE 212. Photograph by Jenean Mohr.

PLATE 213. Photograph by Jenean Mohr.

PLATE 214. Photograph by Jenean Mohr.

PLATE 215. Photograph by Christie Mumm.

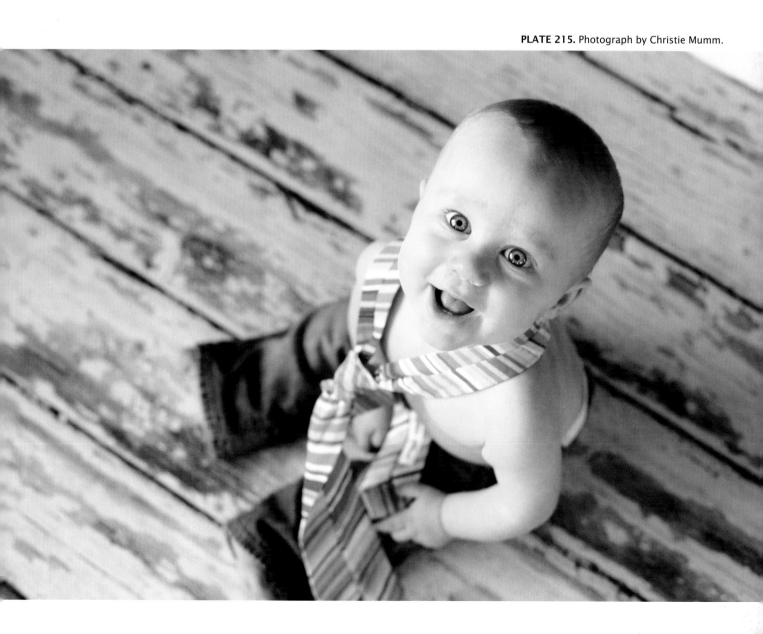

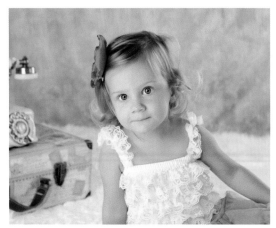

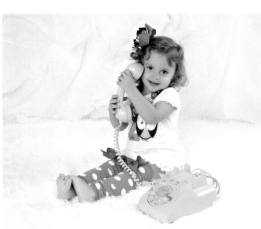

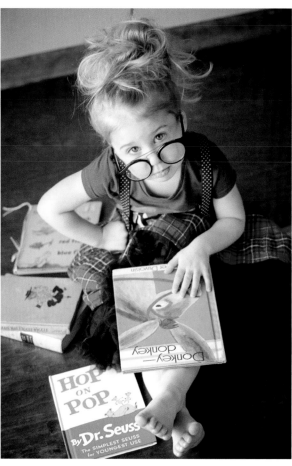

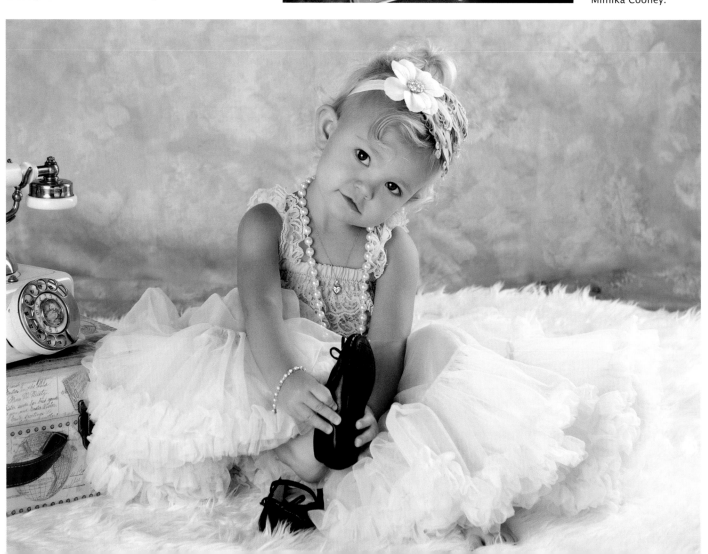

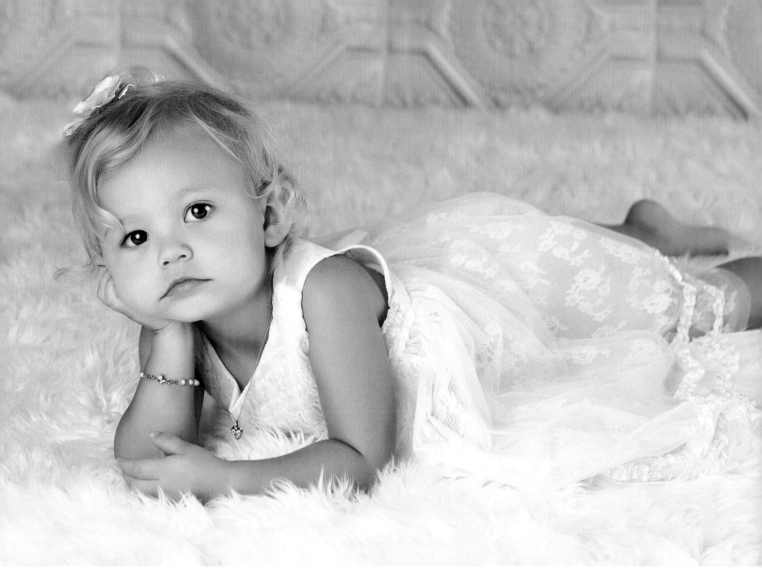

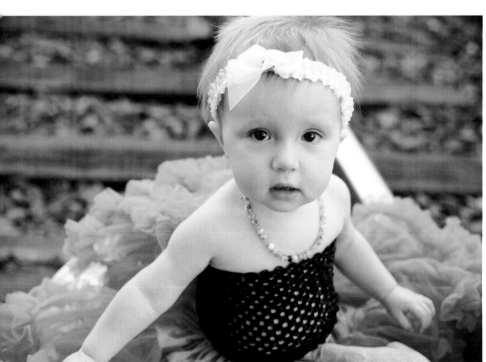

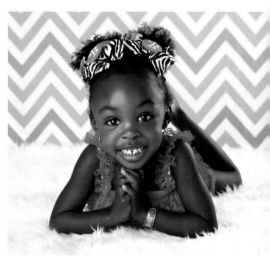

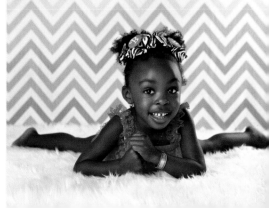

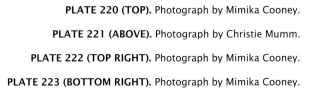

PLATE 220 (TOP). Photograph by Mimika Cooney.

PLATE 221 (ABOVE). Photograph by Christie Mumm.

PLATE 222 (TOP RIGHT). Photograph by Mimika Cooney.

PLATE 223 (BOTTOM RIGHT). Photograph by Mimika Cooney.

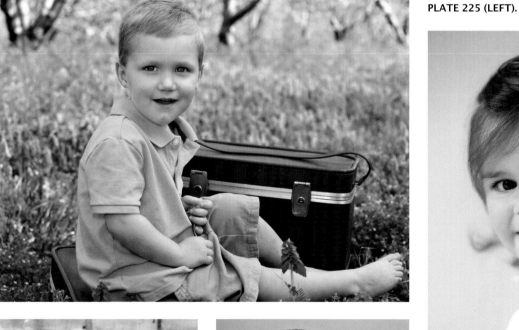

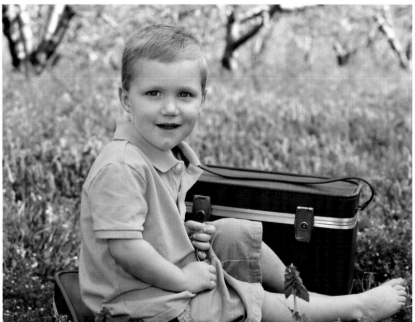

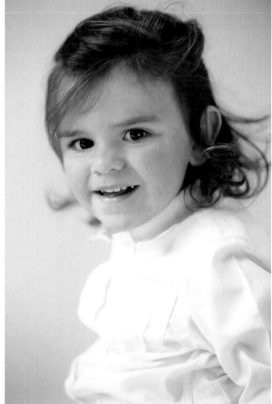

PLATE 224 (ABOVE). Photograph by Jenean Mohr.

PLATE 225 (LEFT). Photograph by Mimika Cooney.

PLATE 226 (ABOVE). Photograph by Brett Florens.

PLATE 227 (FAR LEFT). Photograph by Mimika Cooney.

PLATE 228 (LEFT). Photograph by Mimika Cooney.

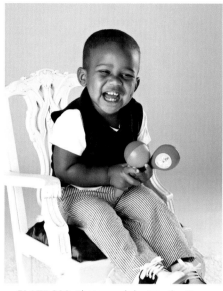

PLATE 229. Photograph by Mimika Cooney.

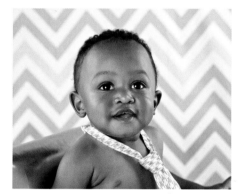

PLATE 230. Photograph by Mimika Cooney.

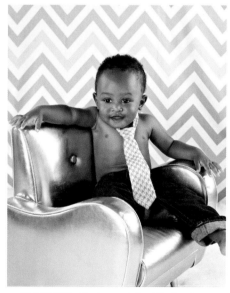

PLATE 231. Photograph by Mimika Cooney.

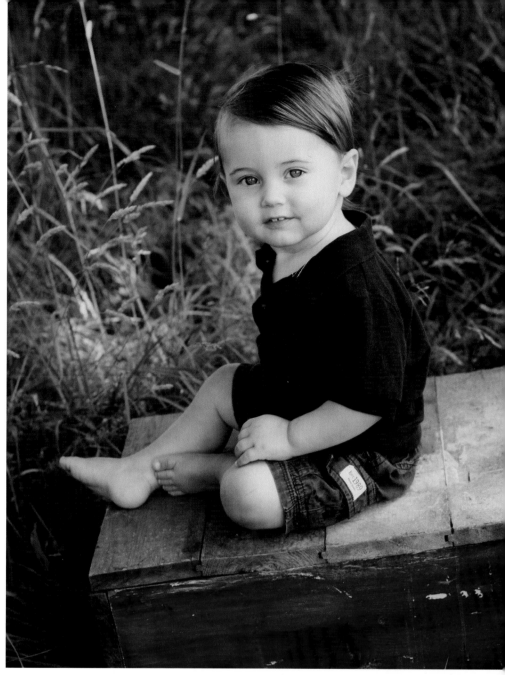

PLATE 232 (TOP RIGHT).
Photograph by Jenean Mohr.

PLATE 233 (BOTTOM LEFT).
Photograph by Marc Weisberg.

PLATE 234 (BOTTOM RIGHT).
Photograph by Tracy Dorr.

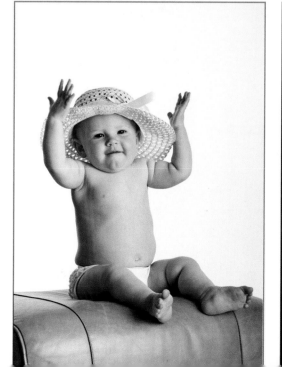

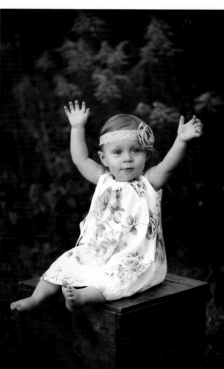

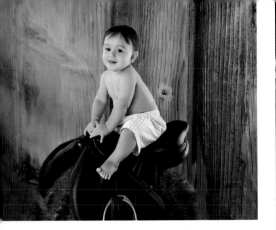

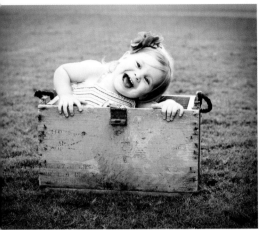

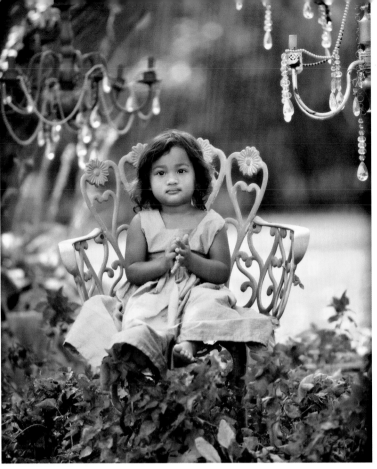

PLATE 235 (TOP LEFT). Photograph by Mimika Cooney.

PLATE 236 (BOTTOM LEFT). Photograph by Krista Smith.

PLATE 237 (RIGHT). Photograph by Vicki Taufer.

PLATE 238 (BELOW). Photograph by Christie Mumm.

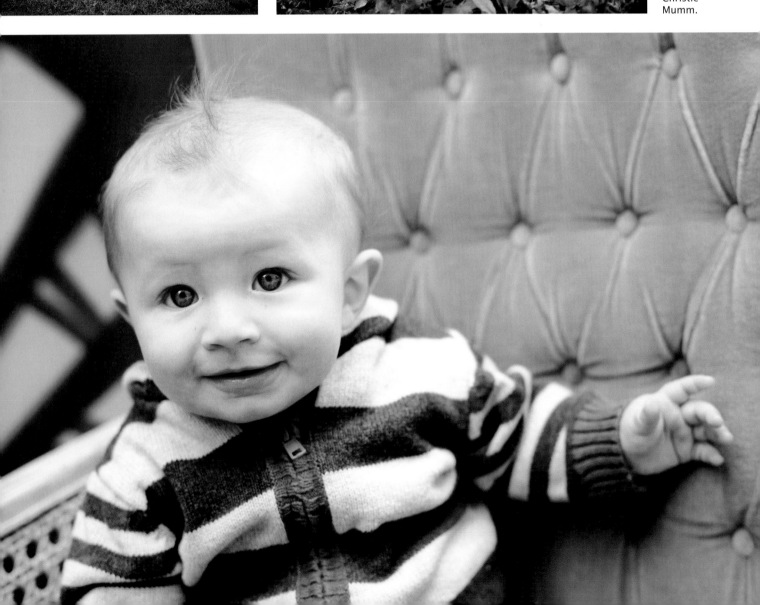

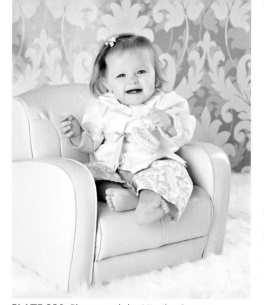

PLATE 239. Photograph by Mimika Cooney.

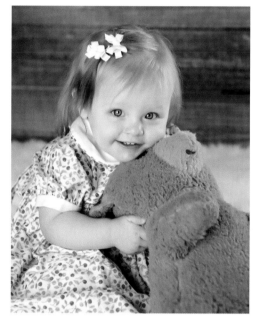

PLATE 240. Photograph by Mimika Cooney.

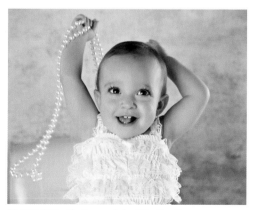

PLATE 241. Photograph by Mimika Cooney.

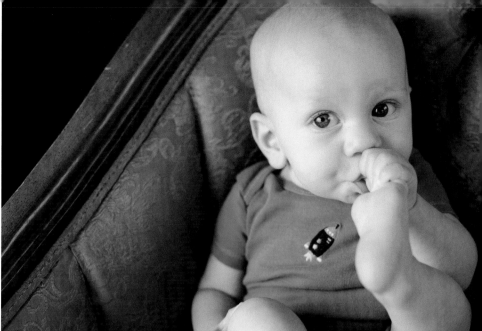

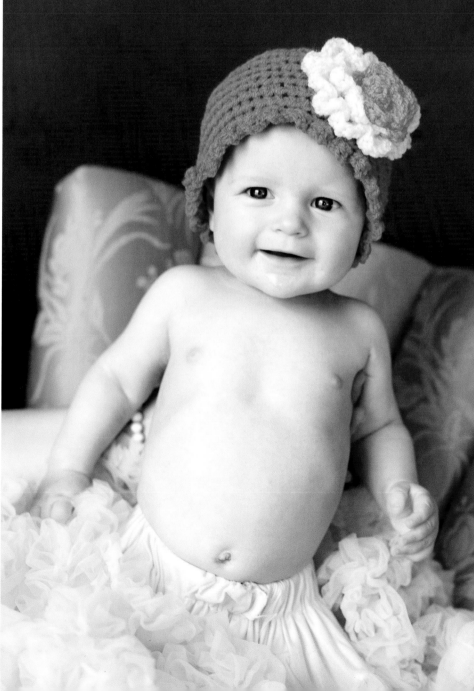

PLATE 242 (TOP RIGHT).
Photograph by Christie Mumm.

PLATE 243 (BOTTOM RIGHT).
Photograph by Christie Mumm.

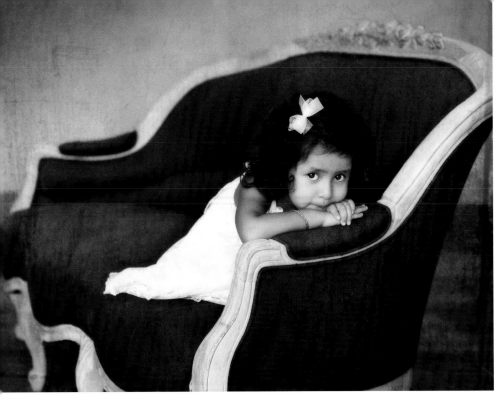

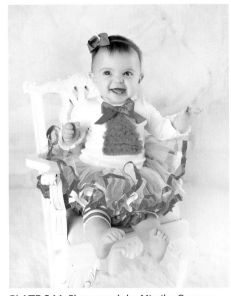

PLATE 244. Photograph by Mimika Cooney.

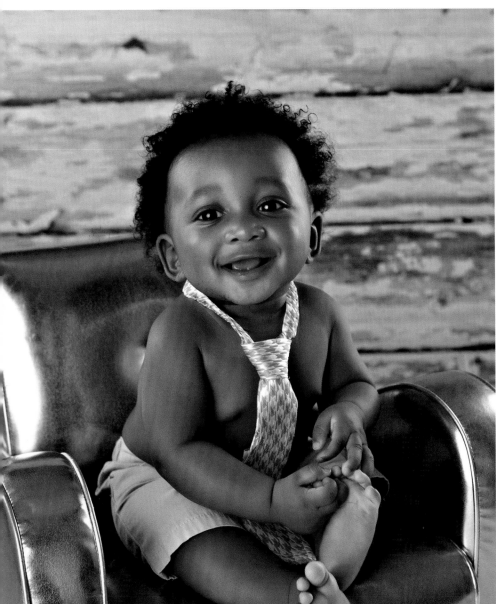

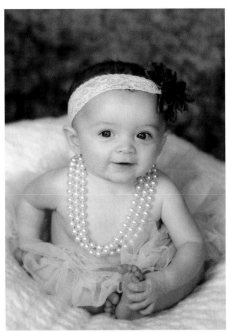

PLATE 245. Photograph by Tracy Dorr.

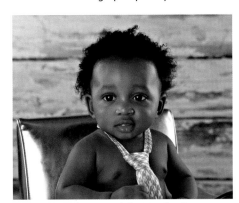

PLATE 246. Photograph by Mimika Cooney.

PLATE 247 (TOP LEFT).
Photograph by Vicki Taufer.

PLATE 248 (BOTTOM LEFT).
Photograph by Mimika Cooney.

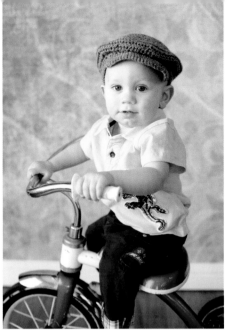

PLATE 249. Photograph by Christie Mumm.

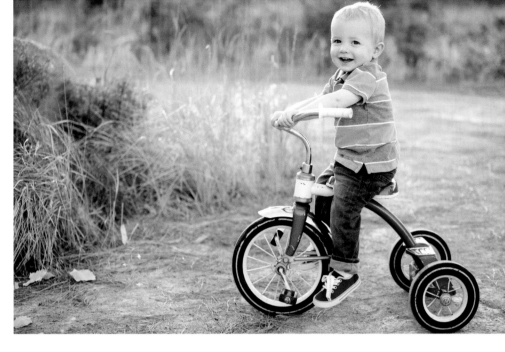

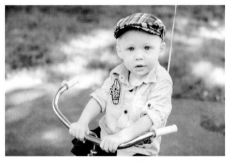

PLATE 250. Photograph by Christie Mumm.

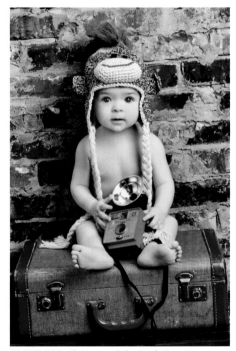

PLATE 251. Photograph by Beth Forester.

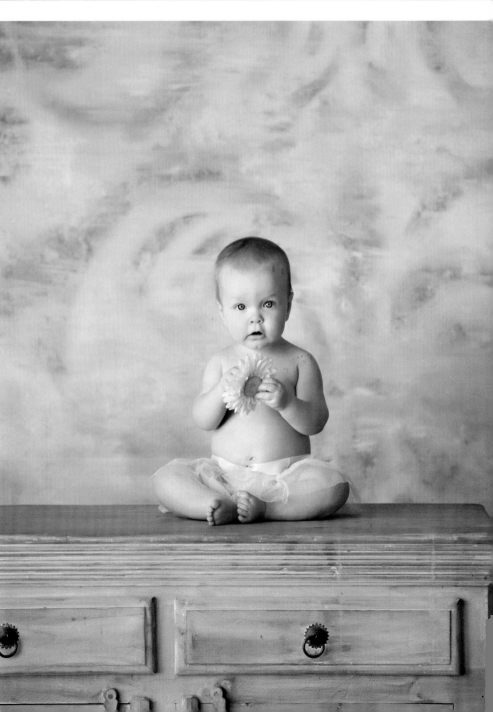

PLATE 252 (TOP RIGHT).
Photograph by Christie Mumm.

PLATE 253 (BOTTOM RIGHT).
Photograph by Vicki Taufer.

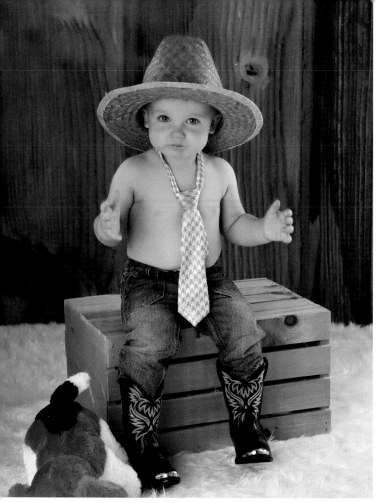

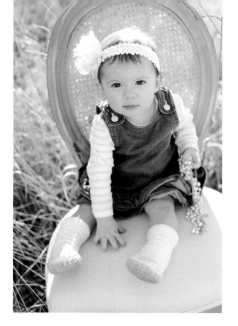

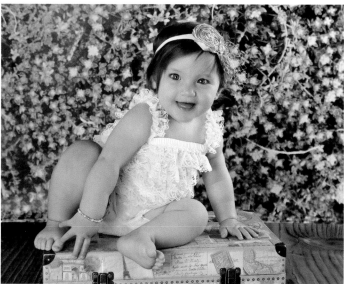

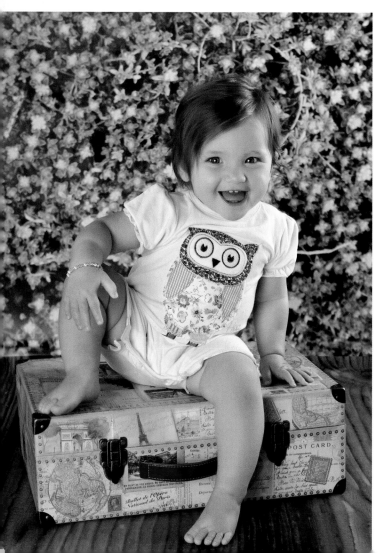

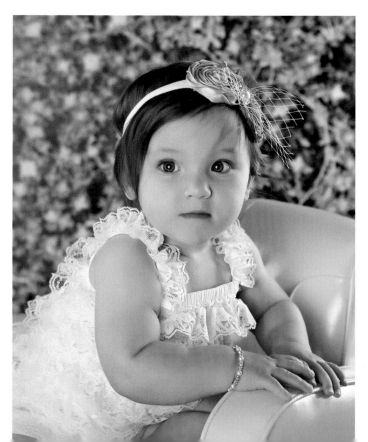

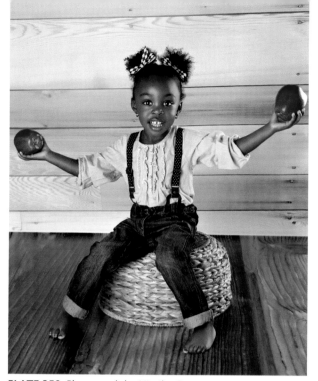

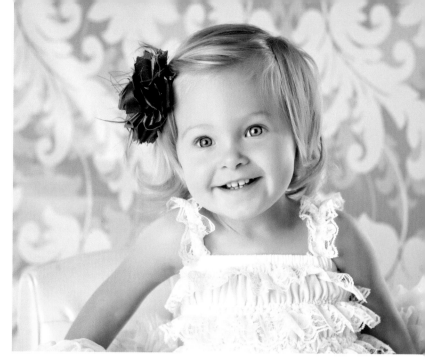

PLATE 259. Photograph by Mimika Cooney.

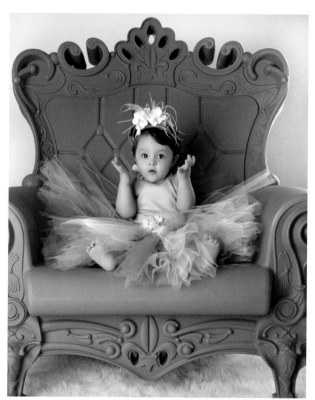

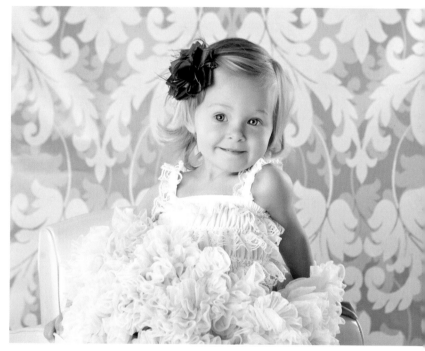

PLATE 260. Photograph by Mimika Cooney.

PLATE 261 (TOP RIGHT). Photograph by Mimika Cooney.

PLATE 262 (CENTER RIGHT). Photograph by Mimika Cooney.

PLATE 263 (BOTTOM RIGHT). Photograph by Mimika Cooney.

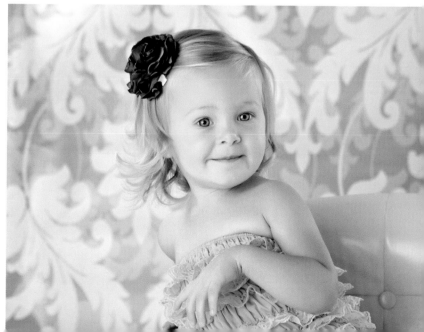

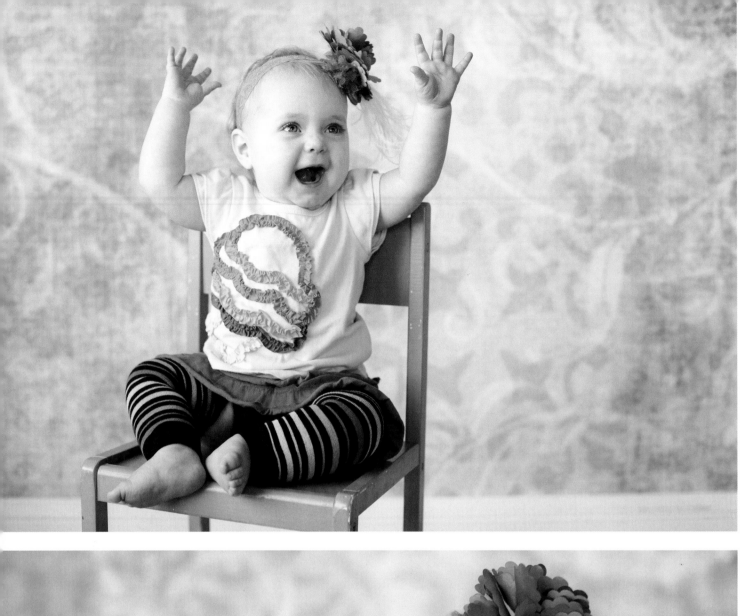
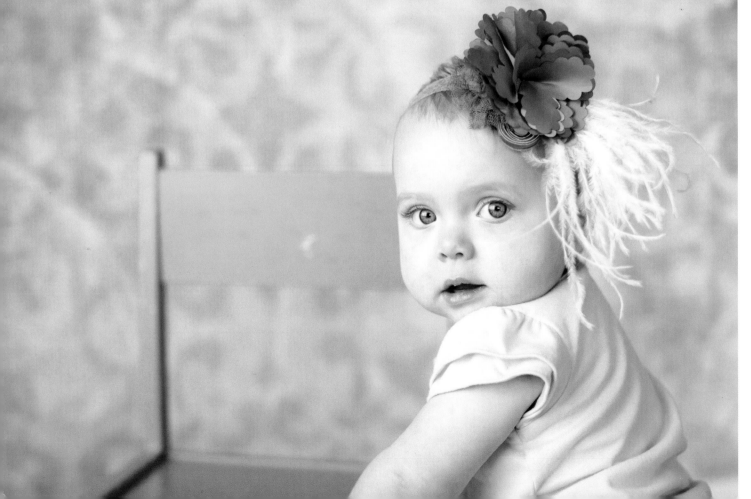

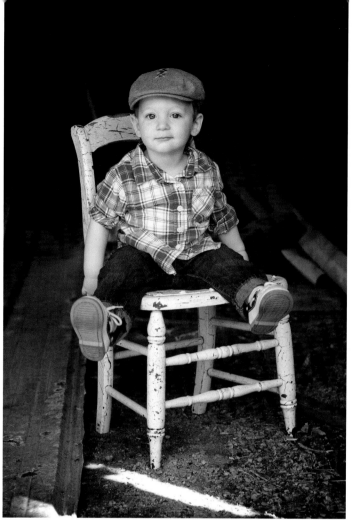

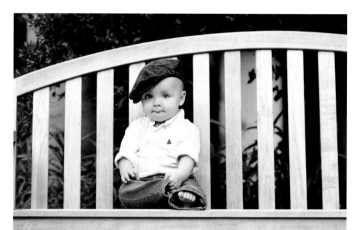

PLATE 266. Photograph by Krista Smith.

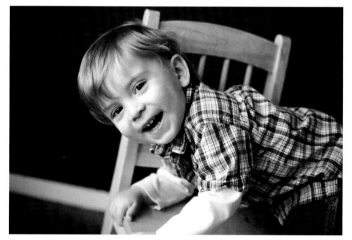

PLATE 267. Photograph by Christie Mumm.

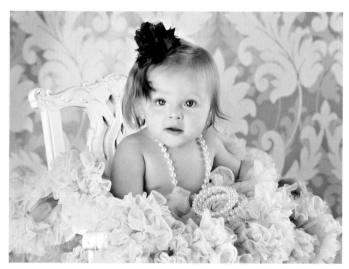

PLATE 268. Photograph by Mimika Cooney.

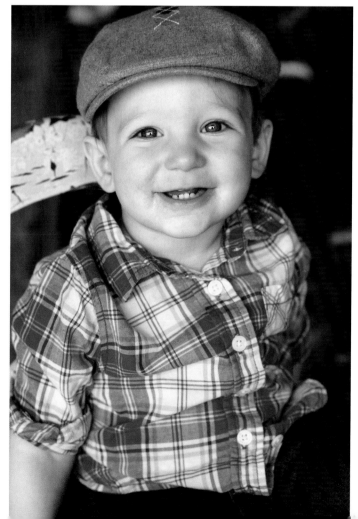

PLATE 269 (TOP RIGHT). Photograph by Jenean Mohr.

PLATE 270 (BOTTOM RIGHT). Photograph by Jenean Mohr.

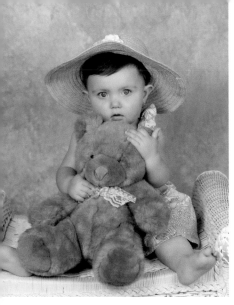

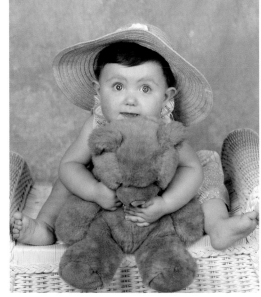

PLATE 271 (TOP LEFT).
Photograph by Tracy Dorr.

PLATE 272 (TOP RIGHT).
Photograph by Tracy Dorr.

**PLATES 273 (BELOW LEFT)
AND 274 (BELOW RIGHT).**
Photographs by Christie Mumm.

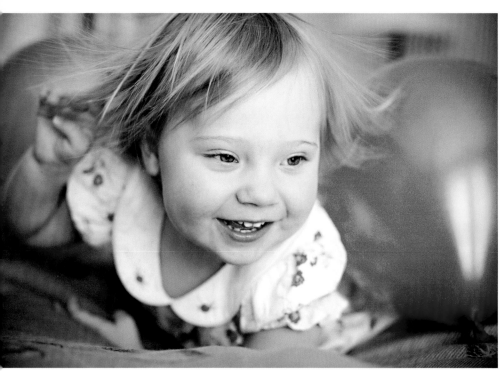

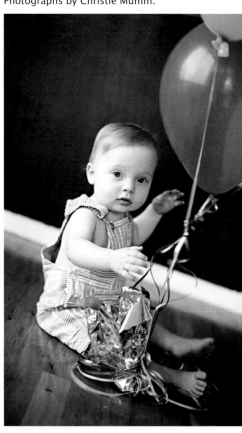

PLATE 275. Photograph by Mimika Cooney.

PLATE 276. Photograph by Mimika Cooney.

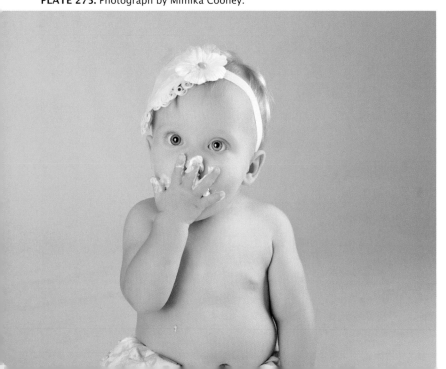

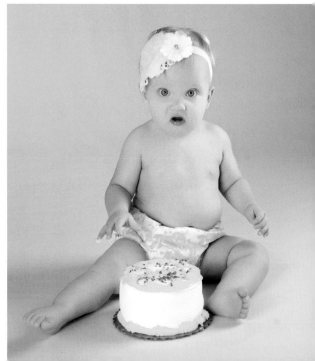

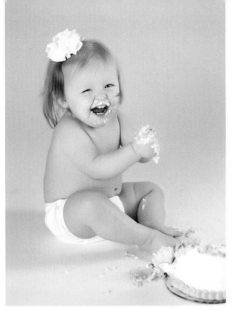

PLATE 277. Photograph by Mimika Cooney.

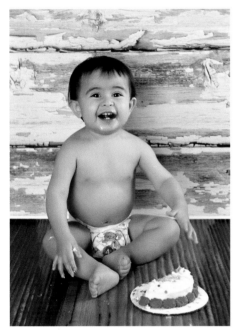

PLATE 278. Photograph by Mimika Cooney.

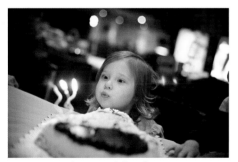

PLATE 279. Photograph by Christie Mumm.

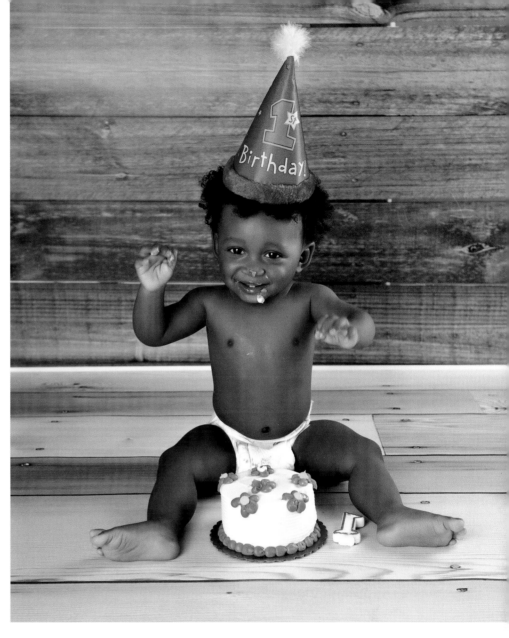

PLATE 280 (TOP RIGHT).
Photograph by Mimika Cooney.

PLATE 281 (BOTTOM RIGHT).
Photograph by Beth Forester.

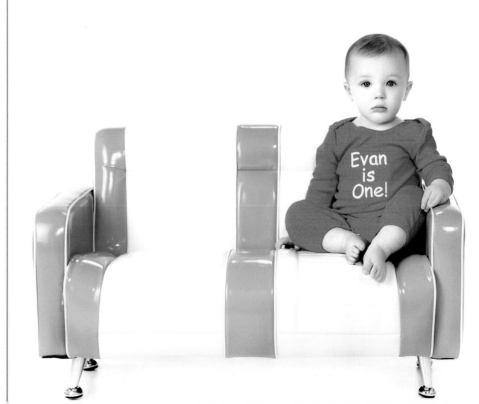

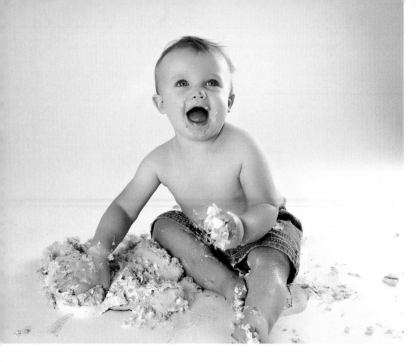

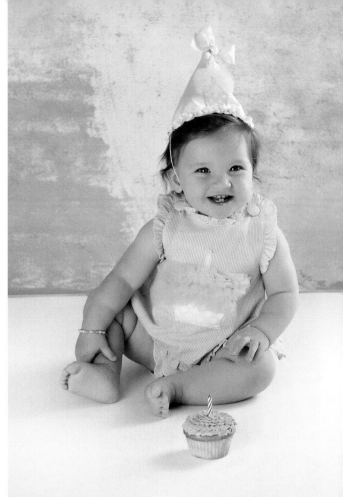

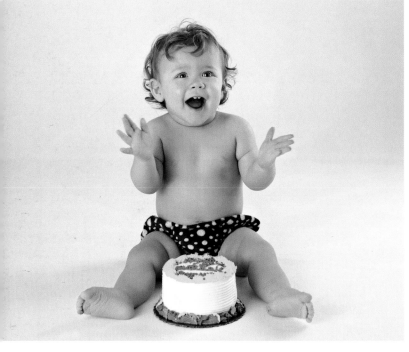

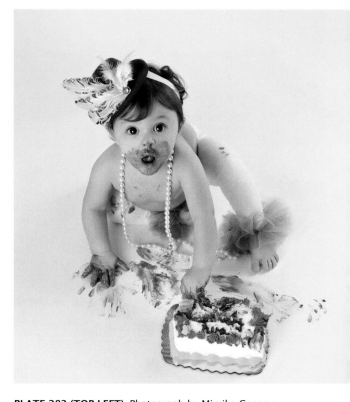

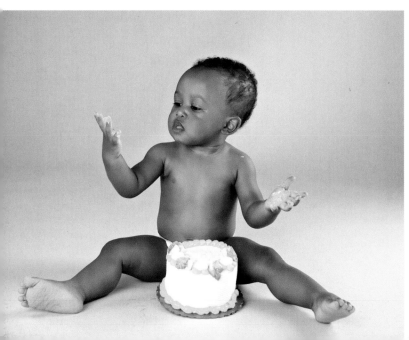

PLATE 282 (TOP LEFT). Photograph by Mimika Cooney.

PLATE 283 (CENTER LEFT). Photograph by Mimika Cooney.

PLATE 284 (BOTTOM LEFT). Photograph by Mimika Cooney.

PLATE 285 (TOP RIGHT). Photograph by Mimika Cooney.

PLATE 286 (BOTTOM RIGHT). Photograph by Mimika Cooney.

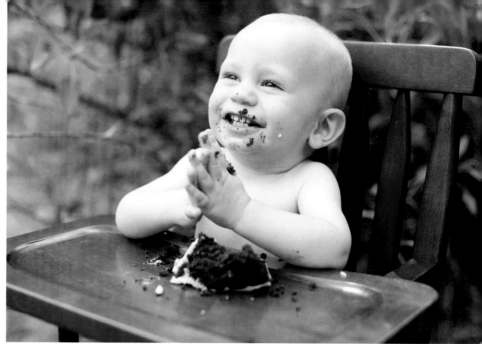

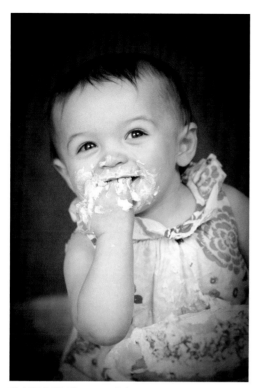

PLATE 287. Photograph by Tracy Dorr.

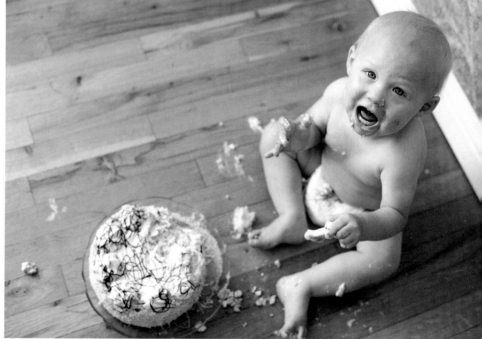

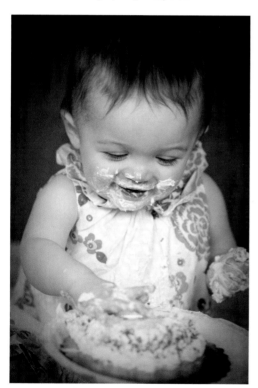

PLATE 288. Photograph by Tracy Dorr.

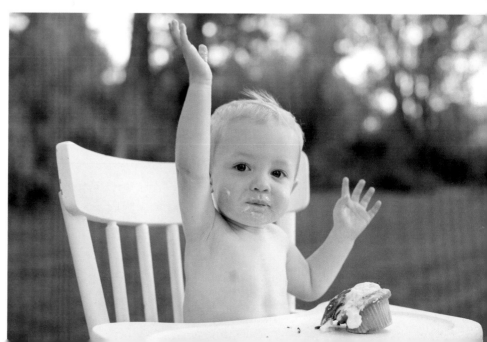

PLATE 289 (TOP RIGHT).
Photograph by Christie Mumm.

PLATE 290 (CENTER RIGHT).
Photograph by Christie Mumm.

PLATE 291 (BOTTOM RIGHT).
Photograph by Christie Mumm.

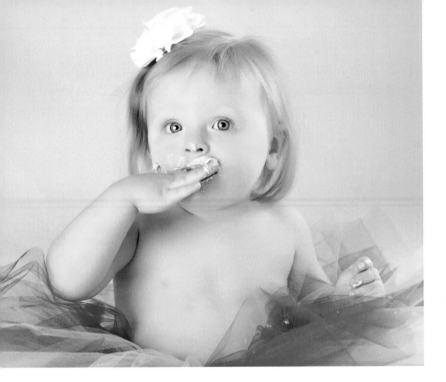

PLATE 292 (TOP LEFT).
Photograph by Mimika Cooney.

PLATE 293 (BOTTOM LEFT).
Photograph by Christie Mumm.

PLATE 294. Photograph by Krista Smith.

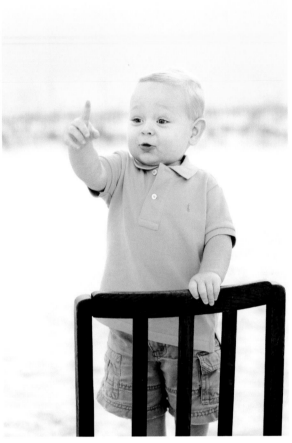

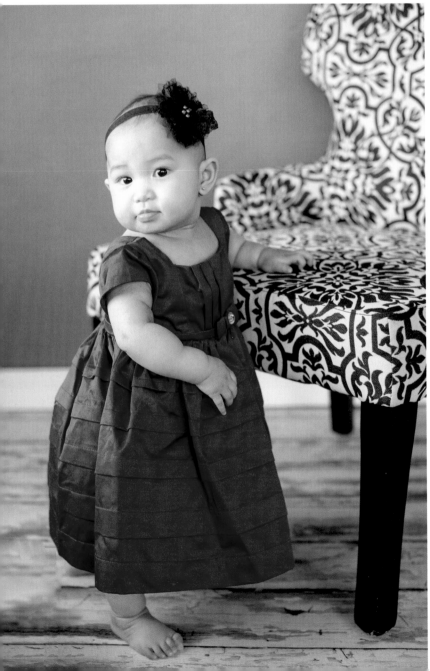

PLATE 295. Photograph by Jenean Mohr.

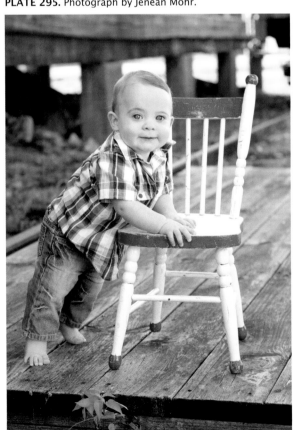

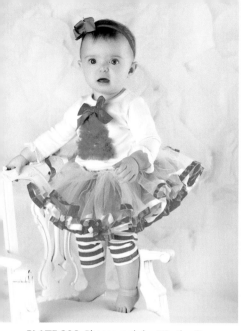

PLATE 296. Photograph by Mimika Cooney.

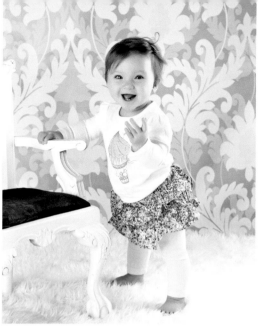

PLATE 297. Photograph by Mimika Cooney.

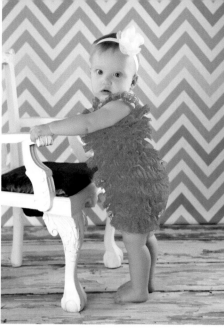

PLATE 298. Photograph by Mimika Cooney.

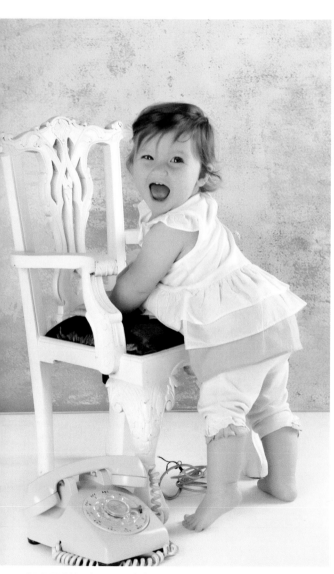

PLATE 299. Photograph by Mimika Cooney.

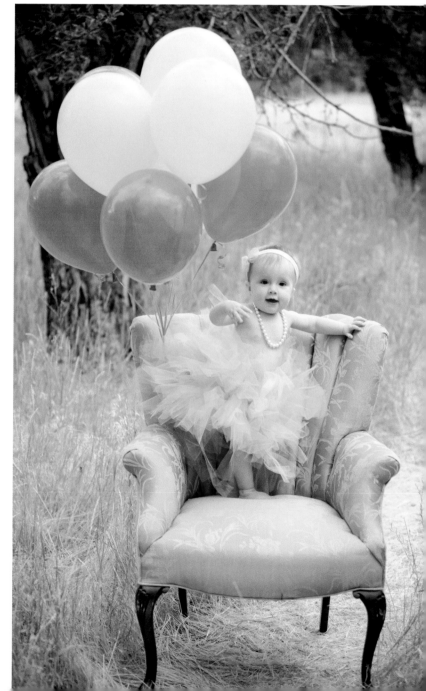

PLATE 300 (RIGHT). Photograph by Christie Mumm.

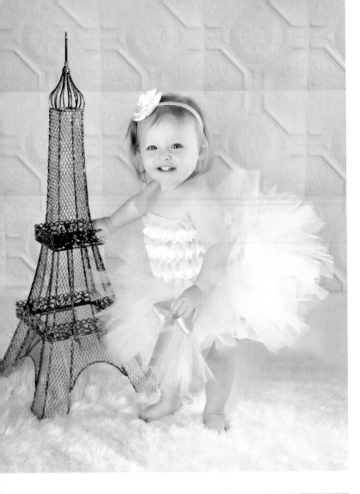

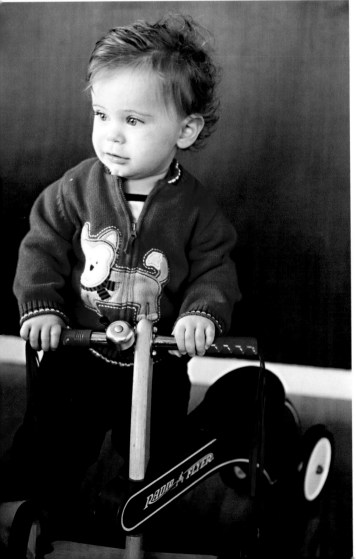

PLATE 301 (TOP LEFT). Photograph by Mimika Cooney.

PLATE 302 (BOTTOM LEFT). Photograph by Christie Mumm.

PLATE 303 (TOP RIGHT). Photograph by Mimika Cooney.

PLATE 304 (BOTTOM RIGHT). Photograph by Mimika Cooney.

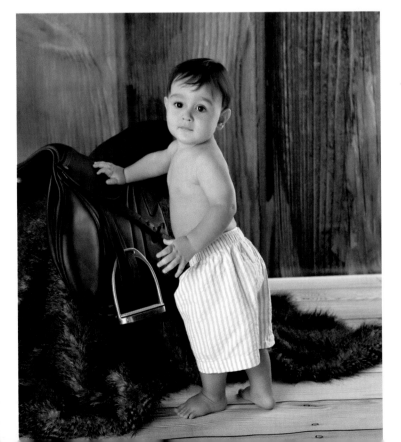

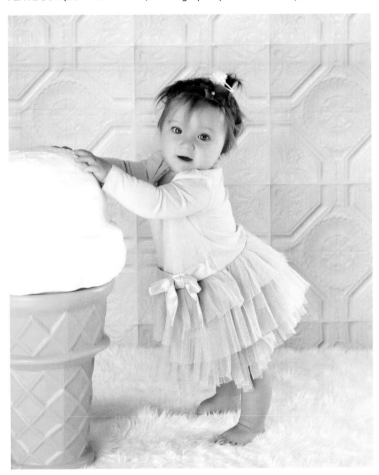

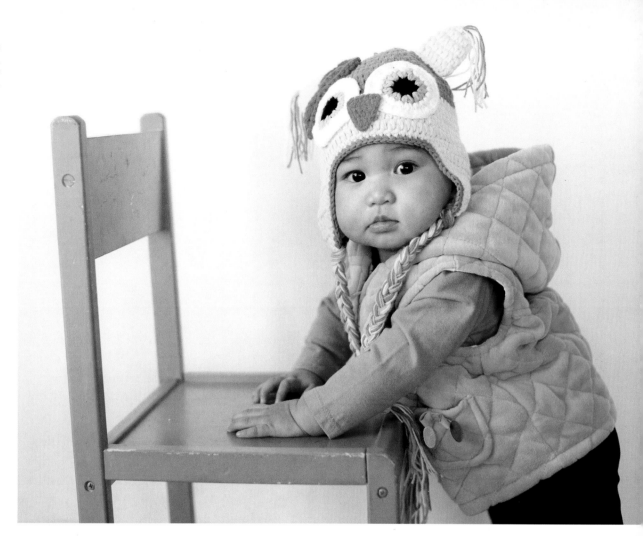

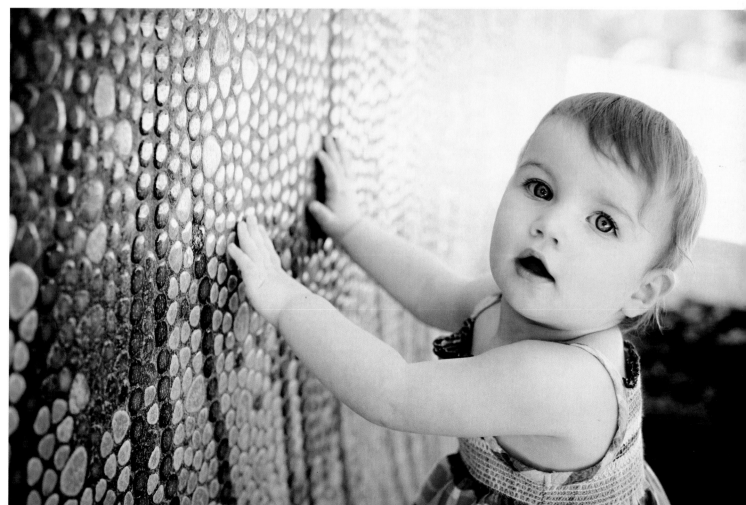

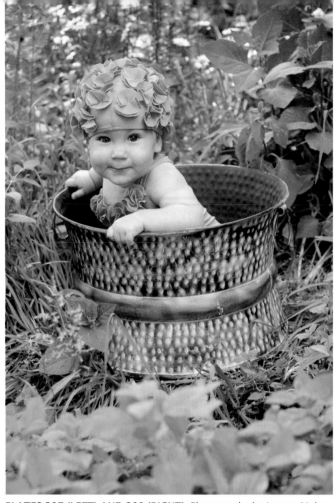

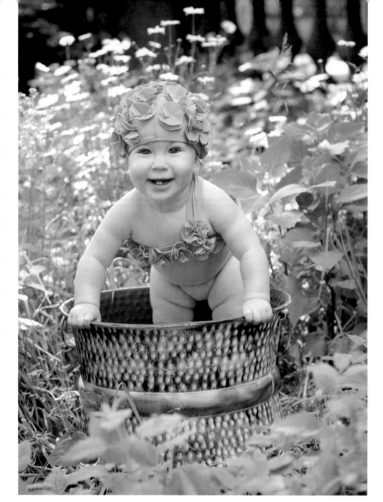

PLATES 307 (LEFT) AND 308 (RIGHT). Photographs by Jenean Mohr.

PLATES 309 (LEFT) AND 310 (RIGHT). Photographs by Jenean Mohr.

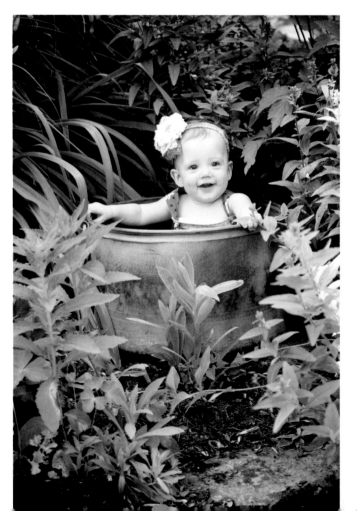

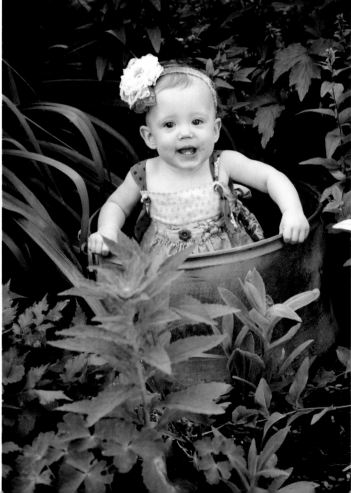

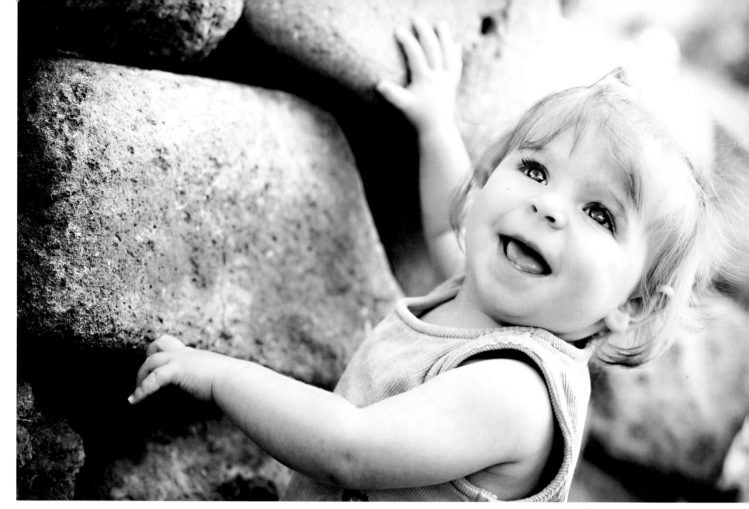

PLATE 311. Photograph by Christie Mumm.

PLATE 312. Photograph by Christie Mumm.

PLATE 313. Photograph by Marc Weisberg.

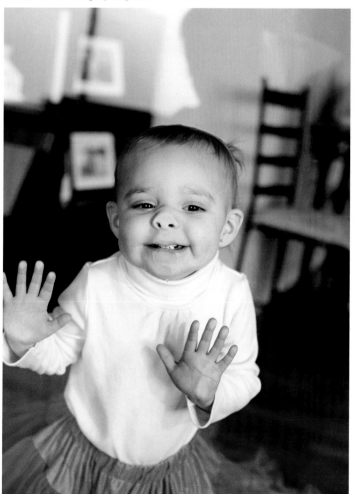

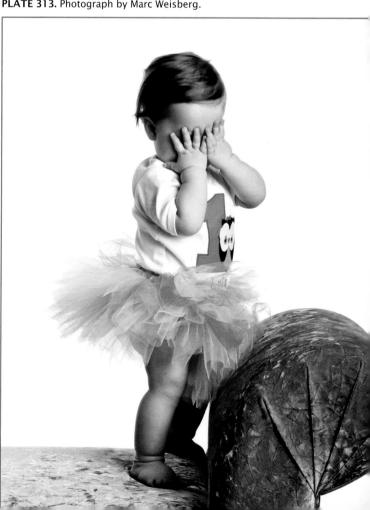

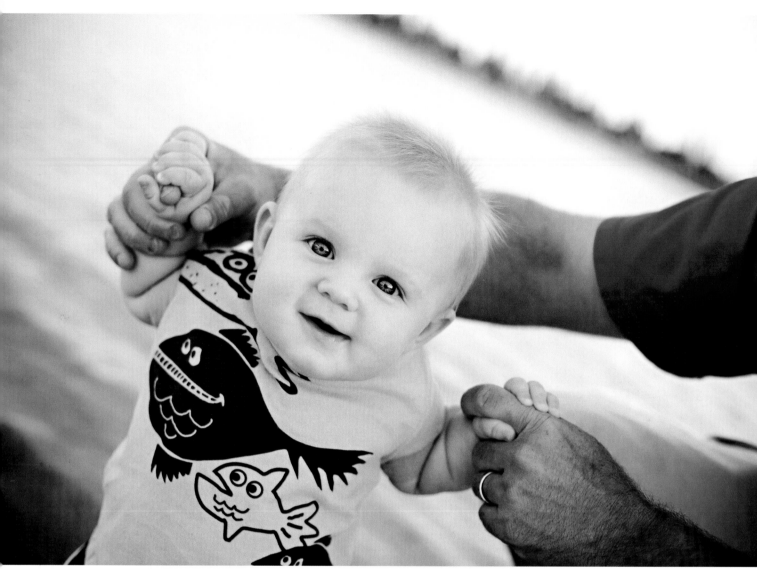

PLATE 314. Photograph by Christie Mumm.

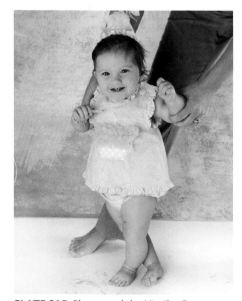

PLATE 315. Photograph by Mimika Cooney.

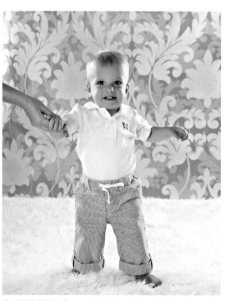

PLATE 316. Photograph by Mimika Cooney.

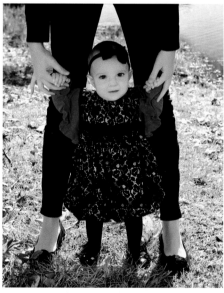

PLATE 317. Photograph by Mimika Cooney.

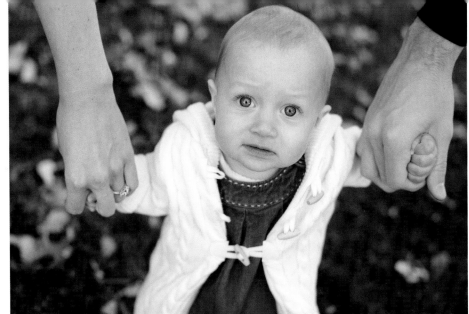

PLATE 318 (TOP RIGHT).
Photograph by Christie Mumm.

PLATE 319 (BOTTOM RIGHT).
Photograph by Christie Mumm.

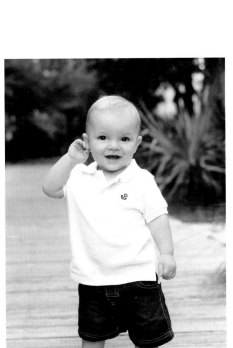

PLATE 320. Photograph by Krista Smith.

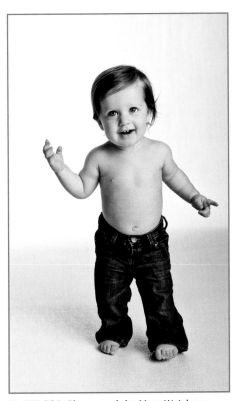

PLATE 321. Photograph by Marc Weisberg.

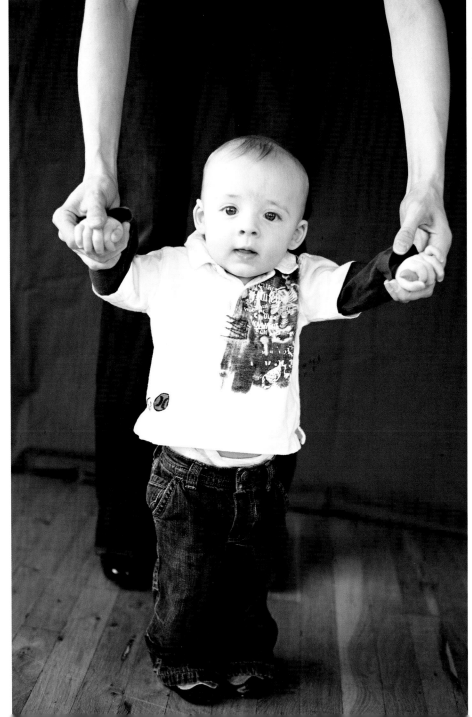

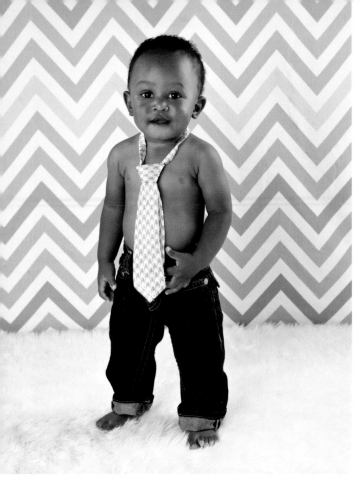

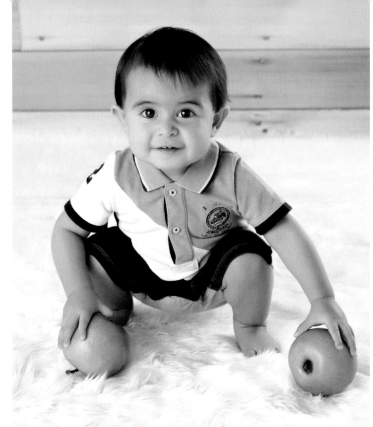

PLATE 322 (TOP LEFT). Photograph by Mimika Cooney.
PLATE 323 (ABOVE). Photograph by Mimika Cooney.

PLATE 324 (BOTTOM LEFT). Photograph by Jenean Mohr.
PLATE 325 (BELOW). Photograph by Brett Florens.

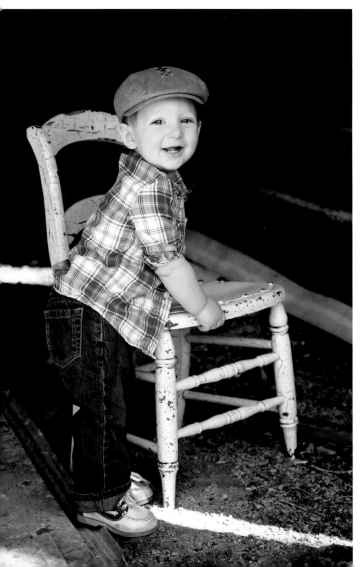

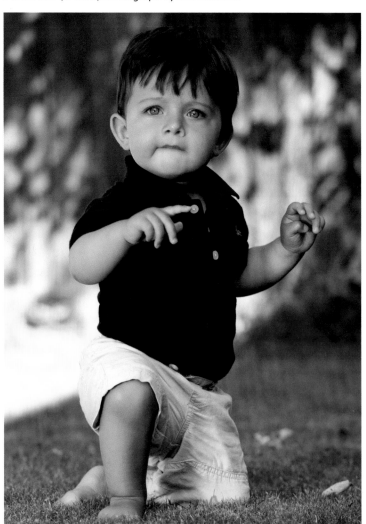

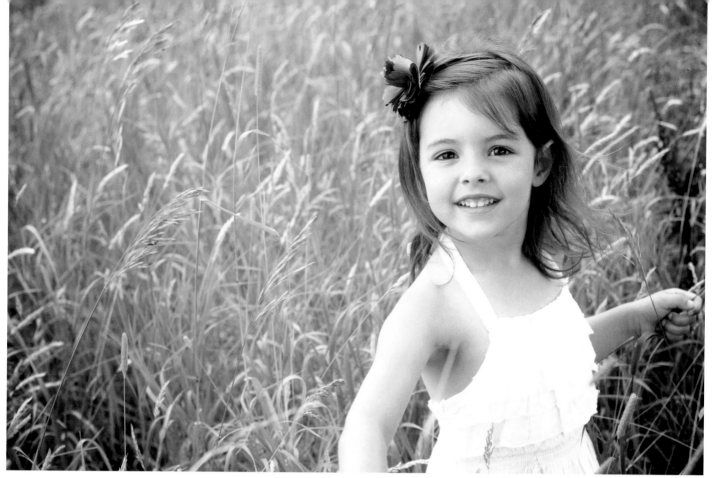

PLATES 326 (ABOVE), 327 (BOTTOM LEFT), AND 328 (BOTTOM RIGHT). Photographs by Jenean Mohr.

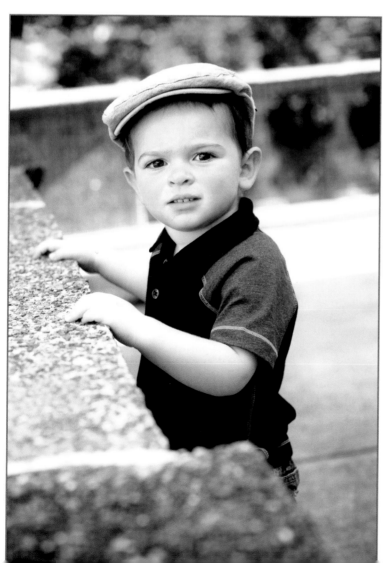

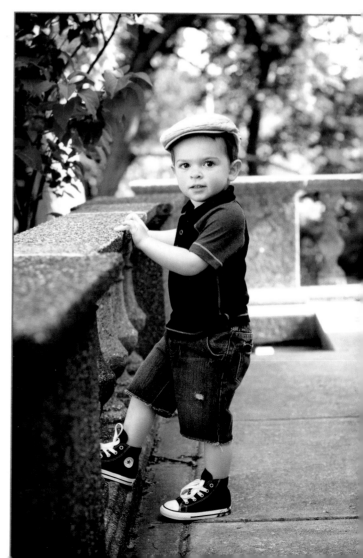

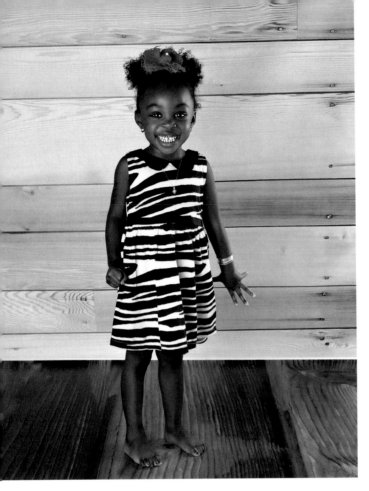

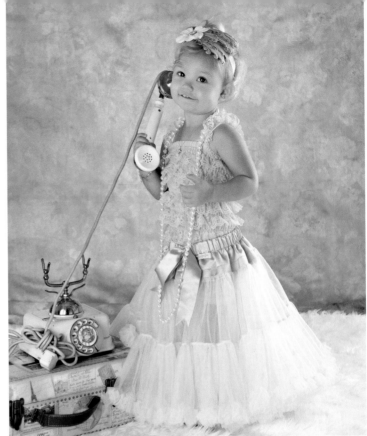

PLATE 329 (TOP LEFT). Photograph by Mimika Cooney.
PLATE 330 (ABOVE). Photograph by Mimika Cooney.

PLATE 331 (BOTTOM LEFT). Photograph by Mimika Cooney.
PLATE 332 (BELOW). Photograph by Mimika Cooney.

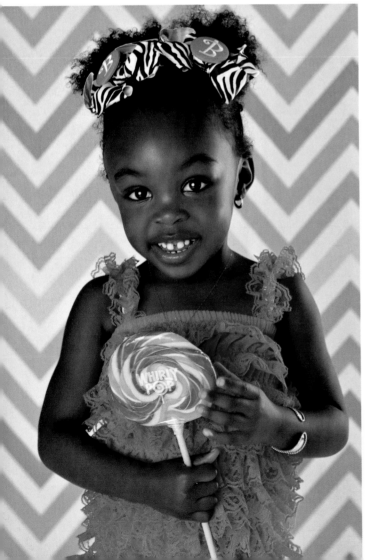

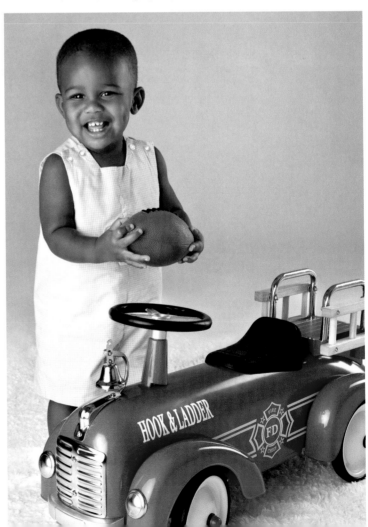

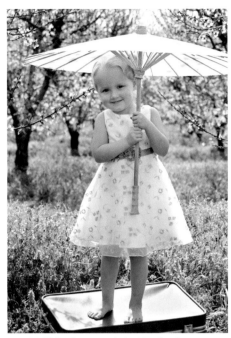

PLATE 333. Photograph by Mimika Cooney.

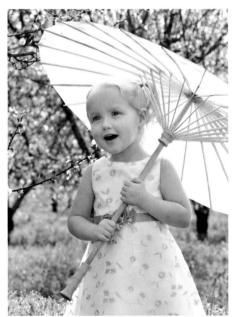

PLATE 334. Photograph by Mimika Cooney.

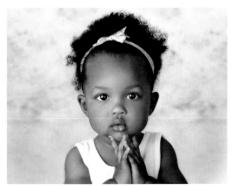

PLATE 335. Photograph by Beth Forester.

PLATE 336 (TOP RIGHT).
Photograph by Mimika Cooney.

PLATE 337 (BOTTOM RIGHT).
Photograph by Mimika Cooney.

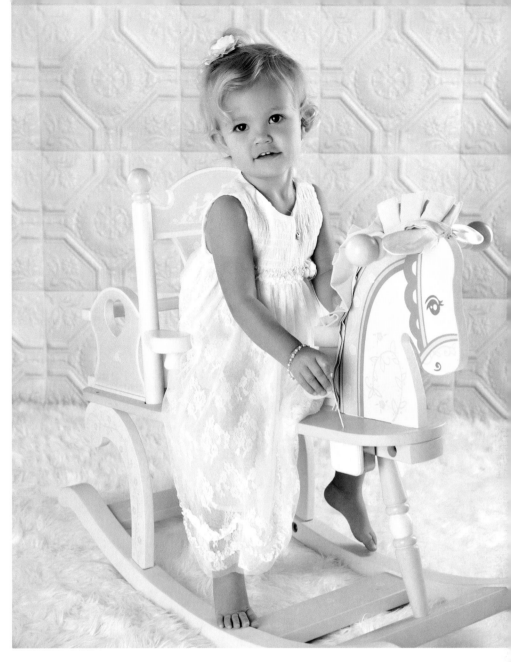

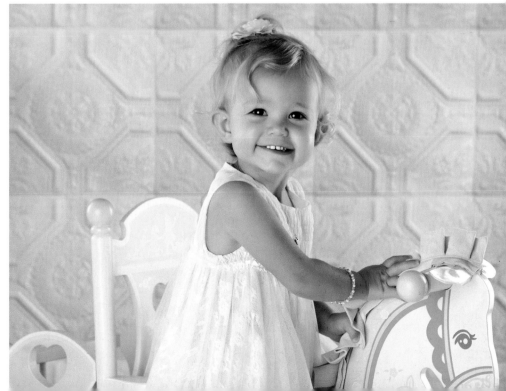

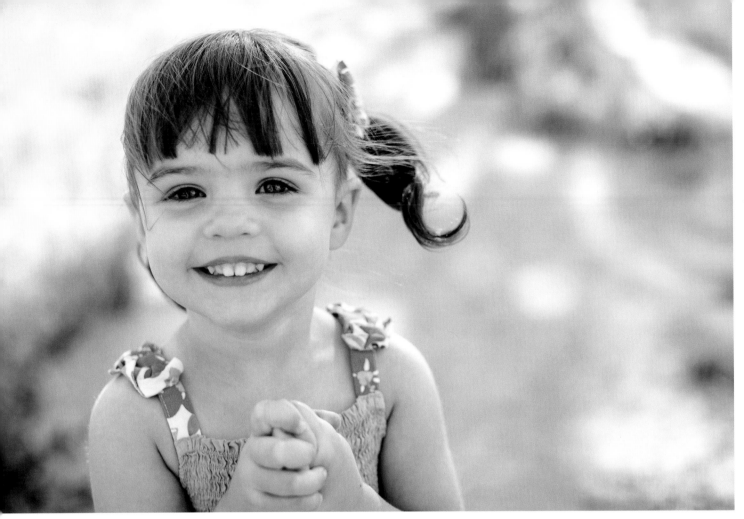

PLATES 338 (ABOVE) AND 339 (BELOW). Photographs by Christie Mumm.

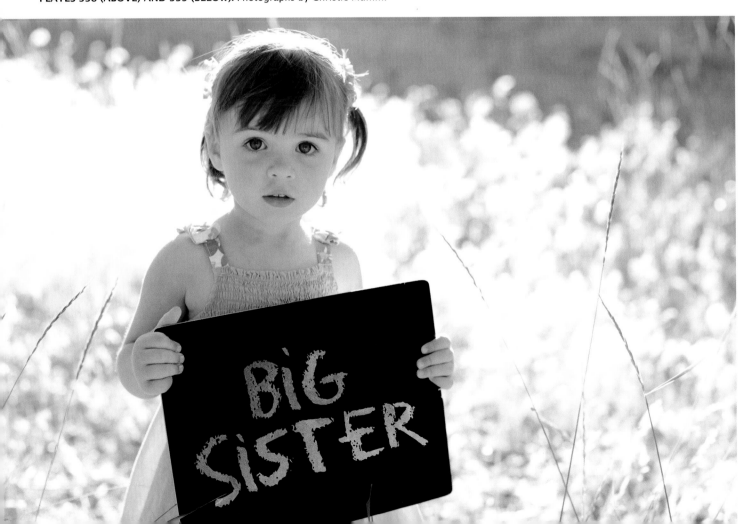

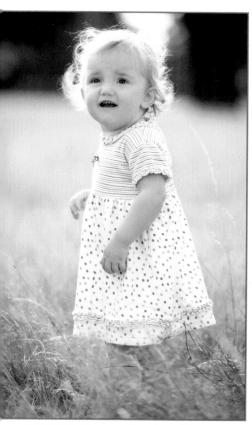

PLATE 340. Photograph by Brett Florens.

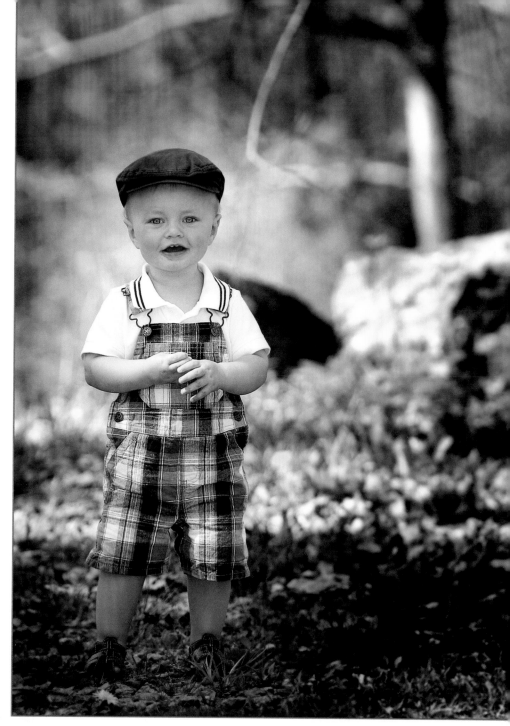

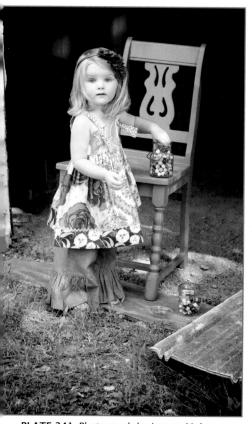

PLATE 341. Photograph by Jenean Mohr.

PLATES 342 (TOP RIGHT), 343 (BOTTOM
LEFT), AND 344 (BOTTOM RIGHT).
Photographs by Tracy Dorr.

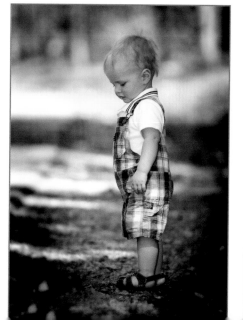

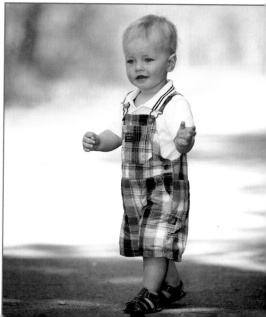

PLATE 345. Photograph by Jenean Mohr.

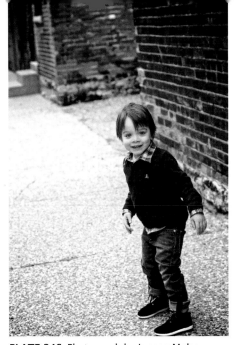

PLATE 346. Photograph by Jenean Mohr.

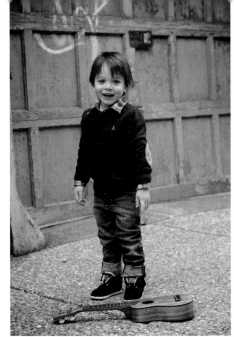

PLATE 347. Photograph by Jenean Mohr.

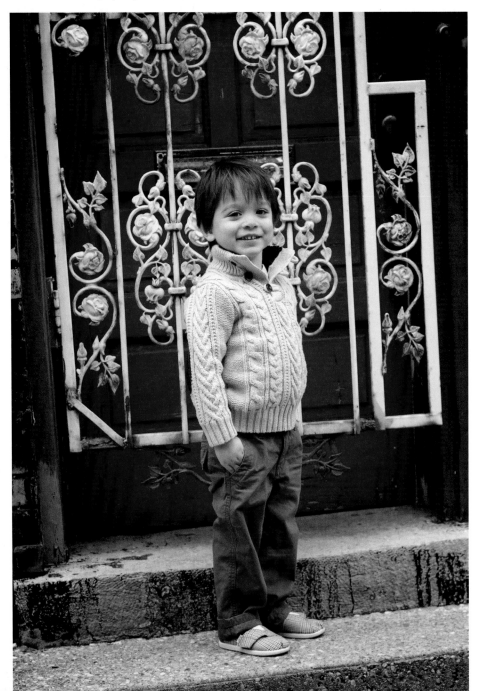

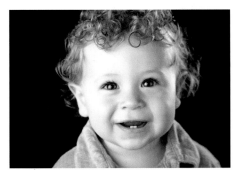

PLATE 348. Photograph by Marc Weisberg.

PLATE 349. Photograph by Beth Forester.

PLATE 350 (LEFT).
Photograph by Jenean Mohr.

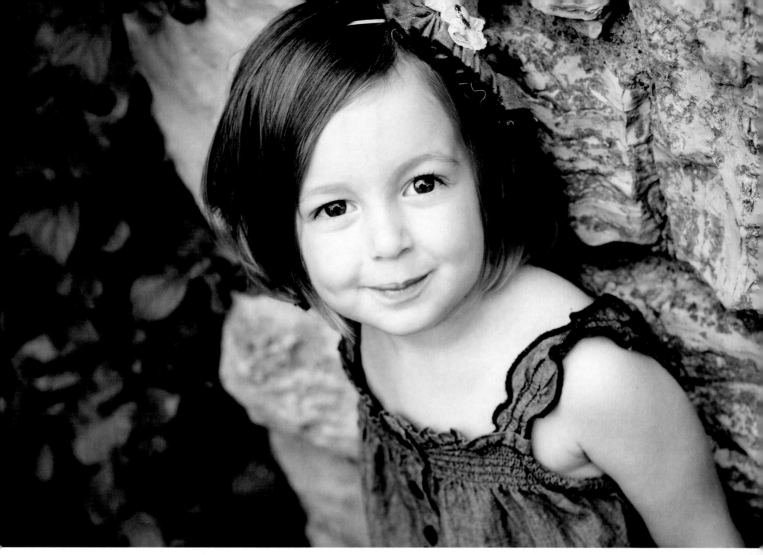

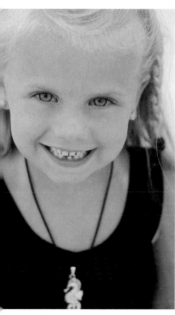

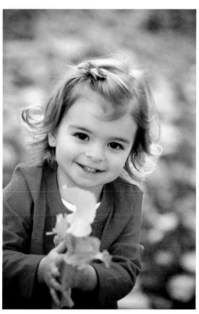

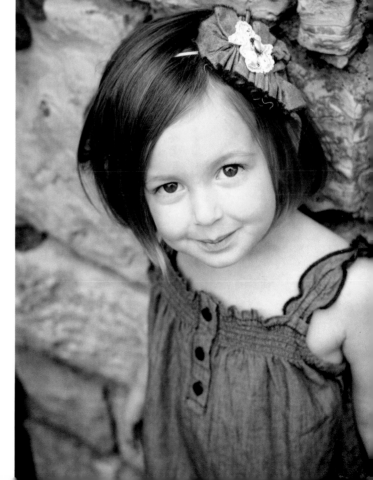

PLATE 351.
Photograph by Krista Smith.

PLATE 352.
Photograph by Christie Mumm.

PLATE 353 (TOP). Photograph by Jenean Mohr.

PLATE 354 (RIGHT). Photograph by Jenean Mohr.

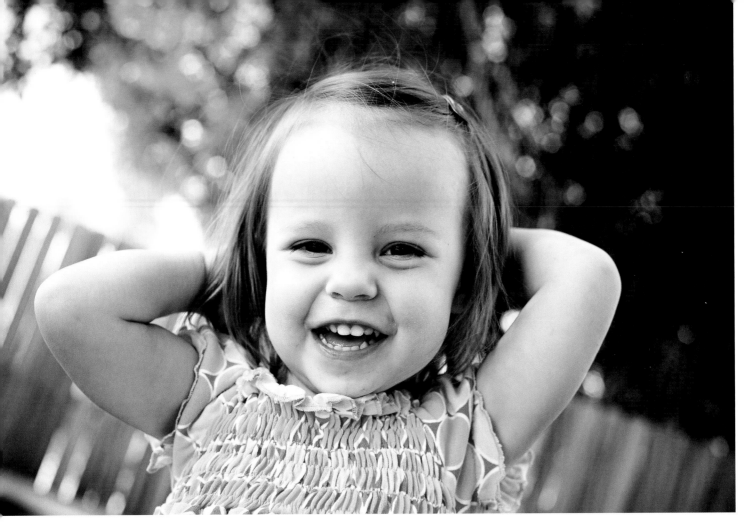

PLATES 355 (ABOVE) AND 356 (BELOW). Photographs by Christie Mumm.

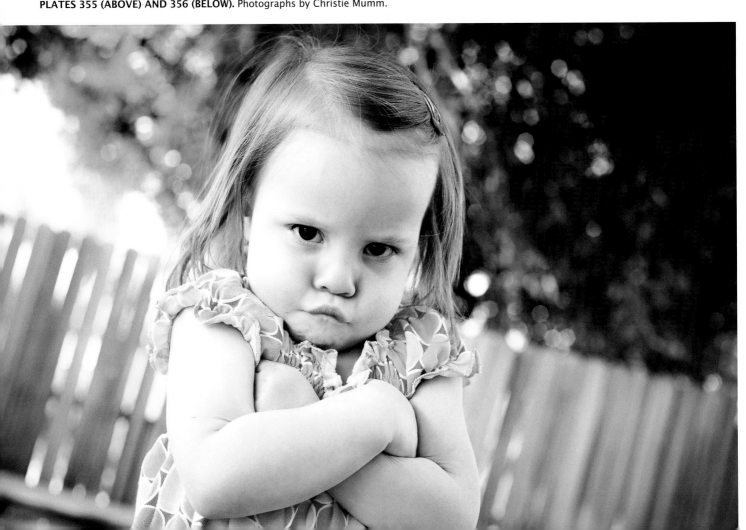

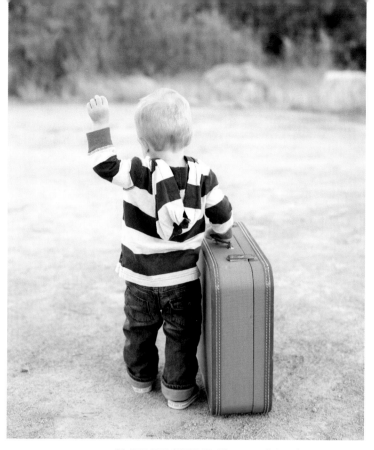

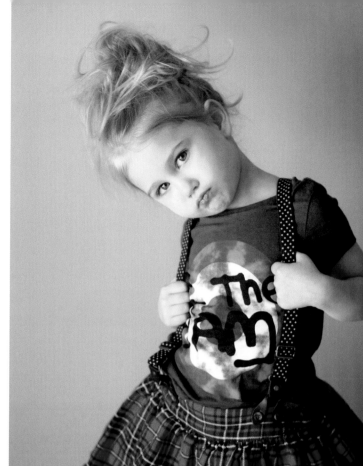

PLATE 357 (ABOVE). Photograph by Christie Mumm.
PLATE 358 (TOP RIGHT. Photograph by Jenean Mohr.

PLATE 359 (BELOW). Photograph by Christie Mumm.
PLATE 360 (BOTTOM RIGHT). Photograph by Christie Mumm.

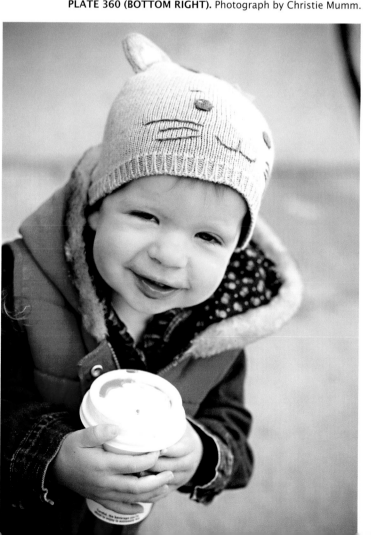

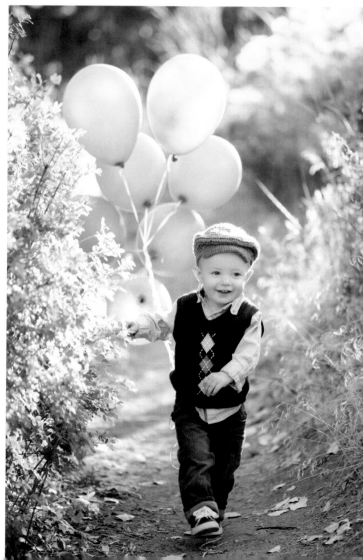

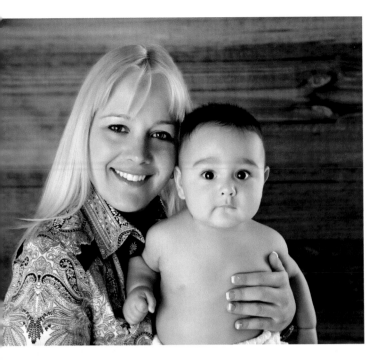

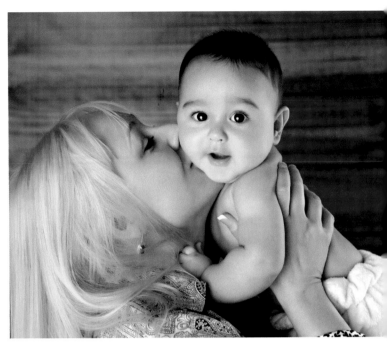

PLATES 361 (TOP LEFT), 362 (TOP RIGHT), AND 363 (LEFT). Photographs by Mimika Cooney.

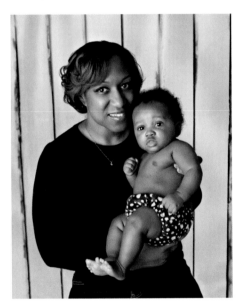

PLATE 364. Photograph by Mimika Cooney.

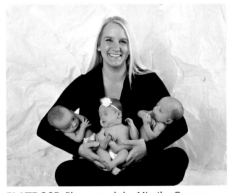

PLATE 365. Photograph by Mimika Cooney.

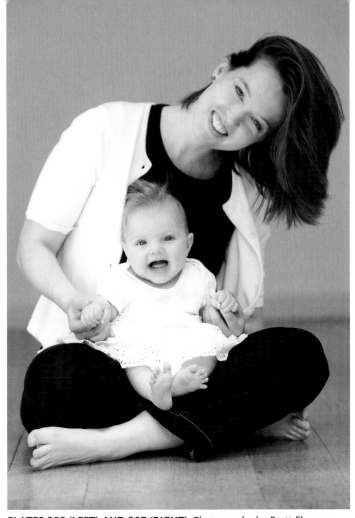

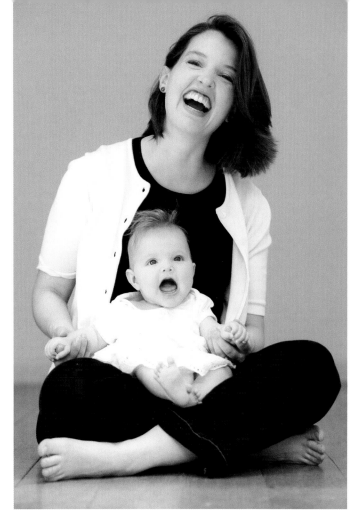

PLATES 366 (LEFT) AND 367 (RIGHT). Photographs by Brett Florens.

PLATES 368 (LEFT) AND 369 (RIGHT). Photographs by Tracy Dorr.

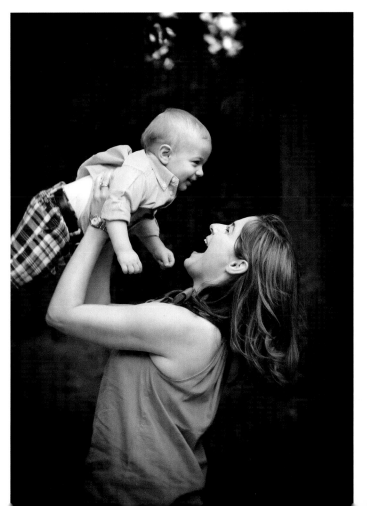

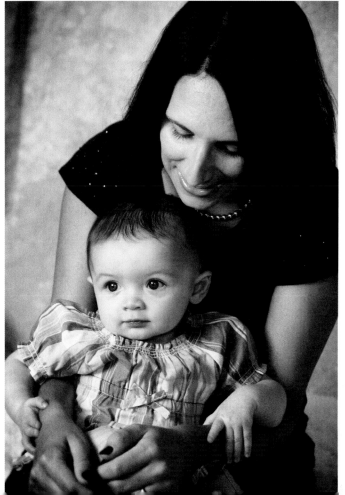

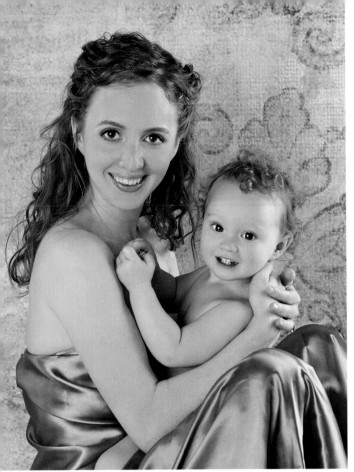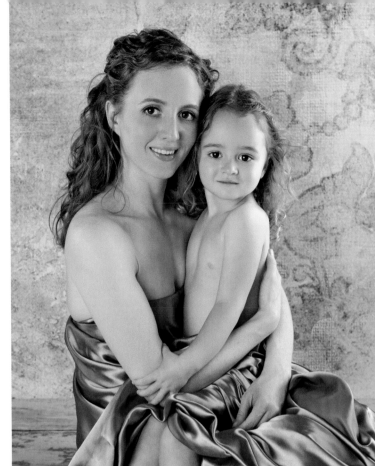

PLATES 370 (LEFT) AND 371 (RIGHT). Photographs by Mimika Cooney.

PLATE 372 (BELOW). Photograph by Beth Forester.

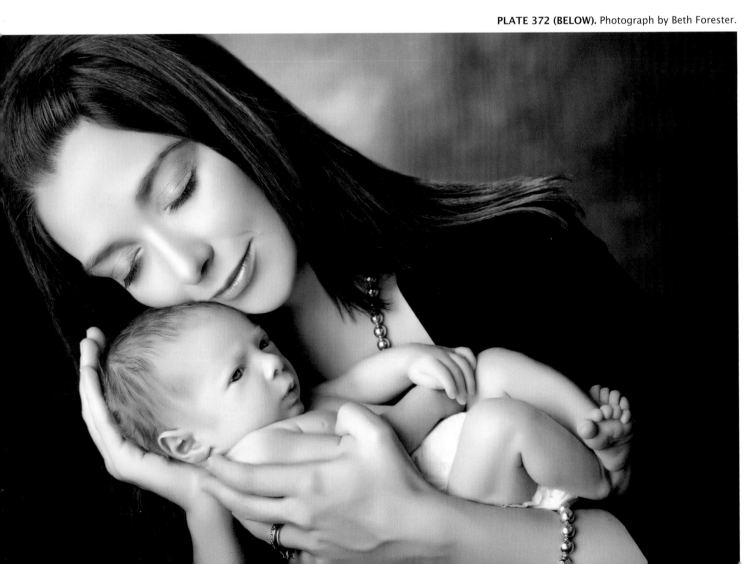

PLATE 373. Photograph by Mimika Cooney.

PLATE 374. Photograph by Christie Mumm.

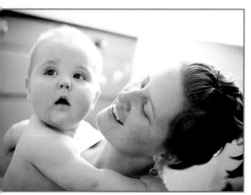

PLATE 375. Photograph by Christie Mumm.

PLATE 376 (TOP RIGHT).
Photograph by Mimika Cooney.

PLATE 377 (BOTTOM RIGHT).
Photograph by Mimika Cooney.

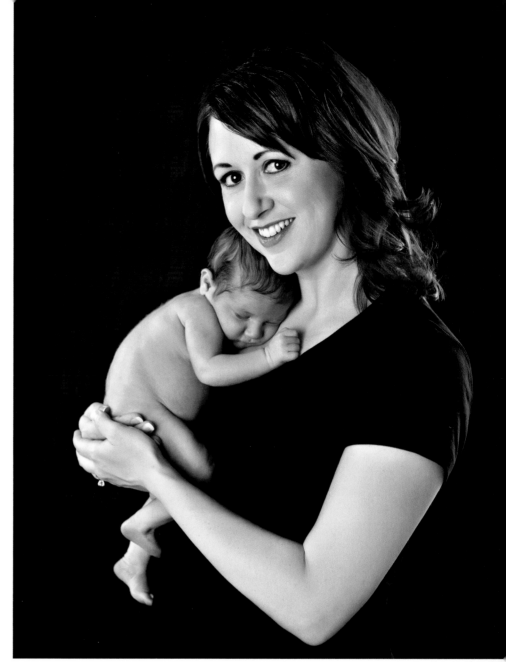

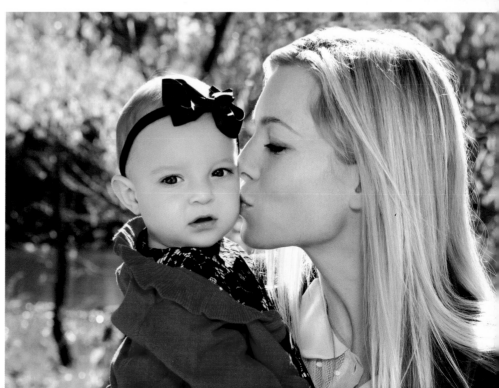

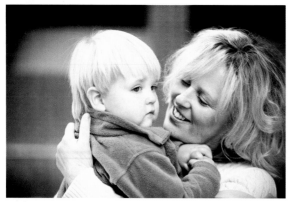

PLATE 378. Photograph by Christie Mumm.

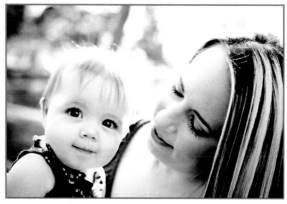

PLATE 379. Photograph by Christie Mumm.

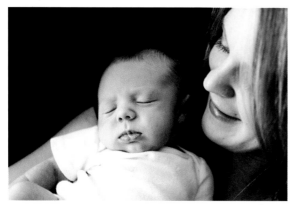

PLATE 380. Photograph by Christie Mumm.

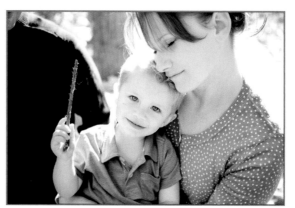

PLATE 381. Photograph by Christie Mumm.

PLATE 382. Photograph by Christie Mumm.

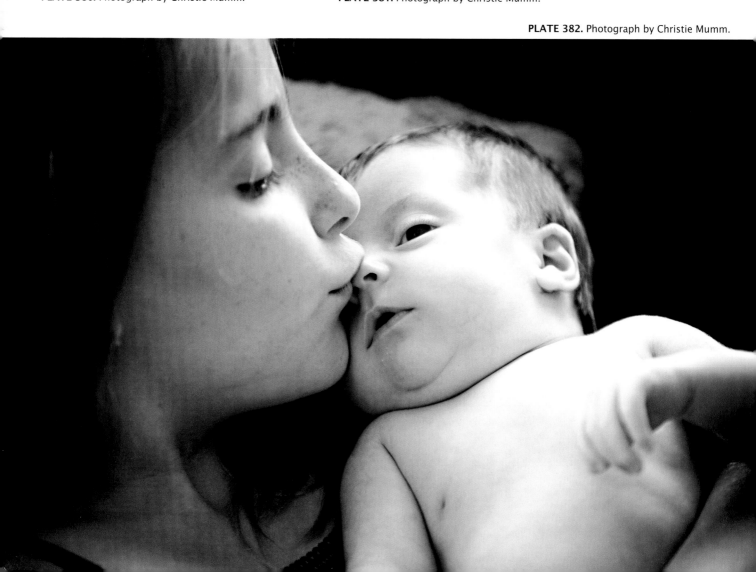

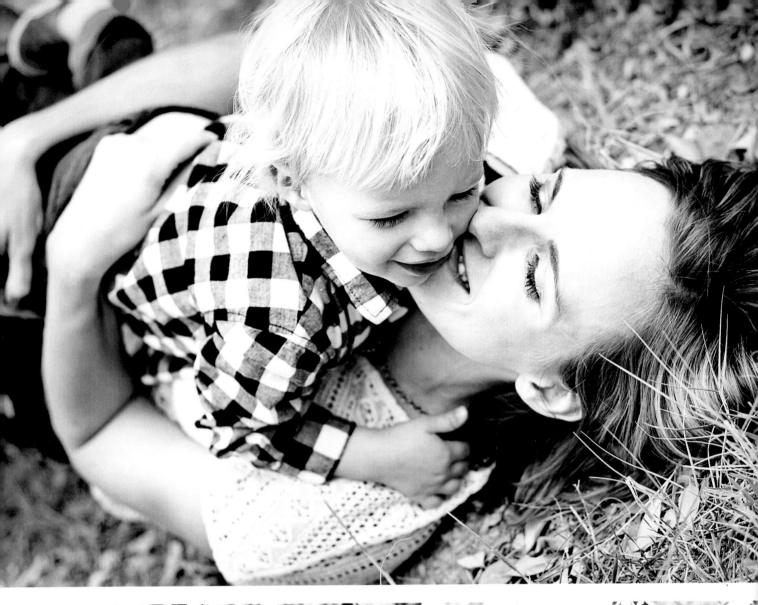

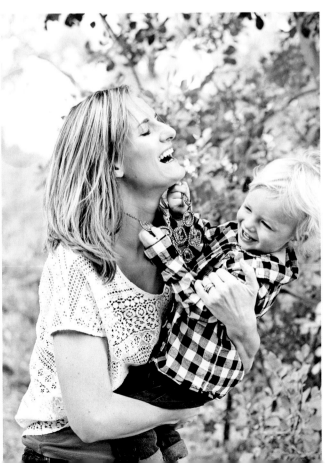

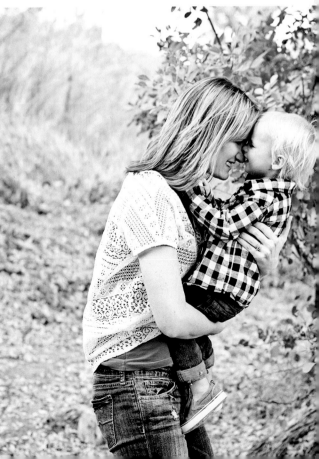

PLATE 383 (TOP). Photograph by Heather Magliarditi.

PLATE 384 (BOTTOM LEFT). Photograph by Heather Magliarditi.

PLATE 385 (BOTTOM RIGHT). Photograph by Heather Magliarditi.

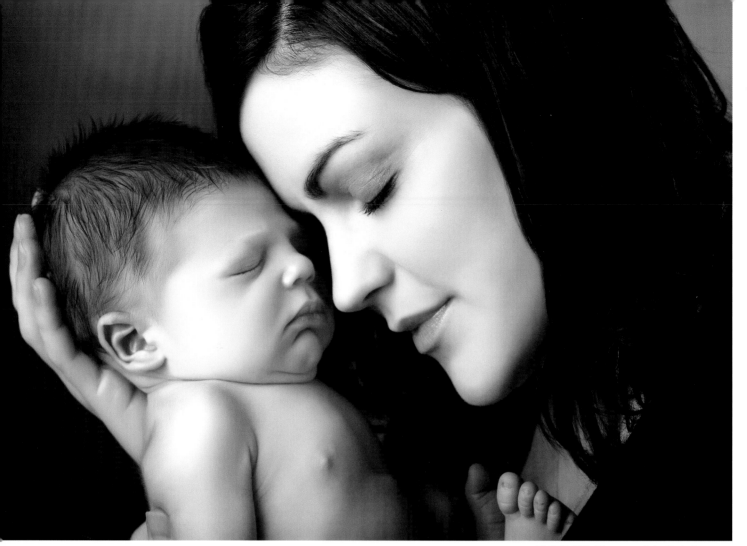

PLATE 386. Photograph by Beth Forester.

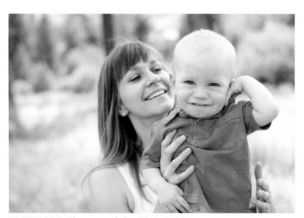

PLATE 387. Photograph by Christie Mumm.

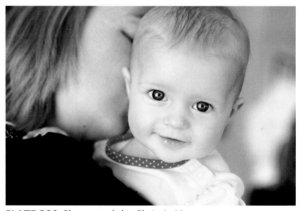

PLATE 388. Photograph by Christie Mumm.

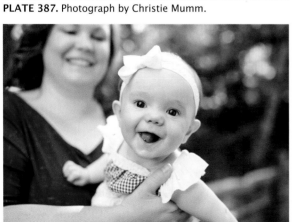

PLATE 389. Photograph by Christie Mumm.

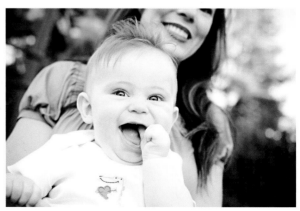

PLATE 390. Photograph by Christie Mumm.

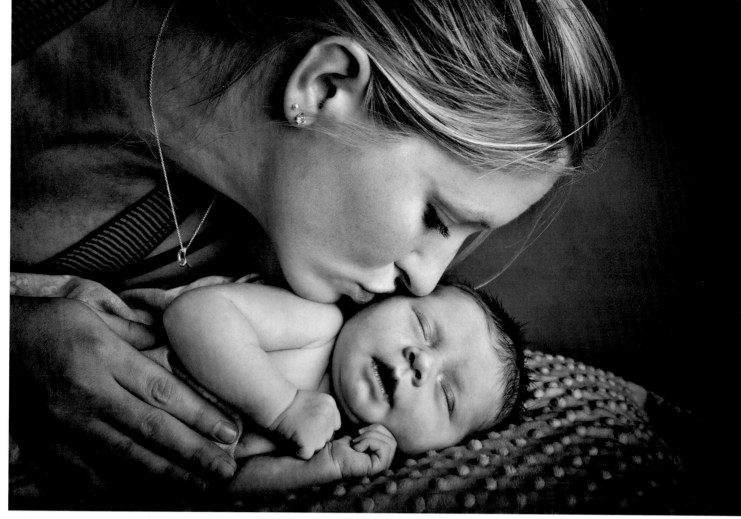

PLATES 391 (ABOVE) AND 392 (BELOW). Photographs by Marc Weisberg.

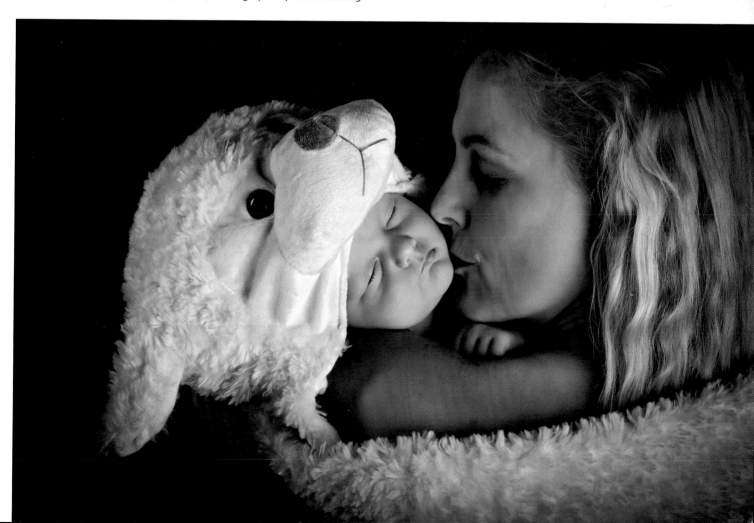

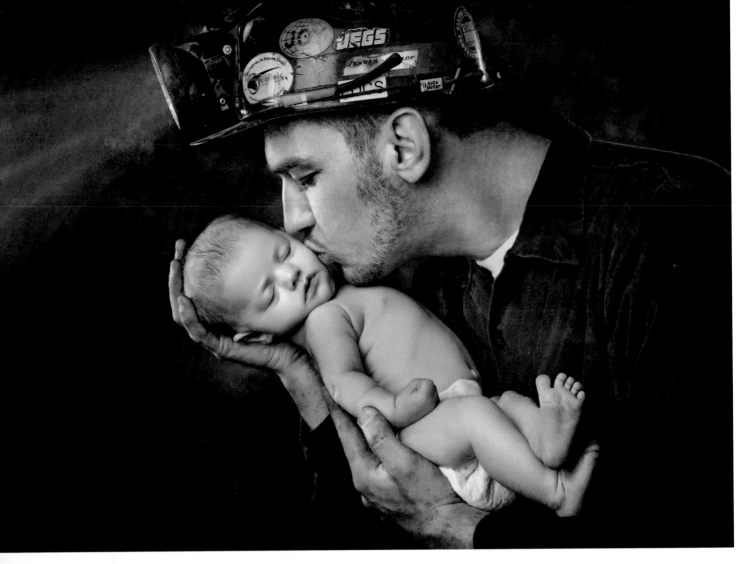

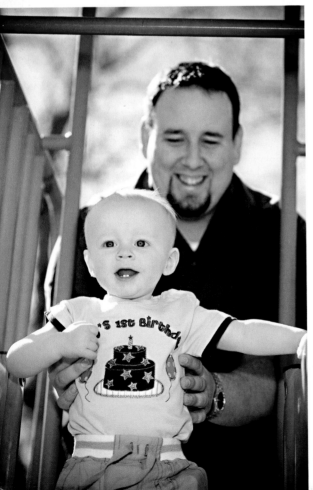

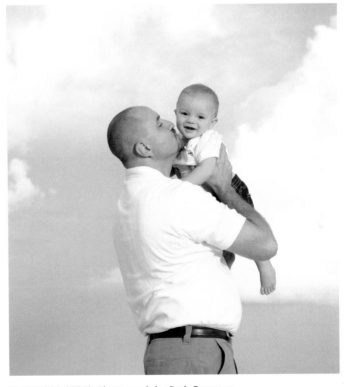

PLATE 393 (TOP). Photograph by Beth Forester.

PLATE 394 (LEFT). Photograph by Christie Mumm.

PLATE 395 (ABOVE). Photograph by Krista Smith.

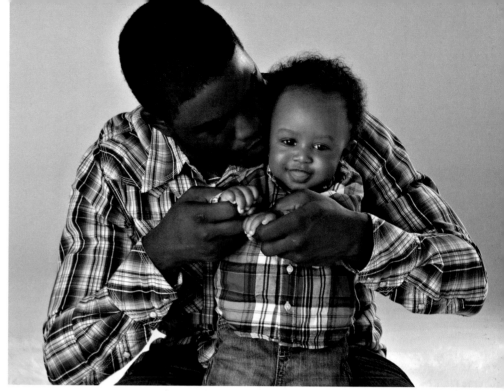

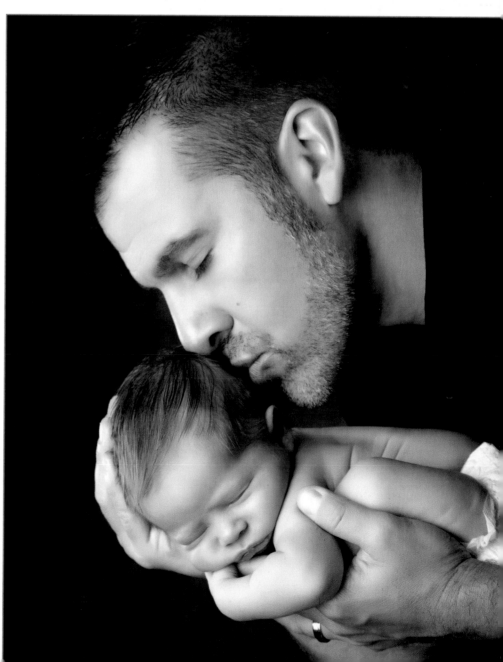

PLATE 396 (TOP RIGHT).
Photograph by Mimika Cooney.

PLATE 397 (BOTTOM RIGHT).
Photograph by Beth Forester.

PLATE 398. Photograph by Tracy Dorr.

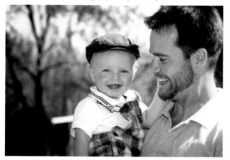

PLATE 399. Photograph by Christie Mumm.

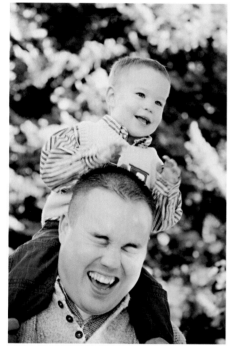

PLATE 400. Photograph by Tracy Dorr.

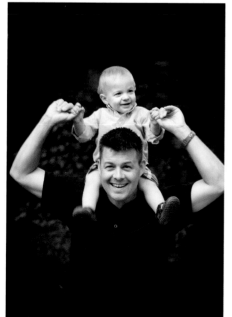

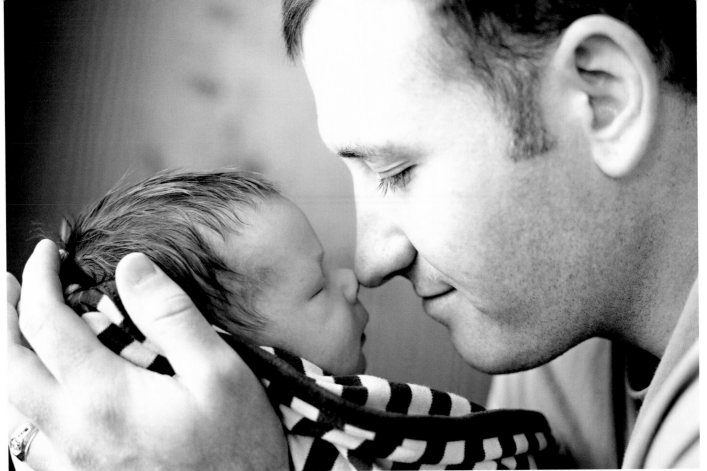

PLATE 401. Photograph by Christie Mumm.

PLATE 402. Photograph by Brett Florens.

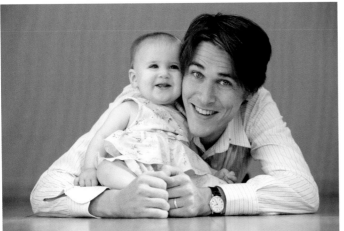

PLATE 403. Photograph by Brett Florens.

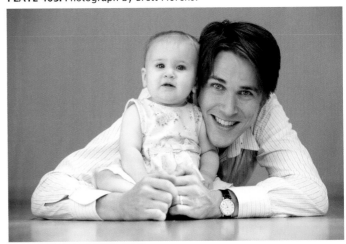

PLATE 404. Photograph by Brett Florens.

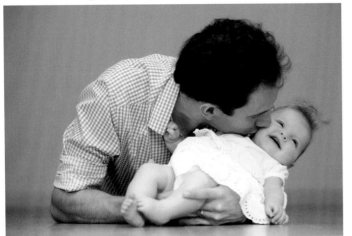

PLATE 405. Photograph by Brett Florens.

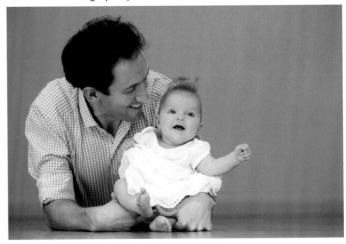

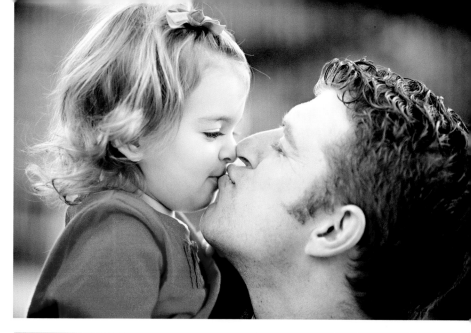

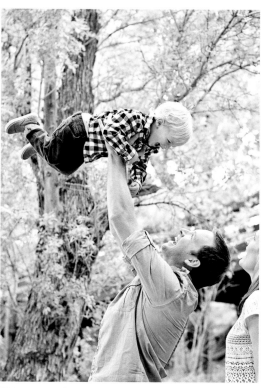

PLATE 406. Photograph by Heather Magliarditi.

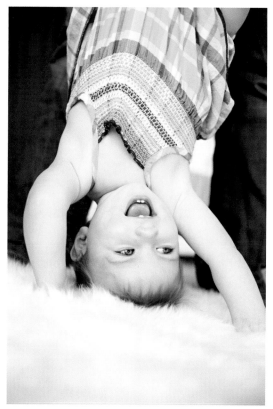

PLATE 407. Photograph by Christie Mumm.

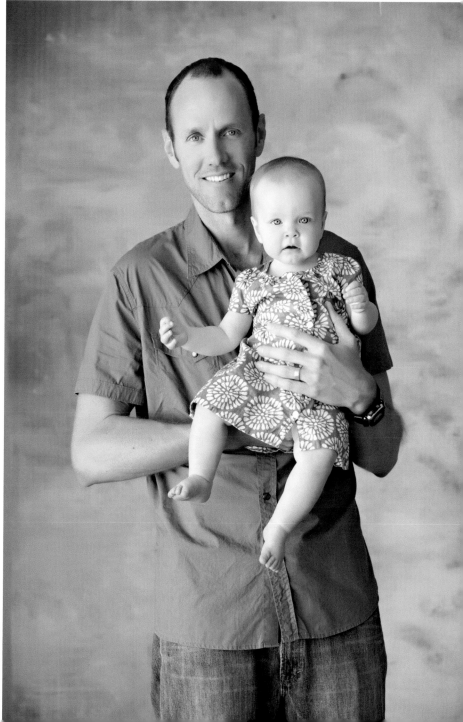

PLATE 408 (TOP RIGHT).
Photograph by Christie Mumm.

PLATE 409 (BOTTOM RIGHT).
Photograph by Vicki Taufer.

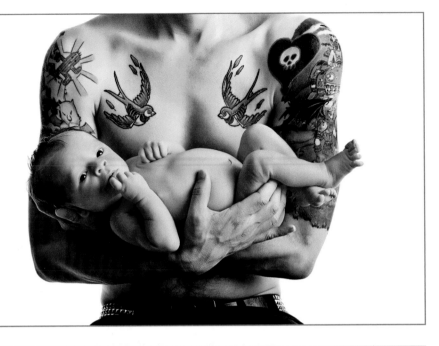

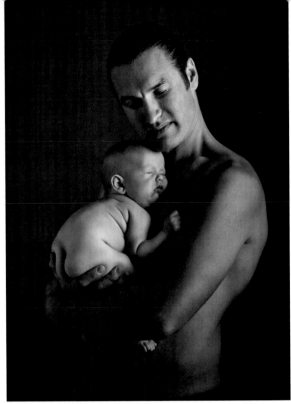

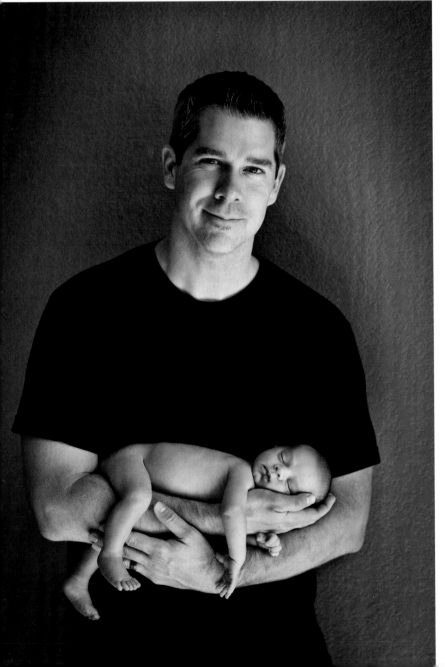

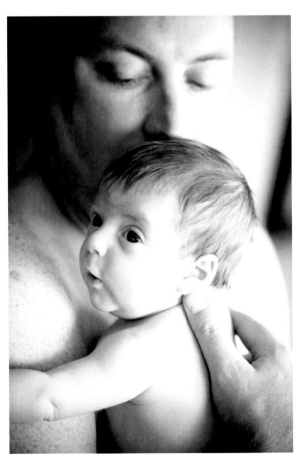

PLATE 410 (TOP LEFT). Photograph by Marc Weisberg.

PLATE 411 (ABOVE). Photograph by Marc Weisberg.

PLATE 412 (ABOVE). Photograph by Christie Mumm.

PLATE 413 (LEFT). Photograph by Marc Weisberg.

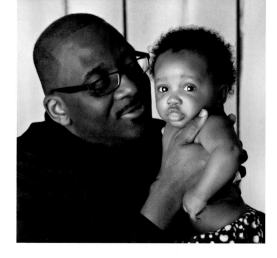

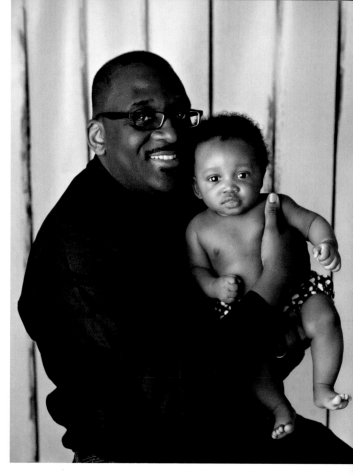

PLATE 414 (RIGHT). Photograph by Mimika Cooney.

PLATE 415 (FAR RIGHT). Photograph by Mimika Cooney.

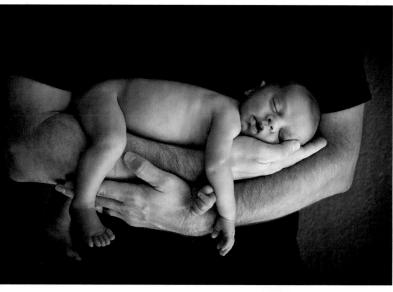

PLATE 416 (LEFT). Photograph by Marc Weisberg.

PLATE 417 (BELOW). Photograph by Marc Weisberg.

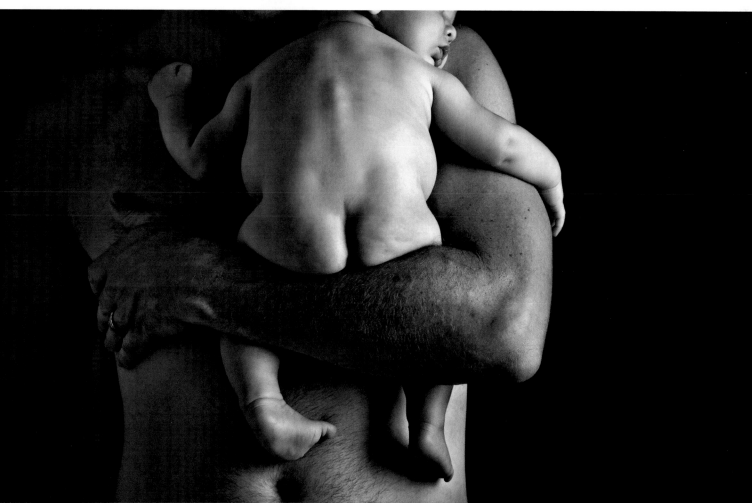

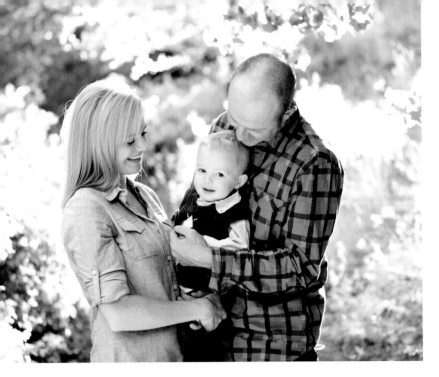

PLATE 418 (TOP LEFT). Photograph by Christie Mumm.

PLATE 419 (CENTER LEFT). Photograph by Mimika Cooney.

PLATE 420 (BOTTOM LEFT). Photograph by Christie Mumm.

PLATE 421. Photograph by Mimika Cooney.

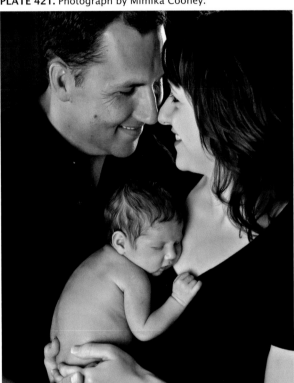

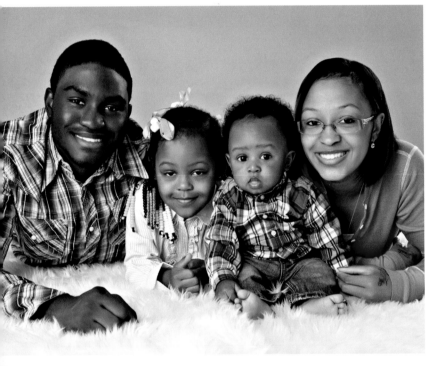

PLATE 422. Photograph by Mimika Cooney.

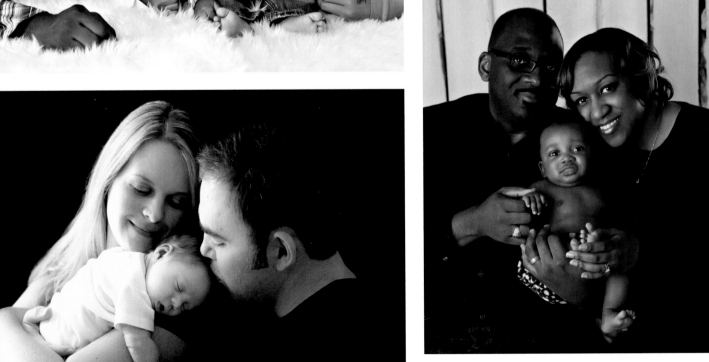

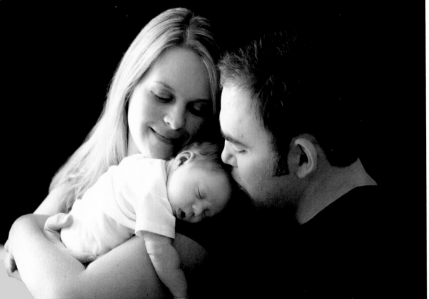

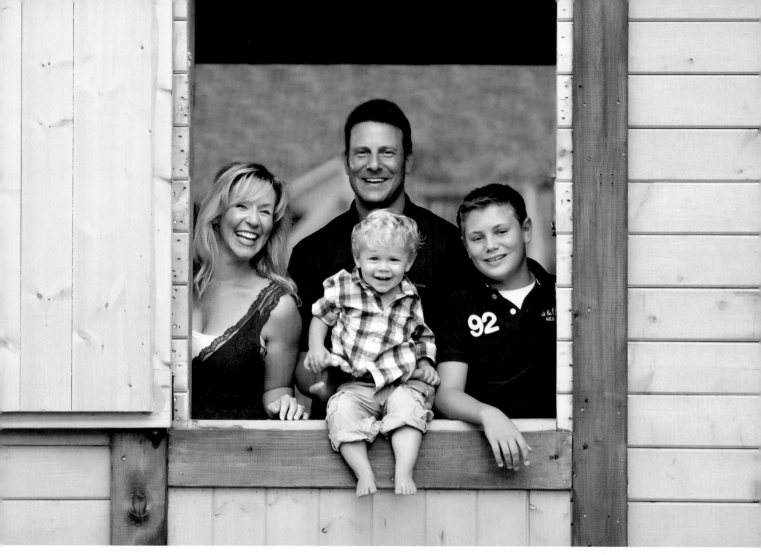

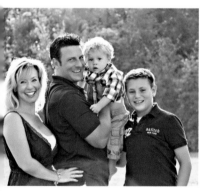

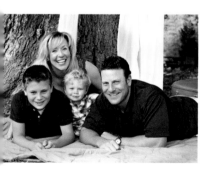

PLATES 423 (TOP),
424 (TOP LEFT),
425 (BOTTOM LEFT), AND
426 (RIGHT). Photographs by
Mimika Cooney.

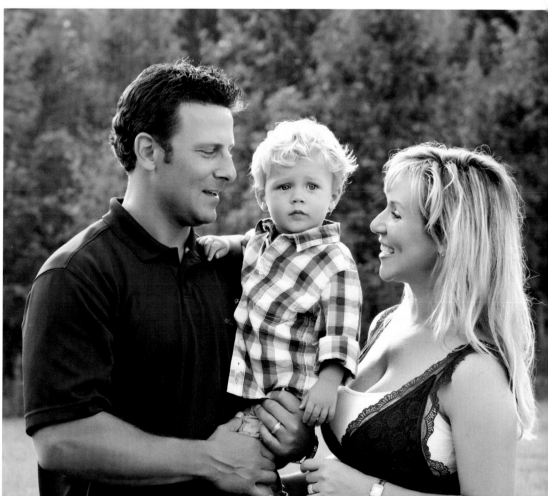

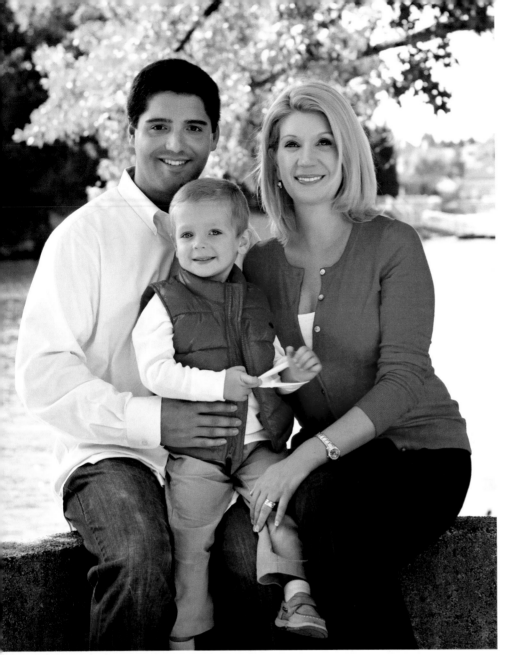

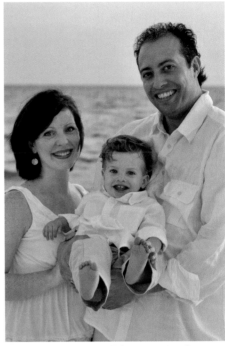

PLATE 427. Photograph by Krista Smith.

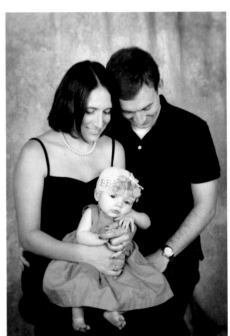

PLATE 428. Photograph by Tracy Dorr.

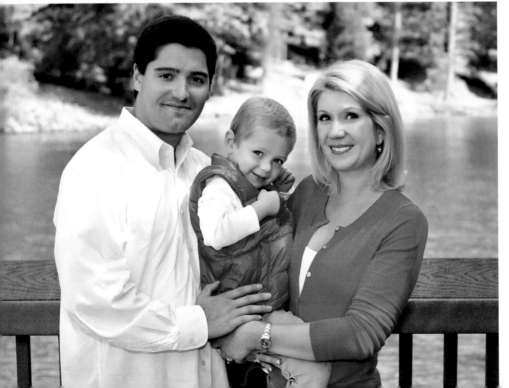

PLATE 429 (TOP LEFT).
Photograph by Mimika Cooney.

PLATE 430 (BOTTOM LEFT).
Photograph by Mimika Cooney.

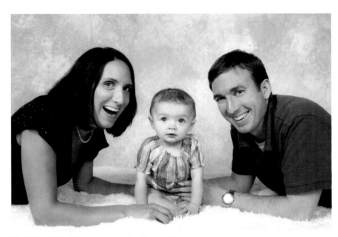

PLATE 431. Photograph by Tracy Dorr.

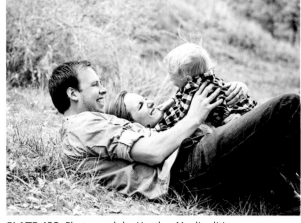

PLATE 432. Photograph by Heather Magliarditi.

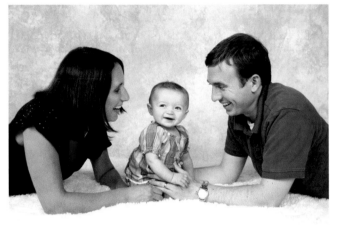

PLATE 433. Photograph by Tracy Dorr.

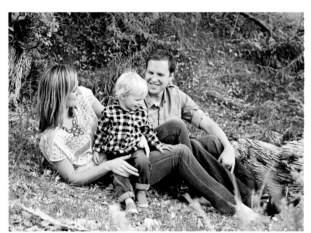

PLATE 434. Photograph by Heather Magliarditi.

PLATE 435. Photograph by Vicki Taufer.

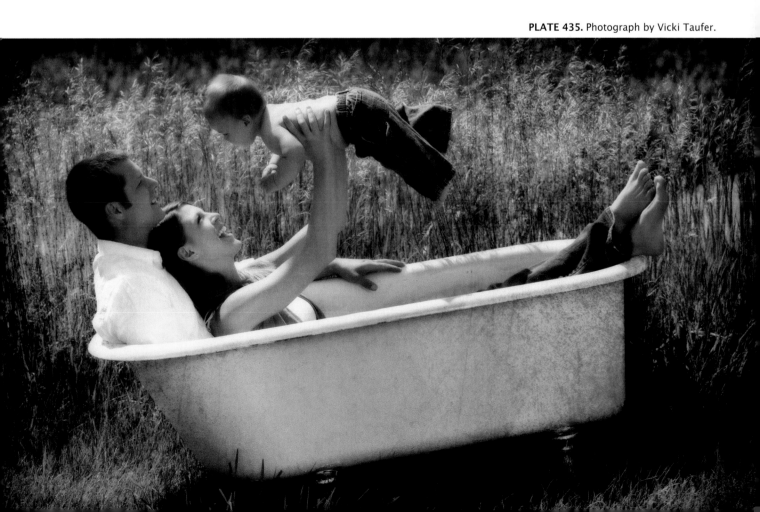

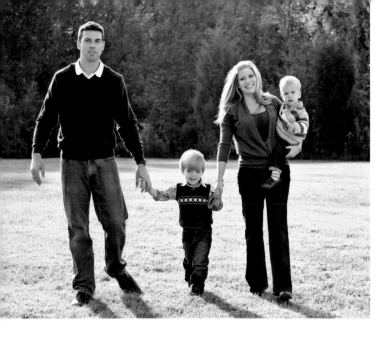
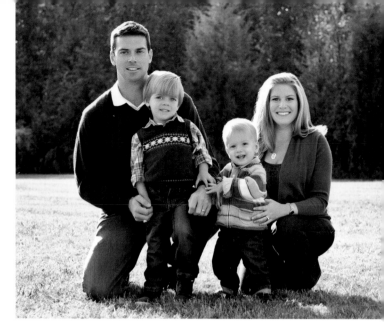
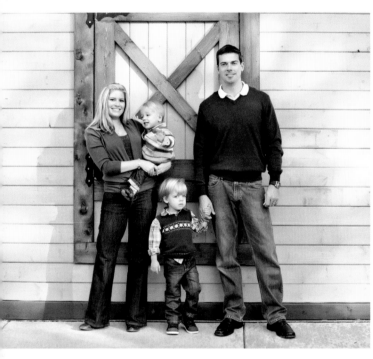
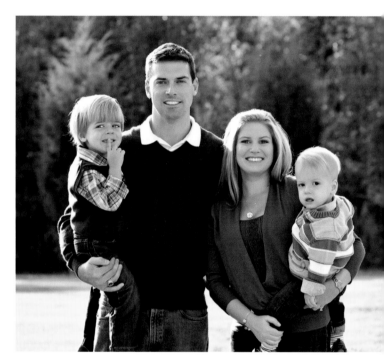
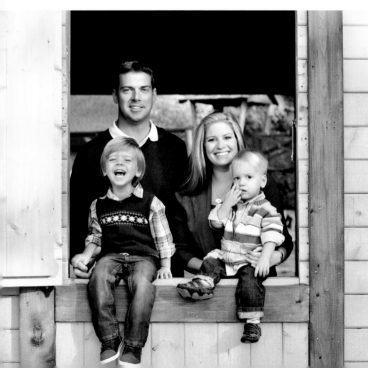
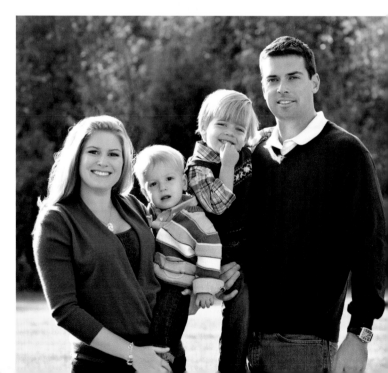

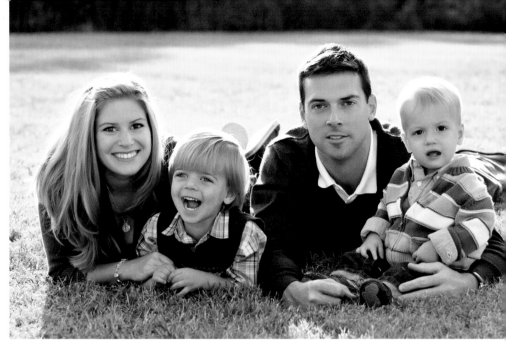

FACING PAGE:
PLATES 436 (TOP LEFT),
437 (TOP RIGHT),
438 (CENTER LEFT),
439 (CENTER RIGHT),
440 (BOTTOM LEFT),
AND 441 (BOTTOM RIGHT).
Photographs by Mimika Cooney.

PLATE 442 (RIGHT).
Photograph by Mimika Cooney.

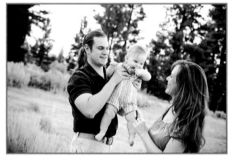

PLATE 443 (ABOVE).
Photograph by Christie Mumm.

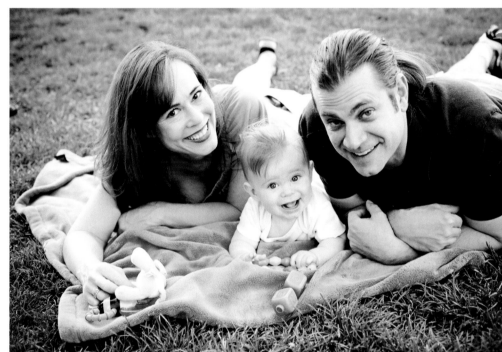

PLATE 444.
Photograph by Christie Mumm.

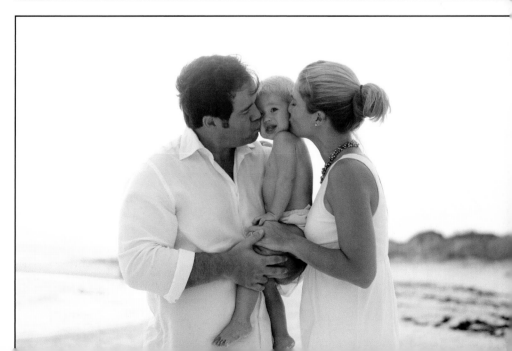

PLATE 445.
Photograph by Krista Smith.

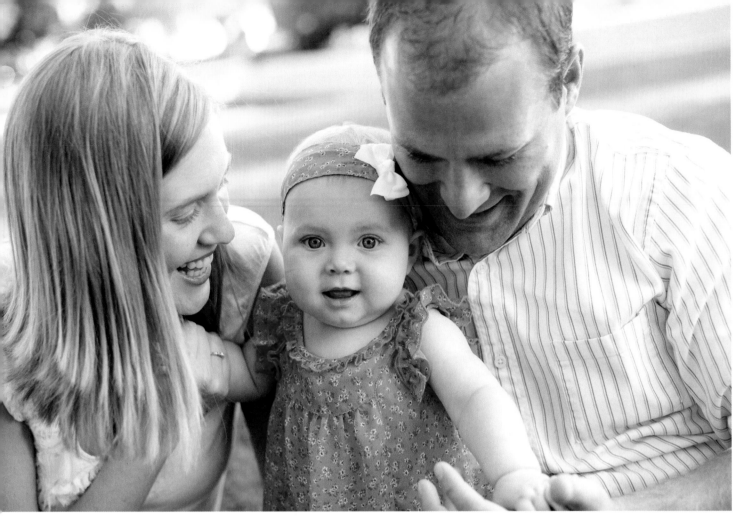

PLATES 446 (ABOVE) AND 447 (BELOW). Photographs by Christie Mumm.

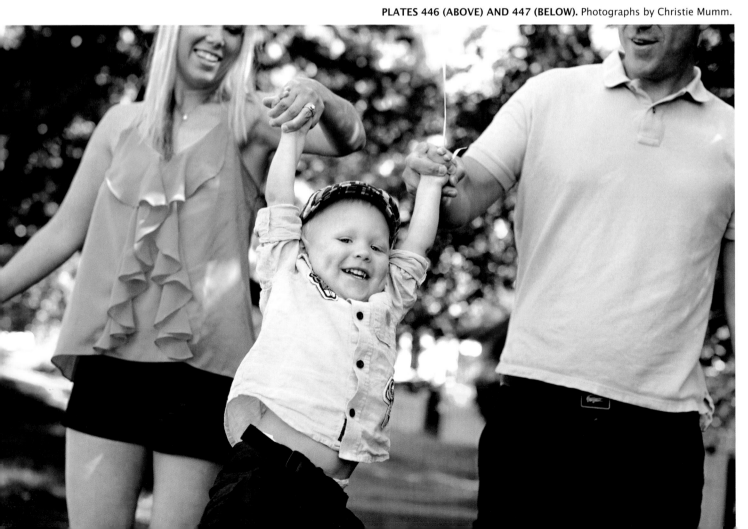

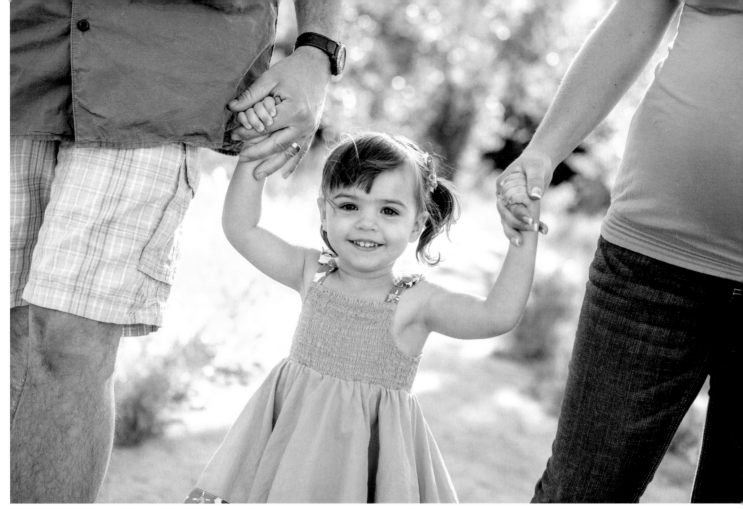

PLATE 448. Photograph by Christie Mumm.

PLATE 449. Photograph by Marc Weisberg.

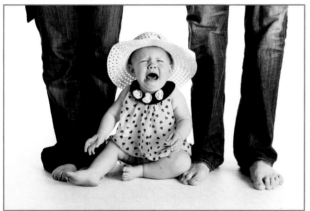

PLATE 450. Photograph by Christie Mumm.

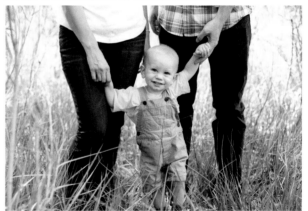

PLATE 451. Photograph by Marc Weisberg.

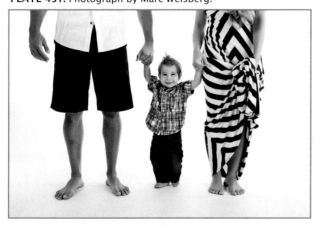

PLATE 452. Photograph by Heather Magliarditi.

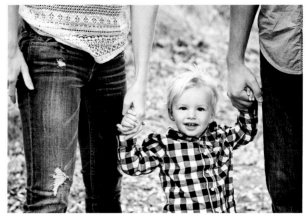

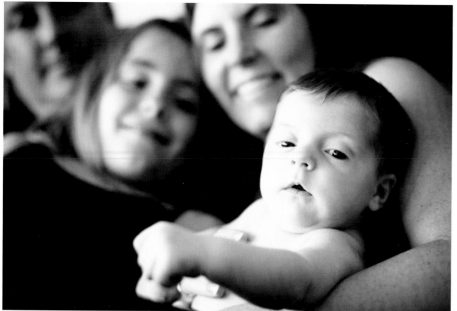

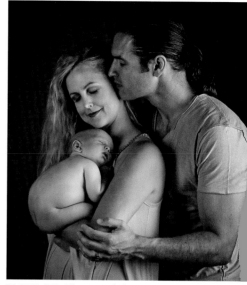

PLATE 453. Photograph by Marc Weisberg.

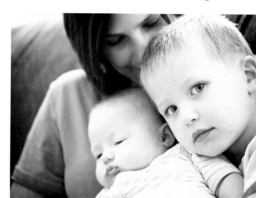

PLATE 454. Photograph by Christie Mumm.

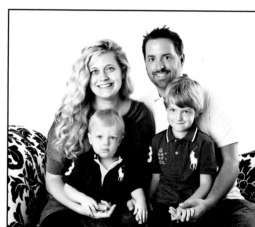

PLATE 455. Photograph by Mimika Cooney.

PLATE 456 (TOP LEFT).
Photograph by Christie Mumm.

PLATE 457 (BOTTOM LEFT).
Photograph by Christie Mumm.

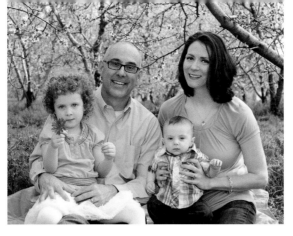

PLATE 458 (LEFT). Photograph by Mimika Cooney.

PLATE 459 (RIGHT). Photograph by Mimika Cooney.

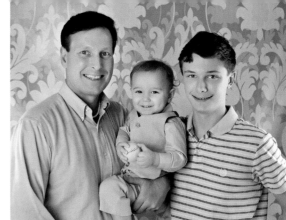

PLATE 460 (LEFT). Photograph by Christie Mumm.

PLATE 461 (RIGHT). Photograph by Mimika Cooney.

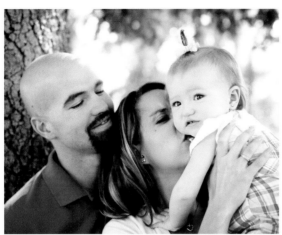

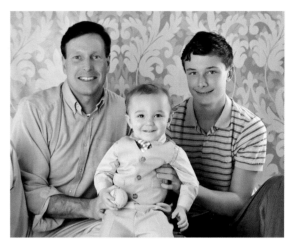

PLATE 462. Photograph by Mimika Cooney.

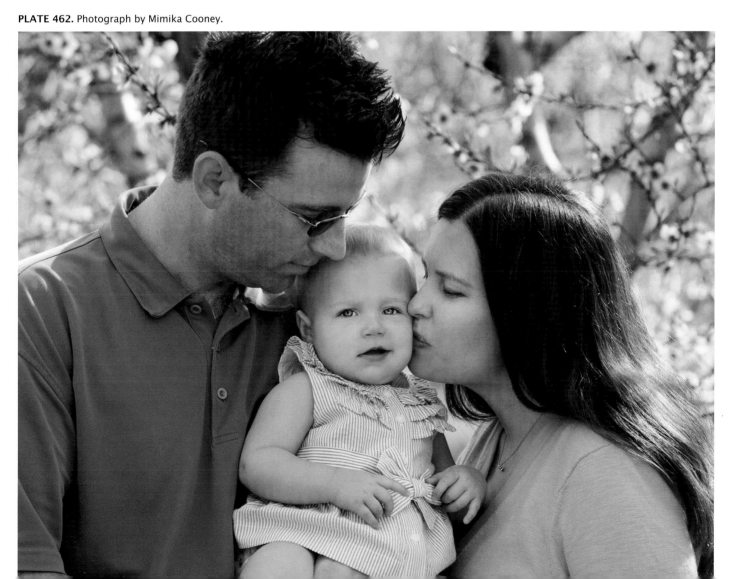

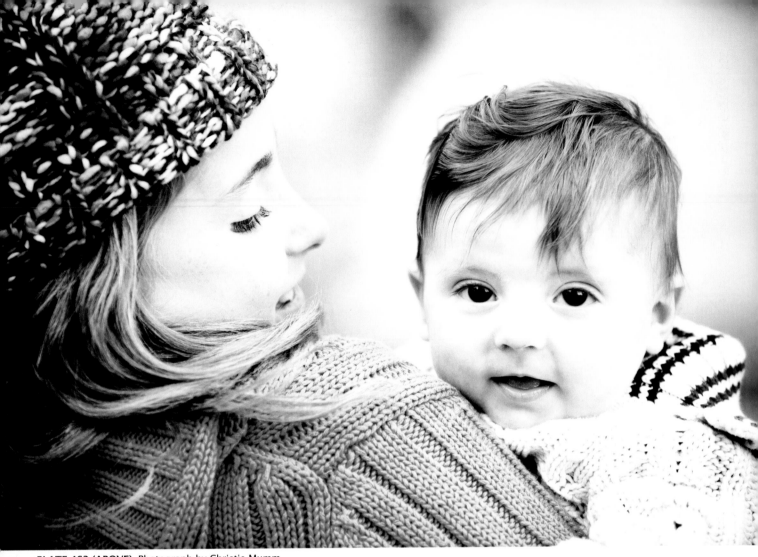

PLATE 463 (ABOVE). Photograph by Christie Mumm.

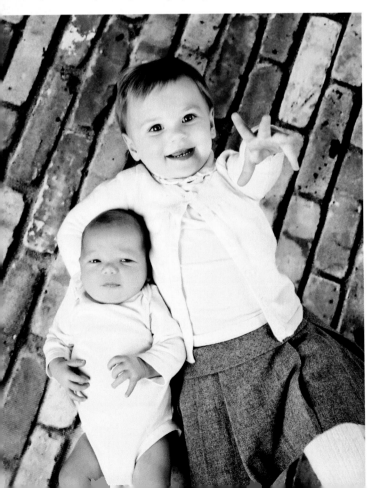

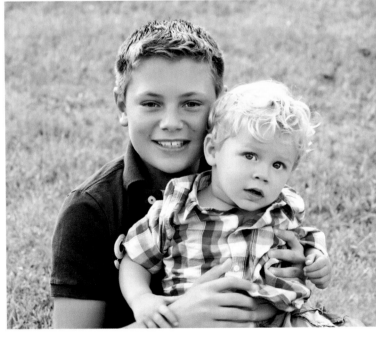

PLATE 464 (LEFT). Photograph by Mimika Cooney.

PLATE 465 (ABOVE). Photograph by Mimika Cooney.

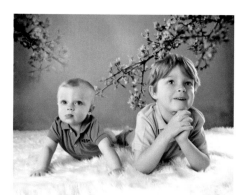

PLATE 466. Photograph by Mimika Cooney.

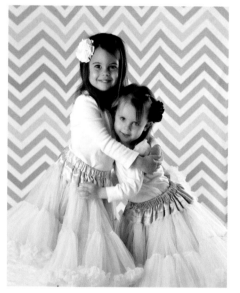

PLATE 467. Photograph by Mimika Cooney.

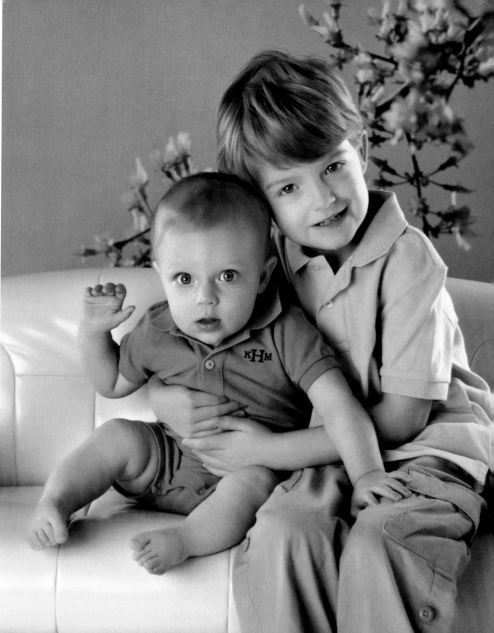

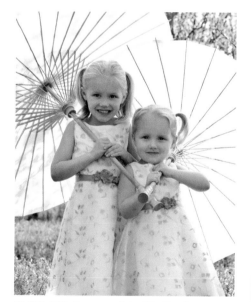

PLATE 468. Photograph by Mimika Cooney.

PLATE 469 (TOP RIGHT).
Photograph by Mimika Cooney.

PLATE 470 (BOTTOM RIGHT).
Photograph by Beth Forester.

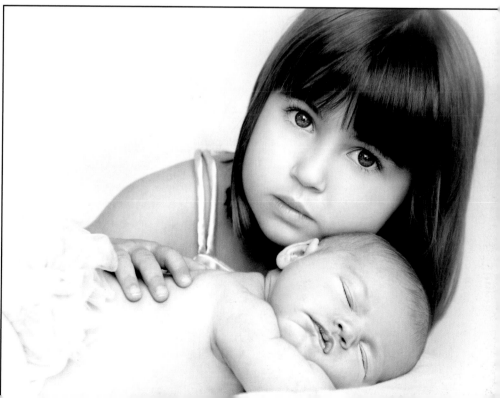

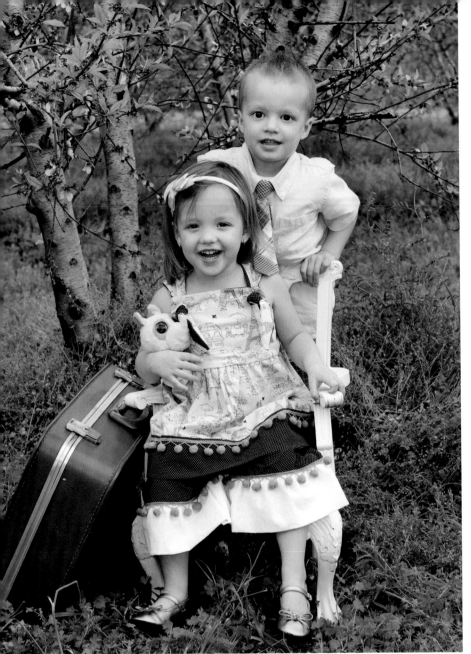

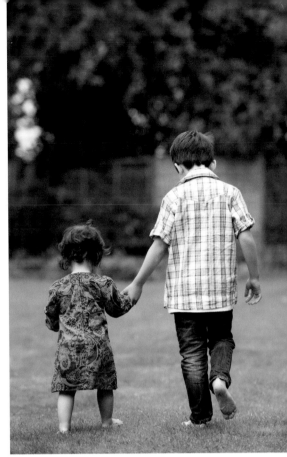

PLATE 471. Photograph by Brett Florens.

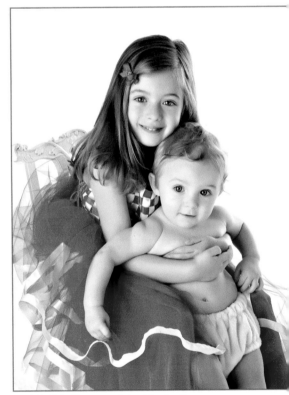

PLATE 472. Photograph by Mimika Cooney.

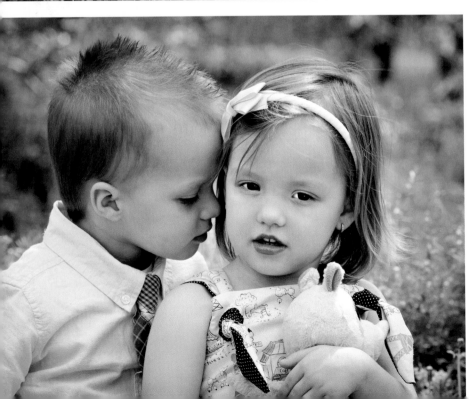

PLATE 473 (TOP LEFT).
Photograph by Mimika Cooney.

PLATE 474 (BOTTOM LEFT).
Photograph by Mimika Cooney.

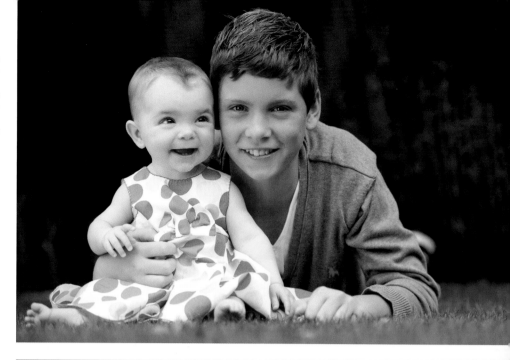

PLATE 475 (TOP RIGHT).
Photograph by Brett Florens.

PLATE 476 (CENTER RIGHT).
Photograph by Brett Florens.

PLATE 477 (BOTTOM RIGHT).
Photograph by Brett Florens.

PLATE 478. Photograph by Brett Florens.

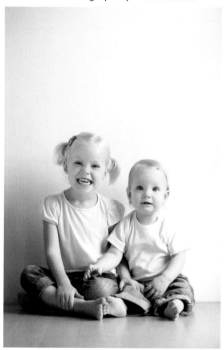

PLATE 479. Photograph by Brett Florens.

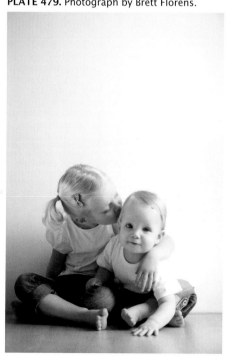

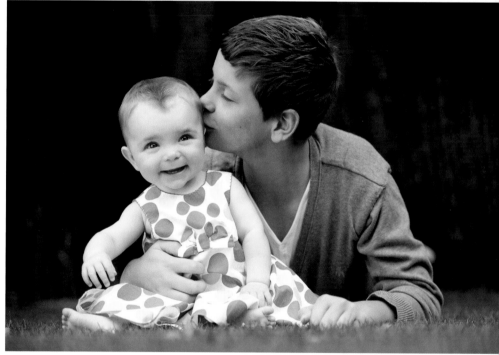

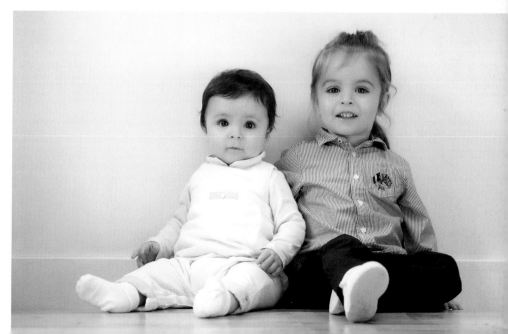

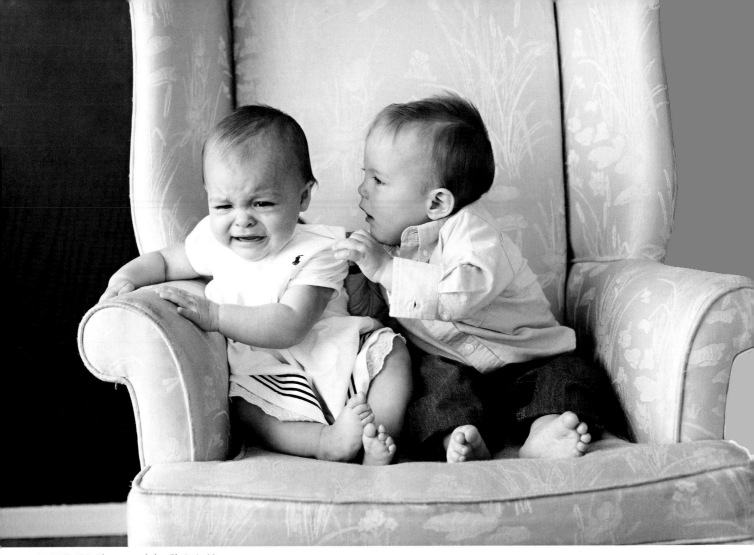

PLATE 480. Photograph by Christie Mumm.

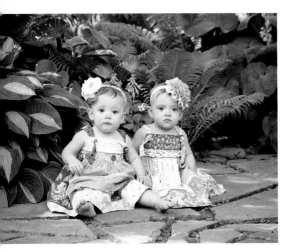

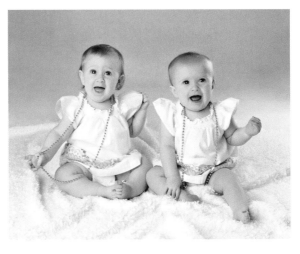

PLATE 481 (LEFT). Photograph by Jenean Mohr.

PLATE 482 (RIGHT). Photograph by Mimika Cooney.

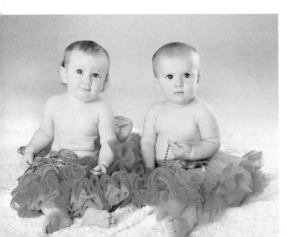

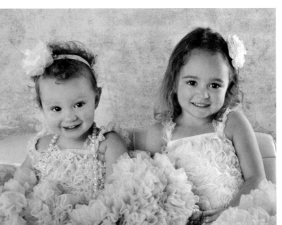

PLATE 483 (LEFT). Photograph by Mimika Cooney.

PLATE 484 (RIGHT). Photograph by Mimika Cooney.

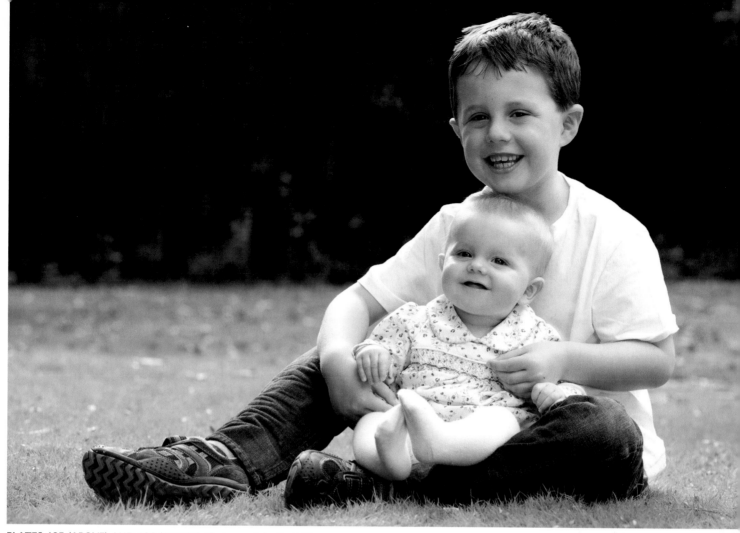

PLATES 485 (ABOVE) AND 486 (BELOW). Photograph by Brett Florens.

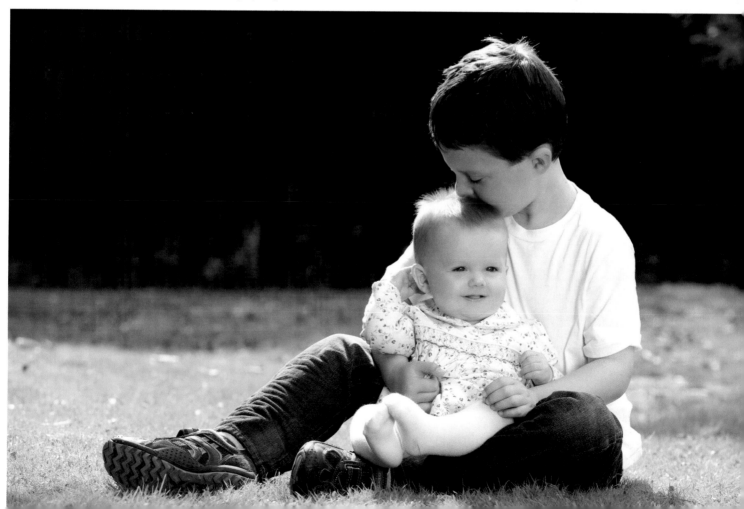

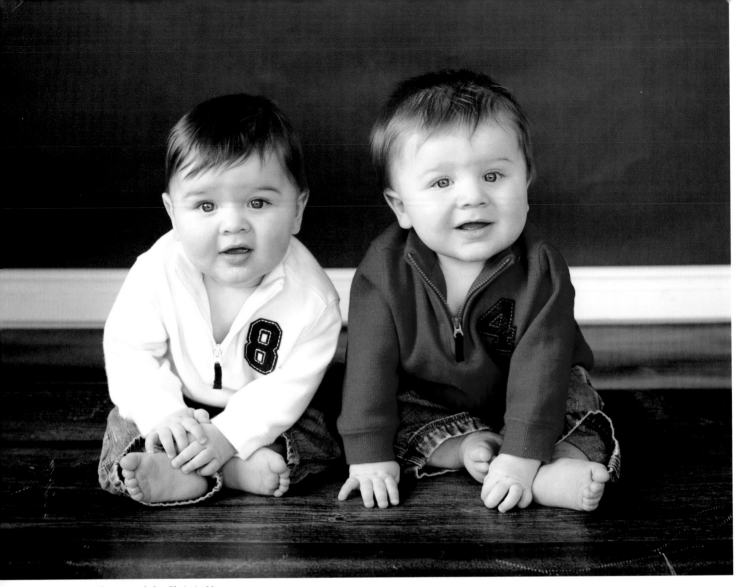

PLATE 487. Photograph by Christie Mumm.

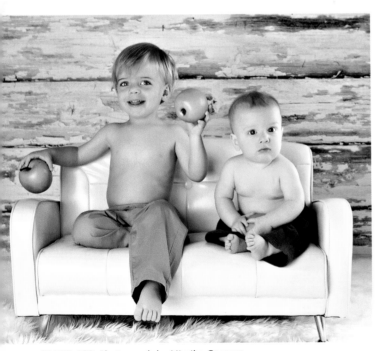

PLATE 488. Photograph by Mimika Cooney.

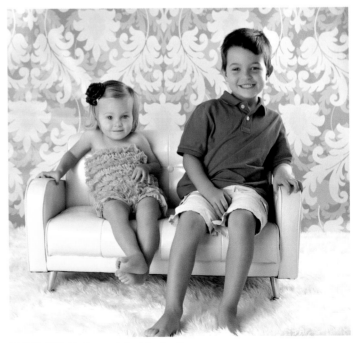

PLATE 489. Photograph by Mimika Cooney.

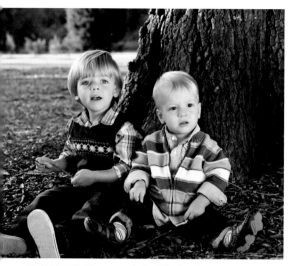

PLATE 490. Photograph by Mimika Cooney.

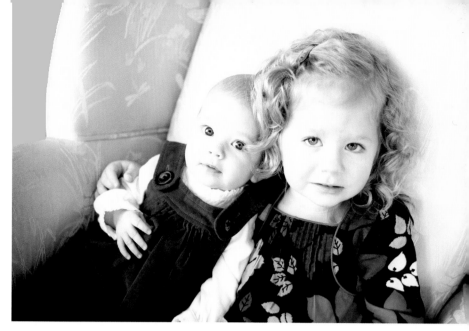

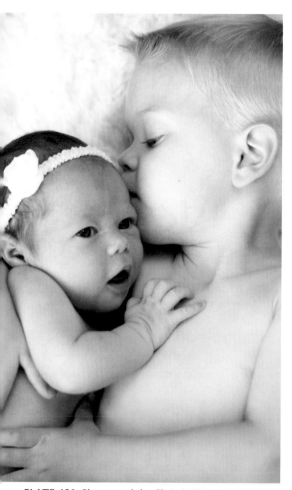

PLATE 491. Photograph by Christie Mumm.

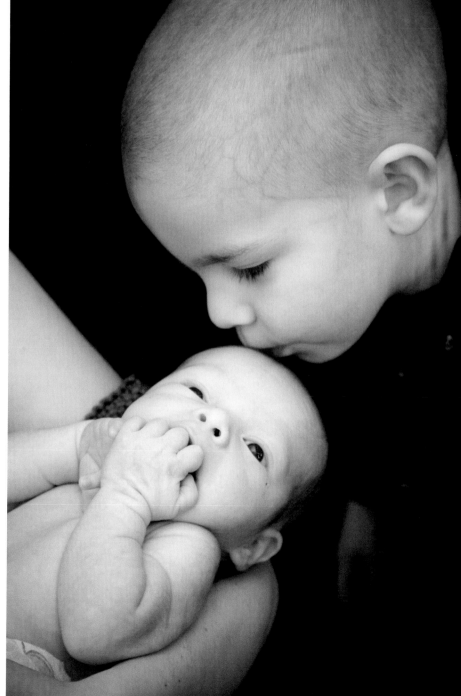

PLATE 492 (TOP RIGHT).
Photograph by Christie Mumm.

PLATE 493 (BOTTOM RIGHT)
Photograph by Christie Mumm.

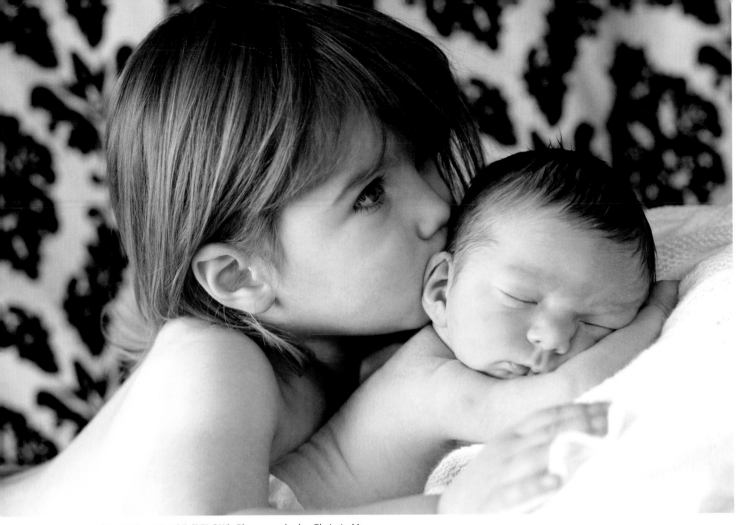

PLATES 494 (ABOVE) AND 495 (BELOW). Photographs by Christie Mumm.

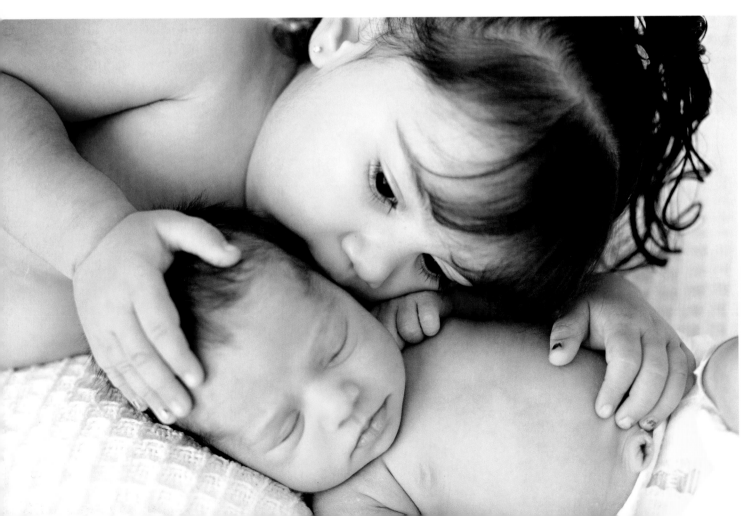

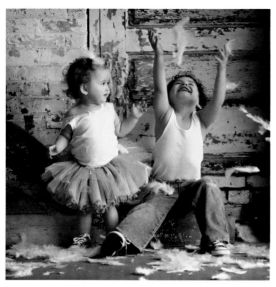

PLATE 496. Photograph by Vicki Taufer.

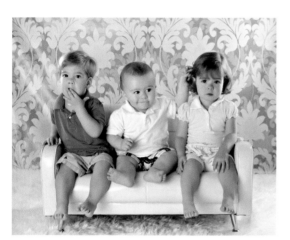

PLATE 497. Photograph by Mimika Cooney.

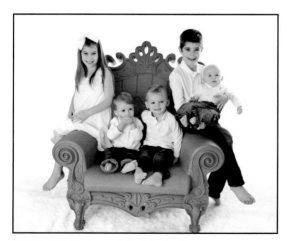

PLATE 498. Photograph by Mimika Cooney.

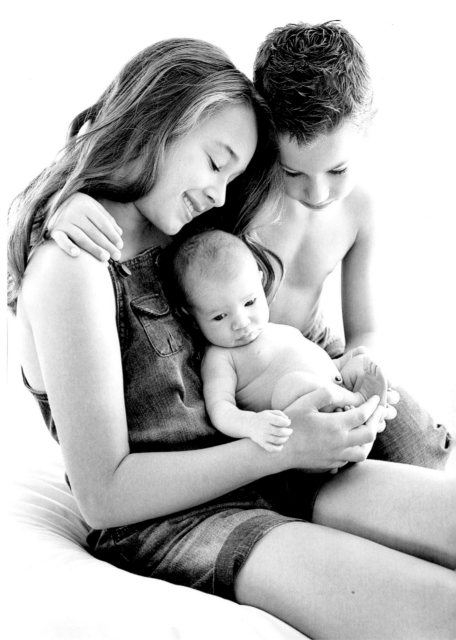

PLATE 499 (TOP RIGHT).
Photograph by Heather Magliarditi.

PLATE 500 (BOTTOM RIGHT).
Photograph by Mimika Cooney.

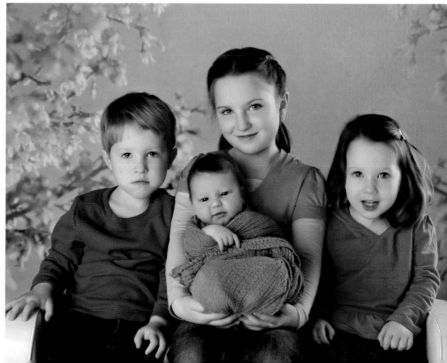

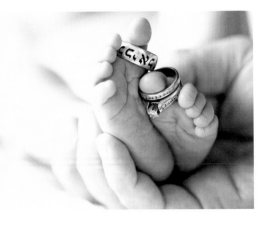

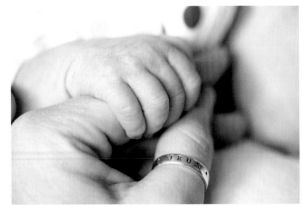

PLATE 501 (FAR LEFT).
Photograph by
Christie Mumm.

PLATE 502 (LEFT).
Photograph by
Christie Mumm.

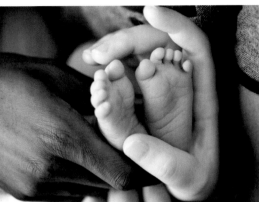

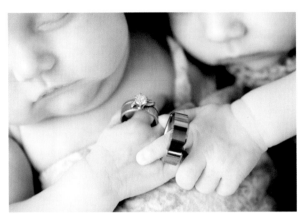

PLATE 503 (FAR LEFT).
Photograph by
Christie Mumm.

PLATE 504 (LEFT).
Photograph by
Christie Mumm.

PLATE 505 (BELOW).
Photograph by
Christie Mumm.

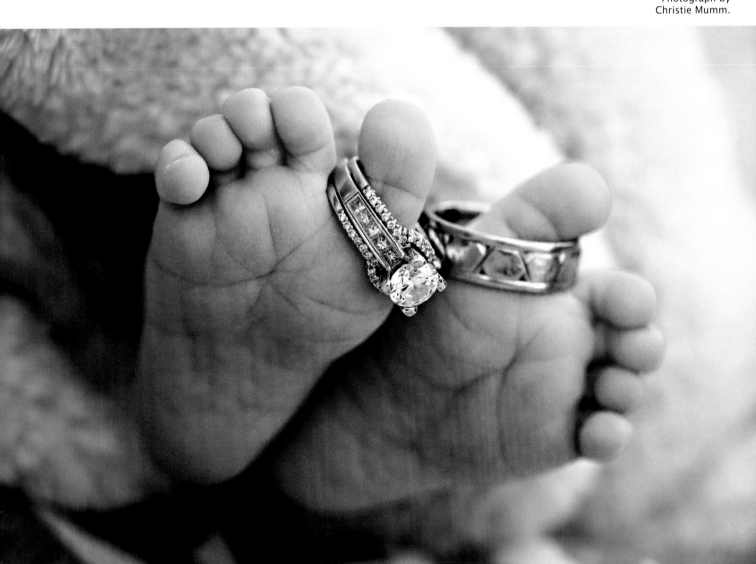

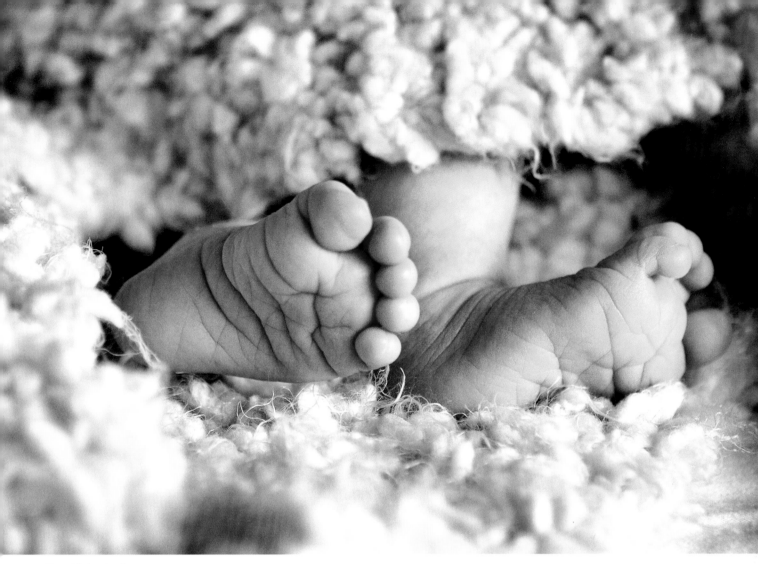

PLATE 506 (ABOVE).
Photograph by
Marc Weisberg.

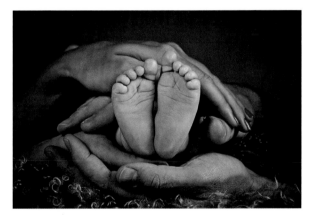

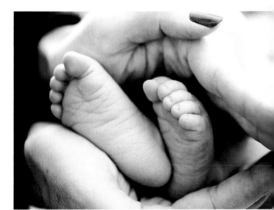

PLATE 507 (RIGHT).
Photograph by
Marc Weisberg.

PLATE 508 (FAR RIGHT).
Photograph by
Christie Mumm.

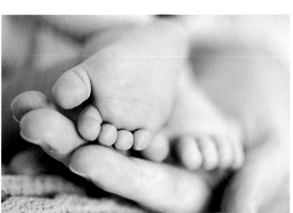

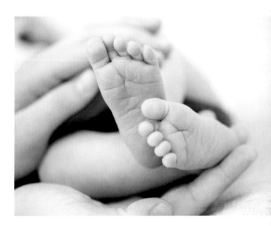

PLATE 509 (RIGHT).
Photograph by
Christie Mumm.

PLATE 510 (FAR RIGHT).
Photograph by
Christie Mumm.

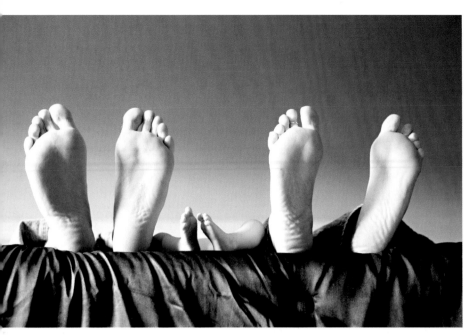

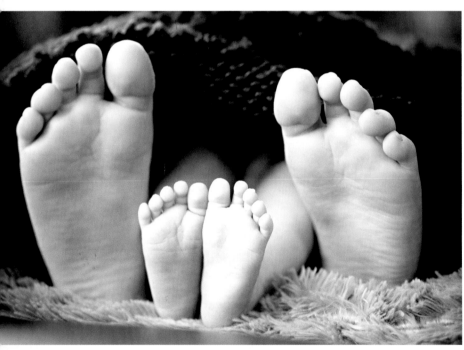

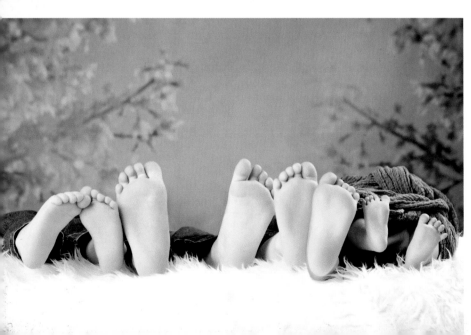

PLATE 511 (TOP LEFT).
Photograph by Christie Mumm.

PLATE 512 (CENTER LEFT).
Photograph by Christie Mumm.

PLATE 513 (BOTTOM LEFT).
Photograph by Mimika Cooney.

PLATE 514. Photograph by Christie Mumm.

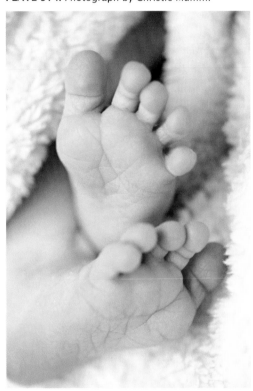

PLATE 515. Photograph by Christie Mumm.

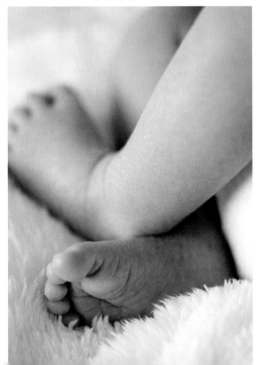

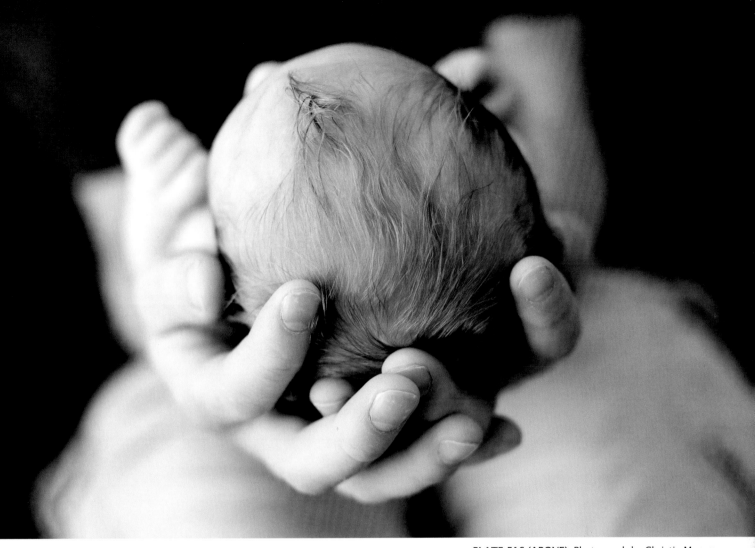

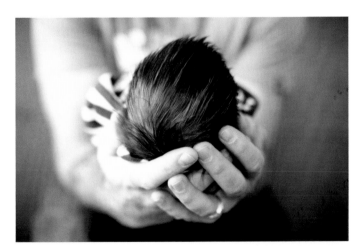

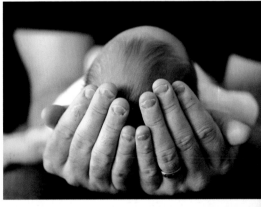

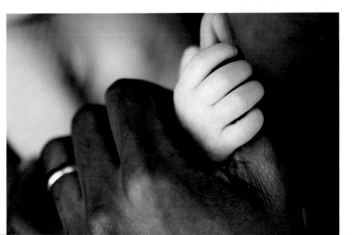

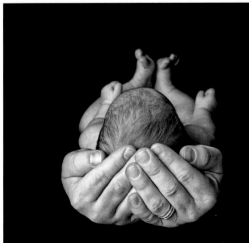

PLATE 521 (FAR LEFT).
Photograph by
Christie Mumm.

PLATE 522 (LEFT).
Photograph by
Christie Mumm.

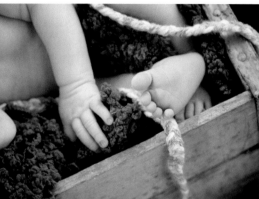

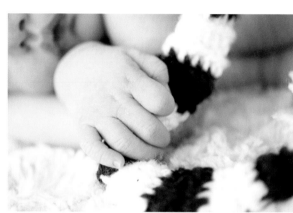

PLATE 523 (FAR LEFT).
Photograph by
Jenean Mohr.

PLATE 524 (LEFT).
Photograph by
Christie Mumm.

PLATE 525 (BELOW).
Photograph by
Christie Mumm.

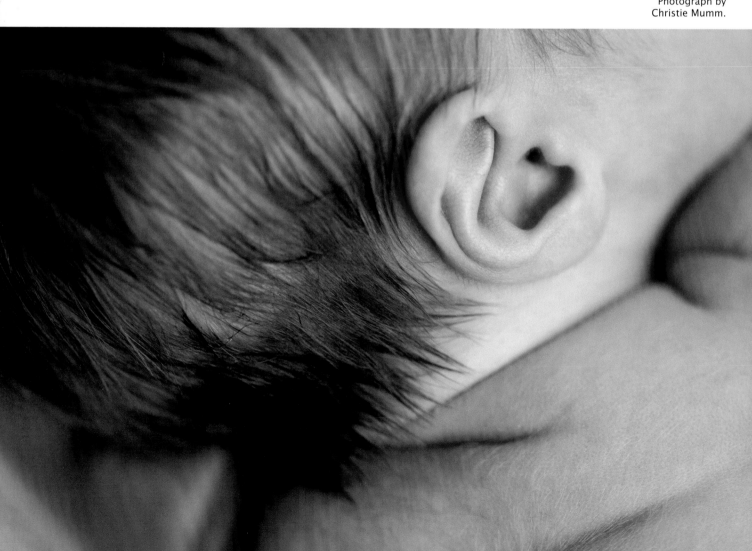

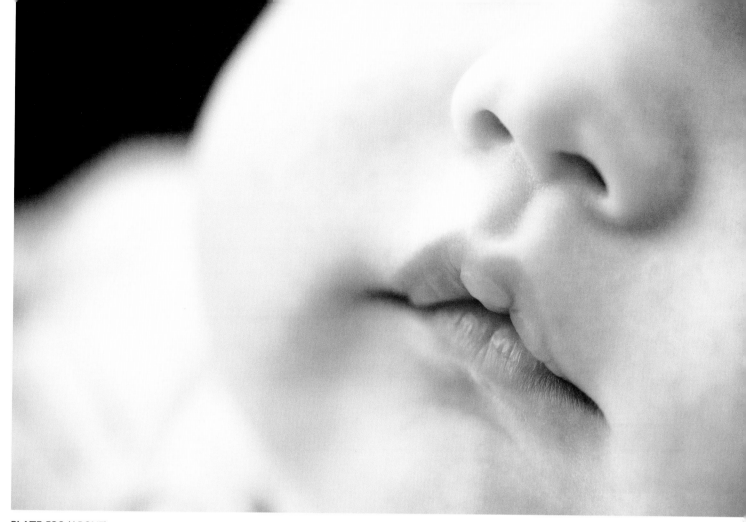

PLATE 526 (ABOVE).
Photograph by
Christie Mumm.

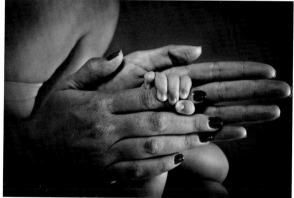

PLATE 527 (RIGHT).
Photograph by
Marc Weisberg.

PLATE 528 (FAR RIGHT).
Photograph by
Christie Mumm.

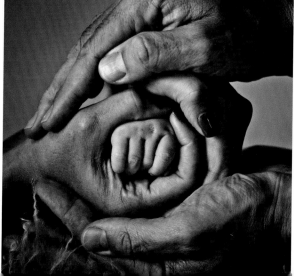

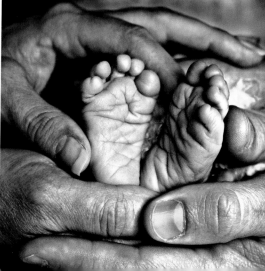

PLATE 529 (RIGHT).
Photograph by
Marc Weisberg.

PLATE 530 (FAR RIGHT).
Photograph by
Marc Weisberg.

Posing Fundamentals

When it comes to photographing children—especially young children—the traditional rules of "good" posing have to go out the window to some degree. However, there are still some qualities that tend to make one pose more appealing or attractive than another. There are also a few tricks that can assist you in reaching that goal.

NEWBORNS

Newborns are usually photographed asleep. This not only facilitates the session for the parents and photographer, it also reflects how infants spend 15 to 17 hours of their days; it's how their parents (the clients) see them most of the time.

To keep the baby asleep as long as possible, have Mom feed the child just before you're ready to shoot. Babies are usually photographed naked or in minimal clothing, so be sure to keep the studio much warmer than you would normally to encourage the infant to sleep comfortably and deeply. Additionally, ensure that your setup provides plenty of soft support for the child.

Once the baby is soundly asleep, you should be able to position the child for posing and gently make minor posing adjustments, such as to the hands or feet without upsetting them.

For naked baby portraits, poses and camera angles that obscure the groin area from view are, naturally, to be used. Tucked poses, particularly when composed with some negative space around the infant, can help emphasize the

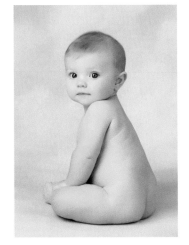 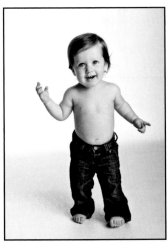

Sitting and standing independently are important milestones to document as the child advances from newborn to toddler. *Plates 165 (Beth Forester) and 321 (Marc Weisberg).*

small size of the newborn. For infants with little or no hair, a soft hat helps keep the emphasis of the portrait on the facial features.

INFANTS

Once the child is of an age where he or she is likely to be awake for some or all of the session, part of the posing task will be attracting the infant's gaze. This is most commonly done using gentle noises or motions just over the lens.

By the time they are 4 to 6 months old, babies will have greater control of their limbs. If you lay these babies on

Small posing refinements made without waking the newborn. *Details of plates 3, 4, and 5 by Marc Weisberg.*

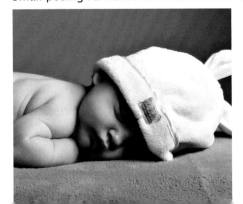 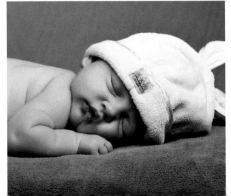 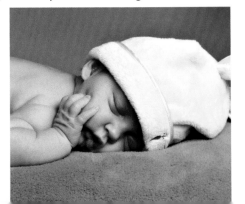

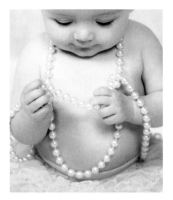

Simple props to hold (or even sit in) will help engage and entertain the young portrait subject. *Details of plates 103 and 194 by Tracy Dorr.*

their backs, they may grab their toes. You'll likely see them rolling over (or trying to), so be sure to pose them on a soft, stable surface that allows for this movement.

The ability to reach for and grasp objects is another developmental milestone that can be documented in your poses; place an interesting object just out of reach and wait for the child to reach for it. Create images of them holding the prop, or passing it from hand to hand.

At around the 6-month session, the baby will likely be sitting up independently. From a tummy-down pose, the child will likely be pushing up with his legs. A month or two later, the child will be crawling. As the infant closes in on one year of age, assisted standing and tentative steps may be seen. These offer your first chance to design standing poses, with the child supported by a prop.

TODDLERS

Once the child is up and on the move, you'll need to embrace the activity and provide clever encouragement to get the look you want—and keep them in the shooting area. Toddlers are often drawn to kid-sized furniture, intriguing toys, or other interesting-looking props. These devices can help anchor them in one spot and provide good posing opportunities. Additionally, showing how the child interacts with the world around them helps reflect their developing personality.

Through games, silly words, or being invited to mimic your actions, kids of this age can start to take some direction in terms of posing. The following are some things to strive for when posing (or look for when editing images from the session).

Stance. For a natural-looking pose, have the child shift their weight onto one leg. This causes one shoulder to

drop slightly, introducing a sense of ease and an appealing diagonal line into the composition.

Head Position. Tilting the head slightly produces diagonal lines that can help a pose feel more dynamic. Unless a child is very responsive to posing instructions, however, adding a head tilt that looks natural may be challenging; children will tend to adopt an exaggerated pose if you directly ask them to tilt their head.

The ability to reach for and grasp objects is another developmental milestone that can be documented in your poses.

Arms. The child's arms should be articulated and not allowed to simply hang at his sides. Having the child put his hands in his pockets, rest them on his hips, or interact with something on the set (pick up a toy, touch a prop, etc.) produces a good look.

Engaging the child in simple, familiar actions is a good way to pose toddlers' arms. *Details of plates 313 (Marc Weisberg; top left), 249 (Christie Mumm; top right), and 327 and 341 (Jenean Mohr; bottom left and right).*

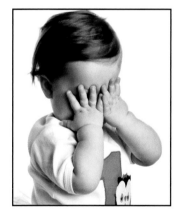
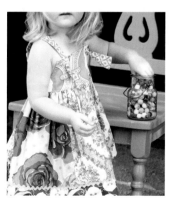
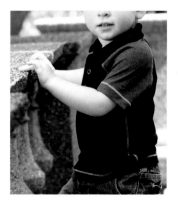
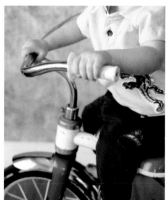

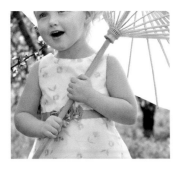
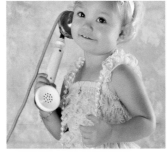
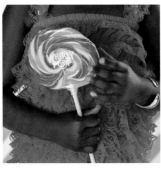
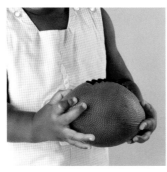

Adding props make it easier to pose toddlers' hands. *Details of plates 329, 331, 332, and 334 by Mimika Cooney.*

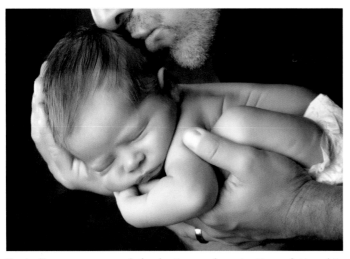

Encircling poses reveal the loving and protective relationship between parent and child. *Detail of plate 397 by Beth Forester.*

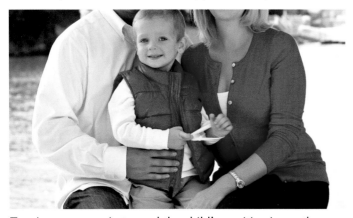

Turning everyone in toward the child's position is another way to encircle the young one and show the connection. *Detail of plate 429 by Mimika Cooney.*

Hands. Children's hands are often easiest to pose when they have something to do—a prop to hold or something to rest upon. Placing the hands in the pockets is a simple solution and one that will feel comfortable to most kids.

Feet. Kids' feet are cute, so barefoot portraits are a good option for less formal sessions (when the location permits). If the child is to wear shoes, avoid poses that show the bottom of the shoe.

INFANTS AND TODDLERS WITH THEIR FAMILY

A new child is not only a new individual but also a new member of a family. Therefore, the arrival of a child is a common reason to have family portraits made. For newborn and infant portraits, particularly those made before the child is sitting up independently, parents and siblings are often used almost like props, supporting the baby for their portraits but also helping the little one feel comfortable and secure.

Parents and siblings are often used almost like props, supporting the baby for their portraits.

These portraits are all about relationships. Even if only part of the parent/sibling is shown in the frame, it should be obvious that the baby is with a loved one. This often entails using poses that surround or encircle the baby. Portraits with Mom or Dad can be made with the parent's arms cradling and supporting the child.

Similar poses can be used for sibling portraits if the brother or sister is old enough to hold the baby securely. Otherwise, the infant can be posed lying down and the older child can be brought in on the same level, placing their arms around the baby or leaning in to place a kiss (a good way to bring the two faces close together).

Turning all of the subjects' bodies and faces toward the center of the frame (or wherever the baby is placed) also helps encircle the young one and demonstrate the close relationships shared.

The Photographers

My deepest thanks to the photographers whose work appears in this book. Their powerful images are inspiring—as is their commitment to educating other professionals. If you have a chance to learn from them, whether at a workshop or through their writing, take it; you won't be disappointed.

Mimika Cooney

www.mimikacooney.com

Mimika Cooney is an international award-winning photographer whose specialty is babies, beauty, and glamor. She owns a home-based portrait studio in Charlotte, NC. Born in South Africa, Mimika received her photographic training in England and is an accredited licenciate by the British Institute of Professional Photographers and the Society of Wedding and Portrait Photographers. Drawing on six years experience in website design, public relations, marketing, and business administration in South Africa and England, Mimika now enjoys focusing her artistic talents on offering a boutique portrait service to her American clientele. She also mentors and teaches other photographers aspects of business and marketing through her on-line photography school. She is the author of *Boutique Baby Photography: The Digital Photographer's Guide to Success in Maternity and Baby Photography* (Amherst Media).

Tracy Dorr

www.tracydorrphotography.com

Tracy Dorr is the author of two books: *Advanced Wedding Photojournalism: Professional Techniques for Digital Photographers* and *Engagement Portraiture: Master Techniques for Digital Photographers* (both from Amherst Media). She holds a BA in English/Photography from the State University of New York at Buffalo and has been shooting professionally since 2003. Tracy won three Awards of Excellence from WPPI (Wedding and Portrait Photographers International) and has been a Master Class teacher at the WPPI convention in Las Vegas. Her work has been published in numerous local wedding publications. Tracy has also been a contributor to five books in the *500 Poses* series by Michelle Perkins (Amherst Media).

Brett Florens

www.brettflorens.com

Brett Florens launched his career in 1992 while fulfilling his national service obligations in South Africa. Within the police riot unit, a photographic unit was formed to document political changes, crimes, and township violence during a volatile time in the country. Brett jumped at the chance to join. With no photographic experience prior to that, Brett thrived on the opportunity, quickly mastering the technical requirements. Since then, Brett's devotion to photography has taken him from photojournalism to a highly successful career in portraiture, wedding, commercial, and fashion photography. He has received numerous accolades along the way, the most recent of which was Nikon recognizing him as one of the world's most influential photographers. Brett frequently travels from South Africa to Europe to photograph family portraiture, shooting over 300 families a year. His easy-going and warm manner and his ability to coax usually unruly children into posing beautifully for him, have earned him the name "The Child Whisperer." He is the author of *Brett Florens' Guide to Photographing Weddings* and *Modern Bridal Photography Techniques* (Amherst Media).

Beth Forester

www.foresterphoto.com

Beth Forester is the owner and operator of Forester Photography, a studio in the small town of Madison, WV. She is a graduate of Centre College of Kentucky and a board member for the Professional Photographers of West Virginia. She is also a member of the Professional Photographers of America, from which she holds the degree of Master of Photography. Beth is always striving to create something unique and original for each of her clients. She states, "I love the control I have over the final look of the portrait. The ability to put that little something extra into each image is a very rewarding experience." In 2007, she decided to create a series of products especially for the professional photographer, which would serve as a "kit" for creating unique portraits and products. Thus, the popular photoDUDS project (www.photoduds.com) was born.

Heather Magliarditi

www.heathermagliarditiphotography.com

Heather Magliarditi, owner of Heather Magliarditi Photography, is based in Las Vegas but also offers summer sessions

in New York. Her style is simple, fun, and pure—centering on natural moments and playful expressions from the children she photographs. Working exclusively with natural light, she also makes use of a wide variety of off-beat locations, working where the light is most flattering. As a mother of three, Heather knows the importance of children's portraiture. "Children grow so fast, and we forget so easily how tiny they were—their cute little toes, the way they giggled with their two little teeth, the blankey they held, and so many more little things we want to remember forever," she says. "I am here to freeze time, so parents can remember all of those things."

Jenean Mohr

www.jeneanmohrphotography.com

Jenean Mohr, owner of Jenean Mohr Photography, began photographing professionally in 2000. She specializes in newborns, children, and families but also photographs weddings and loves engagement sessions. Her uniquely personal approach engages the customer and makes each session memorable. She shoots at unique and fun locations in her local area and rarely works indoors. Jenean enjoys photographing kids as they play, laugh, and have fun—and shooting outside allows for this. She also likes to incorporate props to engage children. Jenean lives in North Tonawanda, NY, with her husband and two children.

Christie Mumm

www.jlmcreative.com

Christie Mumm is the owner of JLM Creative Photography in Reno, NV. Christie maintains a business philosophy that is focused on her clients and their families, and she truly loves the wonderful people she is blessed to work with. In the summer of 2009, Christie realized a long-time dream when she was able to open a small boutique studio in downtown Reno. Christie firmly believes in running her business debt-free and feels that this has allowed her to continue to experience growth even during national economic downturns. She has been married to her best friend for over ten years and is the mother of one precocious and creative young daughter. Christie is the author of *Family Photography: The Digital Photographer's Guide to Building a Business on Relationships,* from Amherst Media.

Krista Smith

www.saltykissesphotography.com

Krista Smith is a portrait photographer from Asheville, NC, who specializes in beach portraits and families. After vacationing to the Emerald Coast every chance they had, Krista and her family decided to make the move to call the beach home and have loved every minute of it! The beautiful white sands and gorgeous sunsets make northwest Florida a perfect spot for beautiful portraits, whether it is for maternity, engagements, children, or families big or small! Krista has three small children and knows exactly how to approach kids of all temperaments, from shy darlings to rambunctious balls of energy. She takes the time to get to know each family and what they want so that their portraits are never stiff, boring photos of people who look uncomfortable. Her passion for fun, unscripted portraits comes from the frustration of seeing her own family portraits lack the energy and fun she felt they needed, so she is truly dedicated to getting the perfect portrait for all her clients.

Vicki Taufer

www.vgallery.net

Vicki has been an artist her whole life and a professional photographer for twelve of those years. Her business, V Gallery, focuses on offering a boutique experience to her children, family, and portrait clients. Vicki has been recognized internationally in the photographic industry through numerous awards, being featured in multiple magazines, books, and websites, as well as teaching photographers around the world. Vicki is known not only for her photography but her unique marketing ideas. Most recently, Vicki became a mother, which has been causing her to reinvent, re-prioritize, and refocus her business while keeping her passion for photography alive.

Marc Weisberg

www.marcweisberg.com

Marc Weisberg operates a boutique studio in California, specializing in magazine-style portraits of newborns, children, and families. Marc teaches photography and marketing both privately and as a guest lecturer at local colleges. He taught a Master Class in marketing at the WPPI convention in Las Vegas and has spoken on wedding photography and marketing at the Professional Photographers of California convention in Pasadena. Additionally, he was a featured speaker at the Pictage Partner-Con meetings in Los Angeles and New Orleans. Marc has won over a dozen national and international awards from WPPI and PPA. His photography has been featured in *Rangefinder* magazine as well as in more than a dozen books by Amherst Media®—including *The Best of Wedding Photography* and *The Best of Photographic Lighting* by Bill Hurter, and *500 Poses for Photographing Women* and *500 Poses for Photographing Brides* by Michelle Perkins.

DOUG BOX'S
Available Light Photography

Popular photo-educator Doug Box shows you how to capture (and refine) the simple beauty of available light—indoors and out. *$29.95 list, 7.5x10, 160p, 240 color images, order no. 1964.*

THE BEST OF
Senior Portrait Photography,
SECOND EDITION

Rangefinder editor Bill Hurter takes you behind the scenes with top pros, revealing the techniques that make their images shine. *$29.95 list, 7.5x10, 160p, 200 color images, order no. 1966.*

Flash Techniques for Location Portraiture

Alyn Stafford takes flash on the road, showing you how to achieve big results with these small systems. *$29.95 list, 7.5x10, 160p, 220 color images, order no. 1963.*

Backdrops and Backgrounds
A PORTRAIT PHOTOGRAPHER'S GUIDE

Ryan Klos' book shows you how to select, light, and modify man-made and natural backdrops to create standout portraits. *$29.95 list, 7.5x10, 160p, 220 color images, order no. 1976.*

75 Portraits by Hernan Rodriquez

Conceptualize and create stunning shots of men, women, and kids with the high-caliber techniques in this book. *$29.95 list, 7.5x10, 160p, 150 color images, 75 diagrams, index, order no. 1970.*

DON GIANNATTI'S Guide to
Professional Photography

Perfect your portfolio and get work in the fashion, food, beauty, or editorial markets. Contains insights and images from top pros. *$29.95 list, 7.5x10, 160p, 220 color images, order no. 1971.*

Master Posing Guide for Portrait Photographers, 2nd Ed.

JD Wacker's must-have posing book has been fully updated. You'll learn fail-safe techniques for posing men, women, kids, and groups. *$29.95 list, 7.5x10, 160p, 220 color images, order no. 1972.*

Books by Featured Photographers . . .

Boutique Baby Photography

Mimika Cooney shows you how to create the ultimate portrait experience—from start to finish—for your higher-end baby and maternity portrait clients. *$34.95 list, 7.5x10, 160p, 200 color images, index, order no. 1952.*

Advanced Wedding Photojournalism

Tracy Dorr shows you how to tune in to the day's events and participants so you can capture beautiful, emotional images. *$34.95 list, 8.5x11, 128p, 200 color images, index, order no. 1915.*

BRETT FLORENS' Guide to Photographing Weddings

Learn the artistic and business strategies Brett Florens uses to remain at the top of his field. *$34.95 list, 8.5x11, 128p, 250 color images, index, order no. 1926.*

Modern Bridal Photography Techniques

Get a behind-the-scenes look at some of Brett Florens' most prized images—from conceptualization to creation. *$39.95 list, 7.5x10, 160p, 200 color images, 25 diagrams, order no. 1987.*

Family Photography

Christie Mumm shows you how to build a business based on client relationships and capture life-cycle milestones, from births, to senior portraits, to weddings. *$34.95 list, 8.5x11, 128p, 220 color images, index, order no. 1941.*

Direction & Quality of Light

Neil van Niekerk shows you how consciously controlling the direction and quality of light in your portraits can take your work to a whole new level. *$39.95 list, 7.5x10, 160p, 195 color images, order no. 1982.*

Other Books in This Series . . .

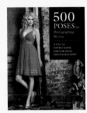

500 Poses for Photographing Women

Michelle Perkins compiles an array of striking poses, from head-and-shoulders to full-length, for classic and modern images. *$34.95 list, 8.5x11, 128p, 500 color images, order no. 1879.*

500 Poses for Photographing Brides

Michelle Perkins showcases an array of head-and-shoulders, three-quarter, full-length, and seated and standing poses. *$34.95 list, 8.5x11, 128p, 500 color images, index, order no. 1909.*

500 Poses for Photographing Men

Michelle Perkins showcases an array of head-and-shoulders, three-quarter, full-length, and seated and standing poses. *$34.95 list, 8.5x11, 128p, 500 color images, order no. 1934.*

500 Poses for Photographing Couples

Michelle Perkins showcases an array of poses that will give you the creative boost you need to create an evocative, meaningful portrait. *$34.95 list, 8.5x11, 128p, 500 color images, order no. 1943.*

500 Poses for Photographing High School Seniors

Michelle Perkins presents head-and-shoulders, three-quarter, and full-length poses tailored to seniors' eclectic tastes. *$34.95 list, 8.5x11, 128p, 500 color images, order no. 1957.*

500 Poses for Photographing Children

Michelle Perkins presents head-and-shoulders, three-quarter, and full-length poses to help you capture the magic of childhood. *$34.95 list, 8.5x11, 128p, 500 color images, order no. 1967.*

500 Poses for Photographing Groups

Michelle Perkins provides an impressive collection of images that will inspire you to design polished, professional portraits. *$34.95 list, 8.5x11, 128p, 500 color images, order no. 1980.*

THE ART AND BUSINESS OF HIGH SCHOOL
Senior Portrait Photography,
SECOND EDITION

Ellie Vayo provides critical marketing and business tips for all senior portrait photographers. *$39.95 list, 7.5x10, 160p, 200 color images, order no. 1983.*

THE DIGITAL PHOTOGRAPHER'S GUIDE TO
Natural-Light Family Portraits

Jennifer George teaches you how to use natural light and meaningful locations to create cherished portraits and bigger sales. *$34.95 list, 8.5x11, 128p, 180 color images, index, order no. 1937.*

Off-Camera Flash
TECHNIQUES FOR DIGITAL PHOTOGRAPHERS

Neil van Niekerk shows you how to set your camera, choose the right settings, and position your flash for exceptional results. *$34.95 list, 8.5x11, 128p, 235 color images, index, order no. 1935.*

Children's Portrait Photography Handbook, 2nd Ed.

Bill Hurter provides insight into creating unique image style, eliciting expressions, gaining cooperation, and more. *$34.95 list, 8.5x11, 128p, 150 color images, index, order no. 1917.*